MY LAST SUPPER

THE NEXT COURSE

50 Great Chefs and Their Final Meals

Portraits, Interviews, and Recipes

MELANIE DUNEA

Introduction by Marco Pierre White

Book Design by No11 Inc.

RODALE

FOR NIGEL

CHEFS

MARCO SAYS

All great chefs have three things in common.

First, they accept and respect that Mother Nature is the true artist and that they are the cooks.

Second, everything they do in the kitchen is an extension of themselves.

Third, they give great insight into the world they were born into and the world that inspired them, and they serve these experiences on plates.

When Melanie asked what I would eat for my last supper, I immediately thought of my mother and how I would give anything to have her present at my final meal. Any consideration of what meal would be prepared would reflect my sense of hope at being reunited with her. Although she died when I was six years old, she has inspired everything I do.

My tribute to Mother Nature is connected in every way to my own mother.

The last supper is the final chapter of a great chef's gastronomic journey. This collection of photographs and interviews celebrates the great diversity and rich experiences of my fellow chefs. However, we all have a connection to the food we prepare, serve our families, and eat. My hope is that the stories here inspire you to appreciate what is most important to you and to respect your personal connection to Mother Nature, however she presents herself to you.

—MARCO PIERRE WHITE

JOËL ROBUCHON

What would be your last meal on Earth?
A good bread. Bread is a symbol of birth, life, and death. It's the symbol of sharing, companionship, friends, and French people—you know, we love bread, bread with a nice dollop of salted butter. Bread is the most beautiful gesture of love. I remember from my childhood we would bake these very large loaves of bread. My mother would hold the bread against her chest and make the sign of the cross, because we were Catholic, and she'd cut the bread on her chest and give it to us, her children, and to her husband. It was our daily bread. She gave us her love and emptied herself giving us this bread. So, for me, it's not so much about the last meal; it's more Proust's madeleines, the nostalgia.

What would be the setting for the meal?
The place isn't that important. I think the most important thing is whom one is with. The time of year and the weather are not important, really, because even if it's the worst weather in the world, if I'm surrounded by people I love, that's the most beautiful ray of sunlight.

What would you drink with your meal?
Water, of course. But if I go in the pursuit of luxury, I would drink a glass of Bordeaux, because it's from my region. I'm from Bordeaux, from Poitou, so I have a weakness for Bordeaux wine. A Pape Clement because at one time I studied in the seminary to be a priest, which is why the Pape Clement wine is symbolic for me. It would be a vintage '45, the vintage of the century. There's '28, '45, '47—those are the three best years. But '45, it's perhaps the best, especially in Pape Clement. I have bottles of '45 at my home. I was born in 1945, so I bought '45s, and people gave me '45s.

Would there be music?
Ah, you know, I don't have an ear for music. But Mozart seems quite nice. Mozart's "Requiem" . . . for leaving, given the circumstances. Or, otherwise, something else I like very much is Vivaldi's "Four Seasons." It's more cheery. We are speaking of death, after all.

Who would be your dining companions?
I would like to be with my children, my grandchildren, my family, the people I love, of course. The goal of life is to find oneself a little bit in that family space, with the children, and to share with them. To leave life surrounded by the people that one loves, with one's children and children's children, I think that's the best one could hope for.

Who would prepare the meal?
I would make the bread. Bread is natural; it's like natural wine—it's like mankind ripening. Man lives like a wine that ferments, that ages to perfection little by little. This bread is life, after all. This bread that you put into an oven develops and afterward becomes crusty, which means everything! And then, of course, these odors, these odors that are extraordinary . . . I remember when my mother would take a chicken to roast—you know, for Sunday—to the baker's, and the baker would cook the chicken in the middle of the breads so the chicken was embalmed with the smell of bread . . . It's very simple! Very simple, really, but so good.

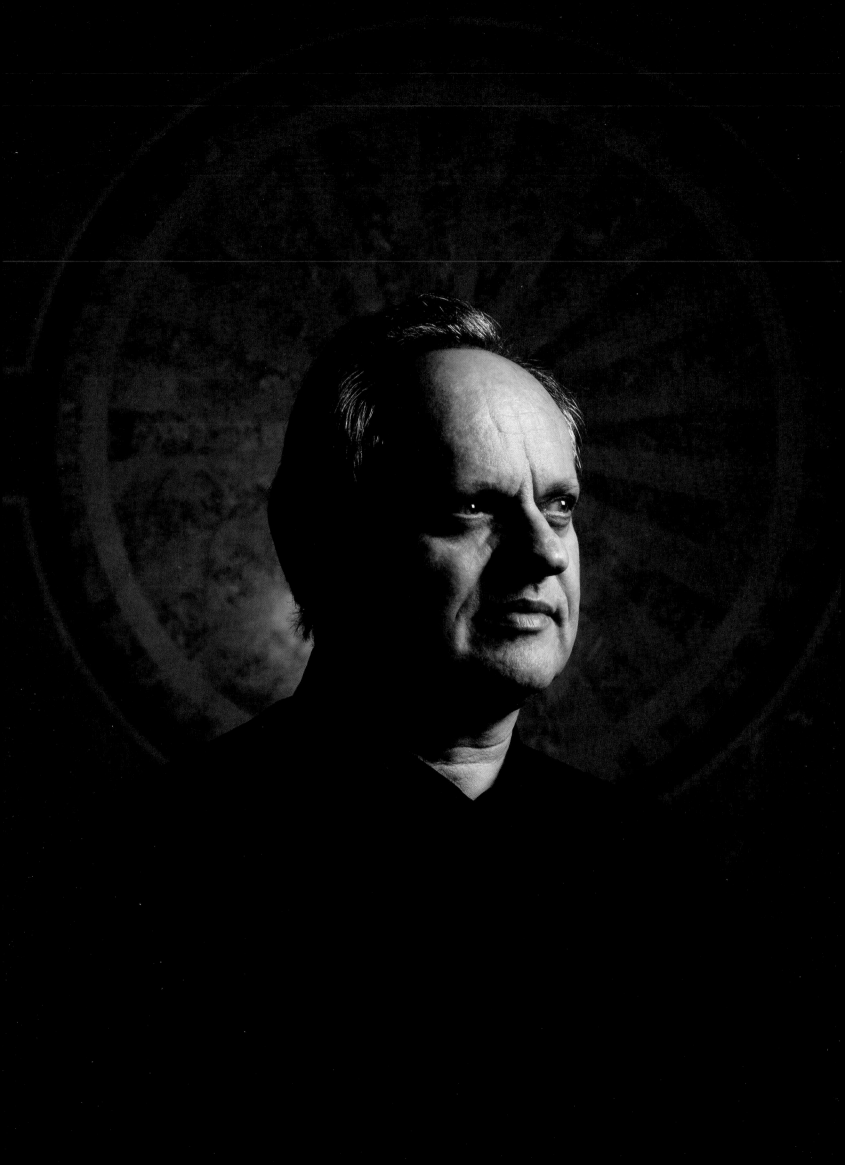

ALBERT ROUX

What would be your last meal on Earth?
I think a little bit of skirt steak, which is the part of the beef next to the rump. It's full of flavor. Might be a little bit hard to masticate, but it has such a flavor that it is my favorite cut of beef on the animal. I would have it with béarnaise sauce and some English chips. I don't like them too crispy, and I don't like them lumpy either . . . somewhere in between the two. And for dessert, I would have a bit of *fromage du chevre* to go with the wine. I love goat cheese.

What would be the setting for the meal?
On a little island somewhere.

What would you drink with your meal?
Well, for the skirt and my chips, I would like a nice bottle of Beaujolais. And I would go for a Côtes du Rhône, a good Côtes du Rhône, nice and strong to go with my *fromage du chevre*.

Would there be music?
Beethoven. It is the last supper, so eating it with the Fifth Symphony would be absolutely perfect.

Who would be your dining companions?
Well, if they are the last breaths I'm going to take, I would like to take them with my wife, only the two of us—and the dog. The three of us. The dog will partake in eating the steak, I'm sure. He always does.

Who would prepare the meal?
I. Yes, I would do that.

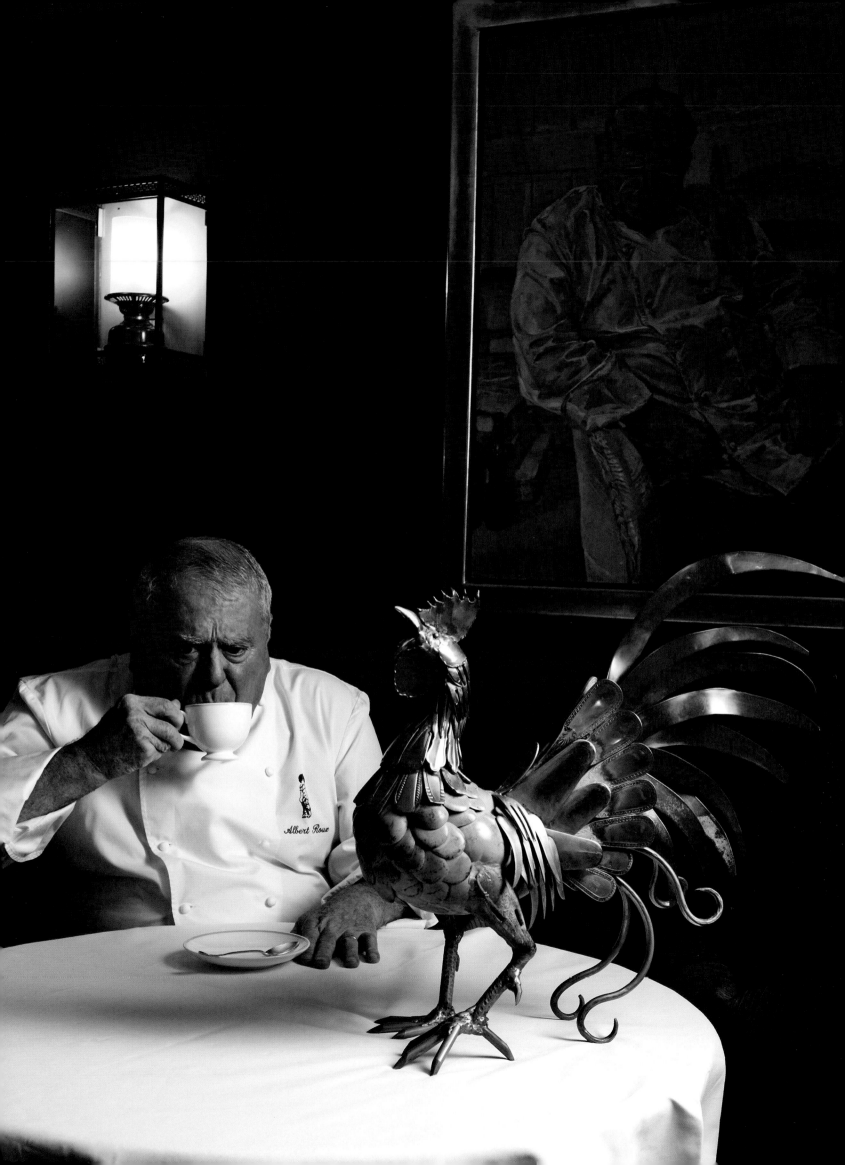

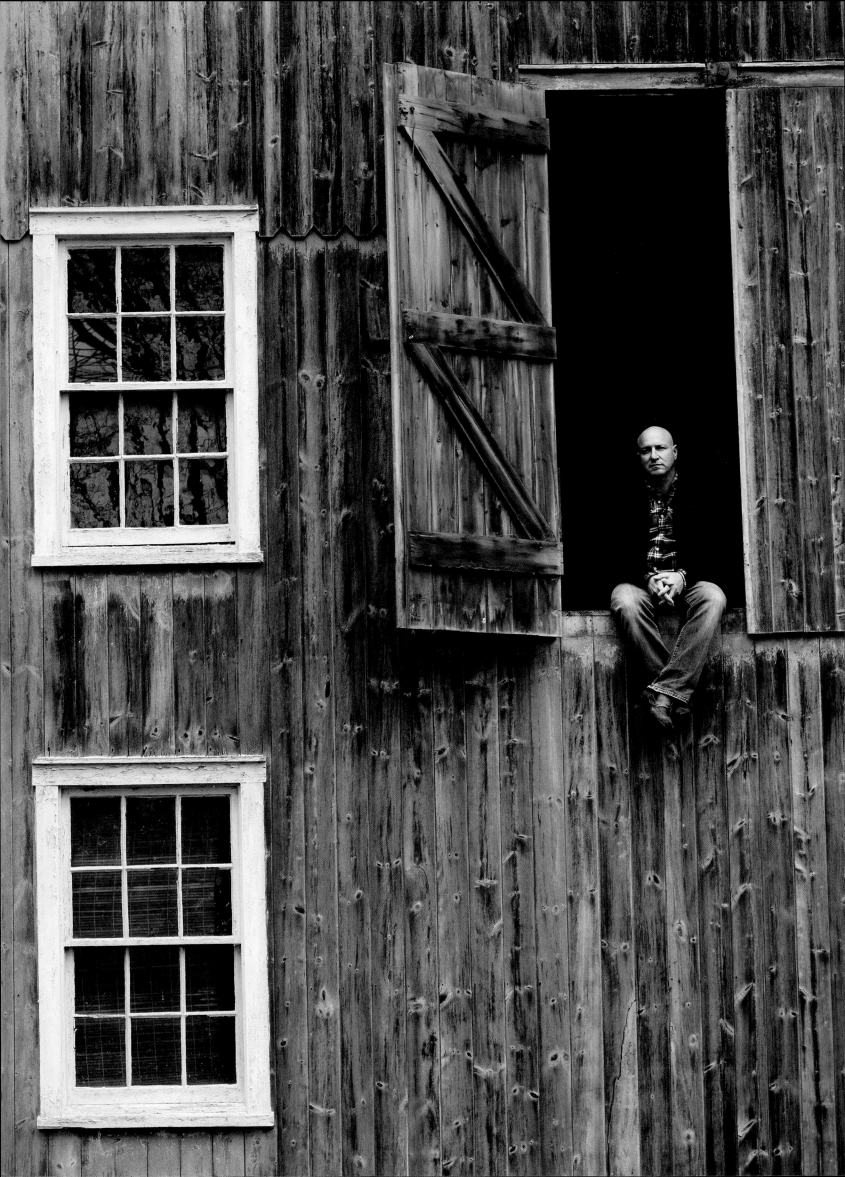

TOM COLICCHIO

What would be your last meal on Earth?
If it were really my last meal, I would want my mother's gravy. Sunday gravy. That's kinda what I was weaned on . . . that's what I would want to take to the grave with me. Somebody asked me this question a while ago, and I was like, well, if I really wanted to stretch it out, I would say, I'd go to Sydney and I'd eat at Tetsuya, and then I'd go to, you know, Singapore, and I'd eat somewhere else, and then from there I'd fly to Hong Kong. But that's not me.

If we were doing a beach thing, seriously, it would be a simply cooked lobster. I would even go as far as a clambake. But then, because I like that whole aspect of a clambake, you would have to finish with meat. Probably pork and beef . . you can keep the chicken and the ducks. You know, all simply roasted on an open fire with just salt and pepper. And then just a great bottle of Burgundy. DRC [Domaine de la Romanée-Conti]. You do the Riesling with seafood, and then once you get the roasted meats going, you move to Burgundy.

Gravy isn't part of this anymore . . . This has moved out to the beach. I really love, love the water.

What would be the setting for the meal?
Probably somewhere on a beach. I love the water; I need to be near the water. So it could be actually the spot where I got married, which is great. Martha's Vineyard . . . Lucy Vincent Beach.

It definitely would not be in a restaurant. That's the last fucking place I want to have my last meal. That's the last thing . . . I'll kill myself in a restaurant one day.

What would you drink with your meal?
Yeah, wine. A good Sauvignon Blanc or something like that. Not so much a Cloudy Bay . . . Maybe actually a Riesling. Something crisp and clean. Yeah, I like Rieslings.

Would there be music?
It's kind of hard to have music on the ocean. I'd love music, and the music would definitely be a part of it, but if it's on the beach, I think you can let the ocean do its thing.

Who would be your dining companions?
Wife and kids. That's morbid, isn't it? My wife and kids are going to be there to say goodbye. (It's more of a fantasy.)

Who would prepare the meal?
Oh god, that's a good question. I think I should do it myself. It's not that I don't trust anybody else, but you know, it's just kinda something . . . If you're doing the whole clambake, you're out there digging a hole, getting the seaweed, the firewood, the rocks, laying out the whole thing. It would be really fun.

RUTH ROGERS

What would be your last meal on Earth?
Tagliatelle with a slow-cooked tomato sauce cooked by Joseph Trivelli. Being married to an Italian, with a large family, I've learned that real Italians love tomato sauces. My mother-in-law, Dada Rogers, taught Rose and me how to make this, and it is my ultimate recipe.

What would be the setting for the meal?
The River Café.

What would you drink with your meal?
Wines from my three closest, gorgeous friends in Chianti: Felsina Chianti Classico from Giuseppe Mazzocolin, Cepparello from Paolo de Marchi, and Fontodi Flaccianello della Pieve from Giovanni Manetti. A friend of mine, Joan Buck, once told me that you could never have a party without margaritas, so I'll follow her advice and have margaritas as well.

Would there be music?
I grew up in a very liberal, political family in Woodstock, New York. As a child, I learned the songs of Woody Guthrie and Pete Seeger, so this music is still close to my heart. I'd also want to hear the music of Motown. A friend in the music industry once told me that the music you listen to between the ages of 16 and 18 is the music that stays with you for the whole of your life. Mine was definitely Motown, so I would have Martha and the Vandellas singing "Dancing in the Street," Otis Reading, the Four Tops.

Who would be your dining companions?
All the staff and chefs at the River Café, and Richard, of course.

Who would prepare the meal?
Sian Wyn Owen.

"A FRIEND OF MINE, JOAN BUCK, ONCE TOLD ME THAT YOU COULD NEVER HAVE A PARTY WITHOUT MARGARITAS."

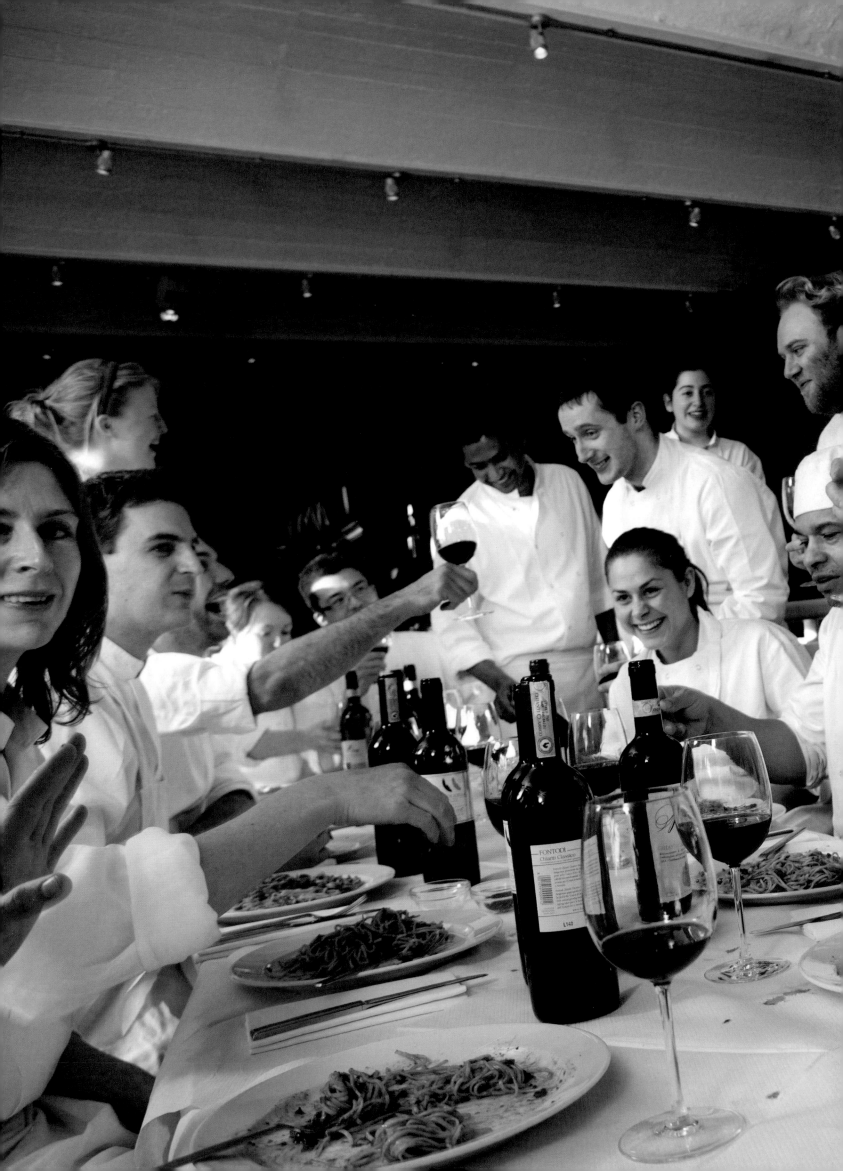

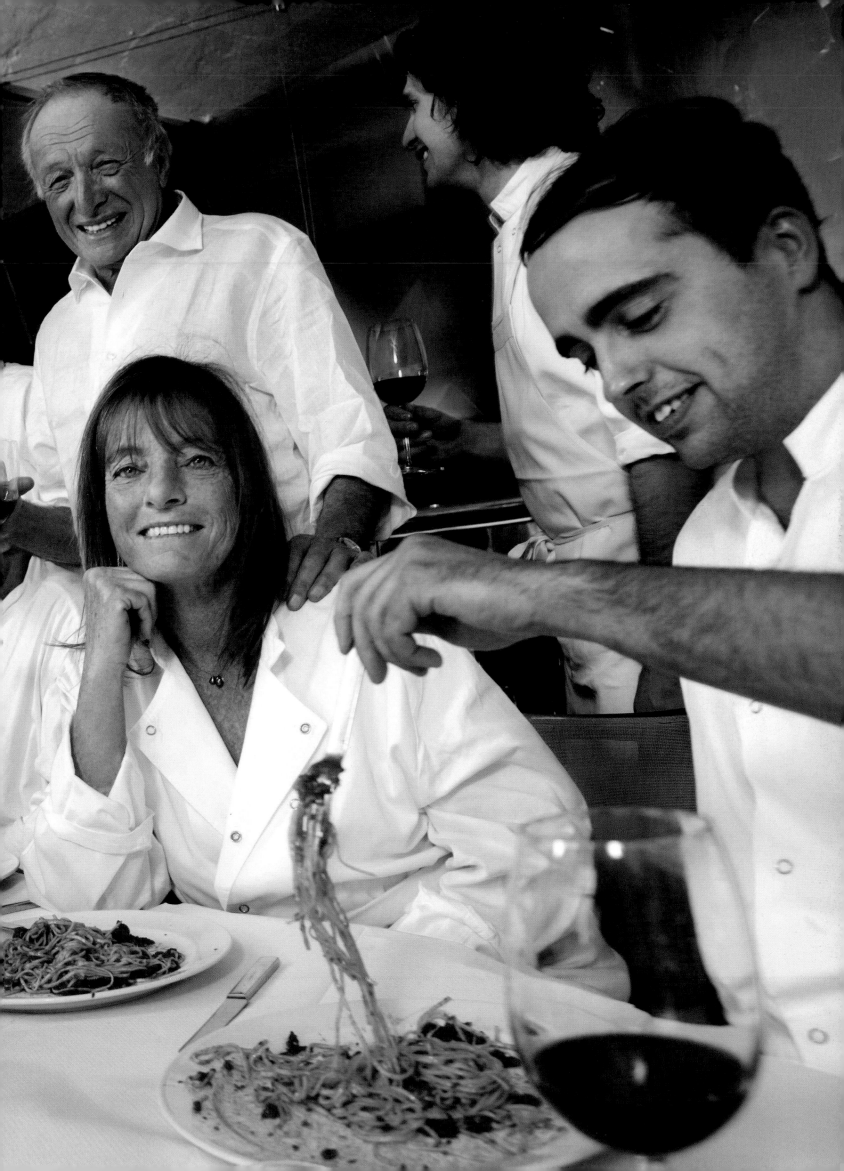

ALEX ATALA

"RICE AND BEANS—A BRAZILIAN ADDICTION."

What would be your last meal on Earth?
Rice and beans—a Brazilian addiction.

What would be the setting for the meal?
On the banks of the Içana River, two days away from the city of São Gabriel da Cachoeira.

What would you drink with your meal?
Cachaça and aromatic waters with fruits and herbs from the Amazon.

Would there be music?
Villa-Lobos.

Who would be your dining companions?
Oscar Niemeyer, Os Gêmeos [Otavio and Gustavo Pandolfo], Irmãos Campana, Viki Muniz.

Who would prepare the meal?
I would.

MARCO PIERRE WHITE

What would be your last meal on Earth?
My last supper? Well, it's the one I have before I die. If I am really honest, I can't imagine fantasizing about my last supper.
Food is irrelevant at that stage of life. It is not important what I would want to eat but what the guests would want.

What would be the setting for the meal?
The setting doesn't matter. The people I sit with are more important to me. I would ask myself who would want to be with me, then I would make a list of those people. Then I would think about who I would want at this meal, and I would have to start to eliminate.

What would you drink with your meal?
I would have a pint.

Would there be music?
No music. Why would you want music? I can't imagine anything worse.

Who would prepare the meal?
M____ _____ ___e

MARTHA ORTIZ

What would be your last meal on Earth?
For my last supper, I would love to taste and feel "day and night," the flavor of the sun and the flavor of the moon—that is, a fresh handmade tortilla with the magnanimous black mole. Tortillas remind me of the communion with the sun and black mole represents the depth of the dark skies. That way, the flight through Mexico's history, which I love and am delighted by, would be complete—life and death, joy and sorrow, love and lack of sentiment, but always with the most important ingredient: passion.

What would be the setting for the meal?
I would love to sit in a Mexican country chair painted in bright colors, to be reminded of how festive, beautiful, and profound my country is, at a simple wooden table mounted on a barge in Xochimilco, full of flowers. It would be at sunset, with the mystical aroma of my land, and I would observe the movement, the candlelight, the multicolored skies imbibed with clouds.

What would you drink with your meal?
Mexican elixir: Dragones white tequila with the mystical and elegant taste of the maguey's core. Sensuousness to be enjoyed in sips, giving away "winks" to the palate.

Would there be music?
I would listen to the Oaxacan song "La Llorona" ("The Weeping Woman") repeatedly, with verses that have been added to it over time, reminding me that in this life, I was loved.

Who would be your dining companions?
I would like to be alone with my unfathomable thoughts and a smile, thanking God for its benevolent presence in the world and existence through beautiful and sensitive things. I'd be grateful for the blessing of being able to taste beauty.

Who would prepare the meal?
A traditional Mexican cook from a lineage of women who share our cuisine, to which I feel proudly connected. Anonymous heroines whose hands caress the ingredients and blend them with mastery and magic as they touch the stone, heating them by fire, together with the bountiful goodness of the wind and voluptuousness of water, always yielding the taste of the sun.

"THE MOST IMPORTANT INGREDIENT: PASSION."

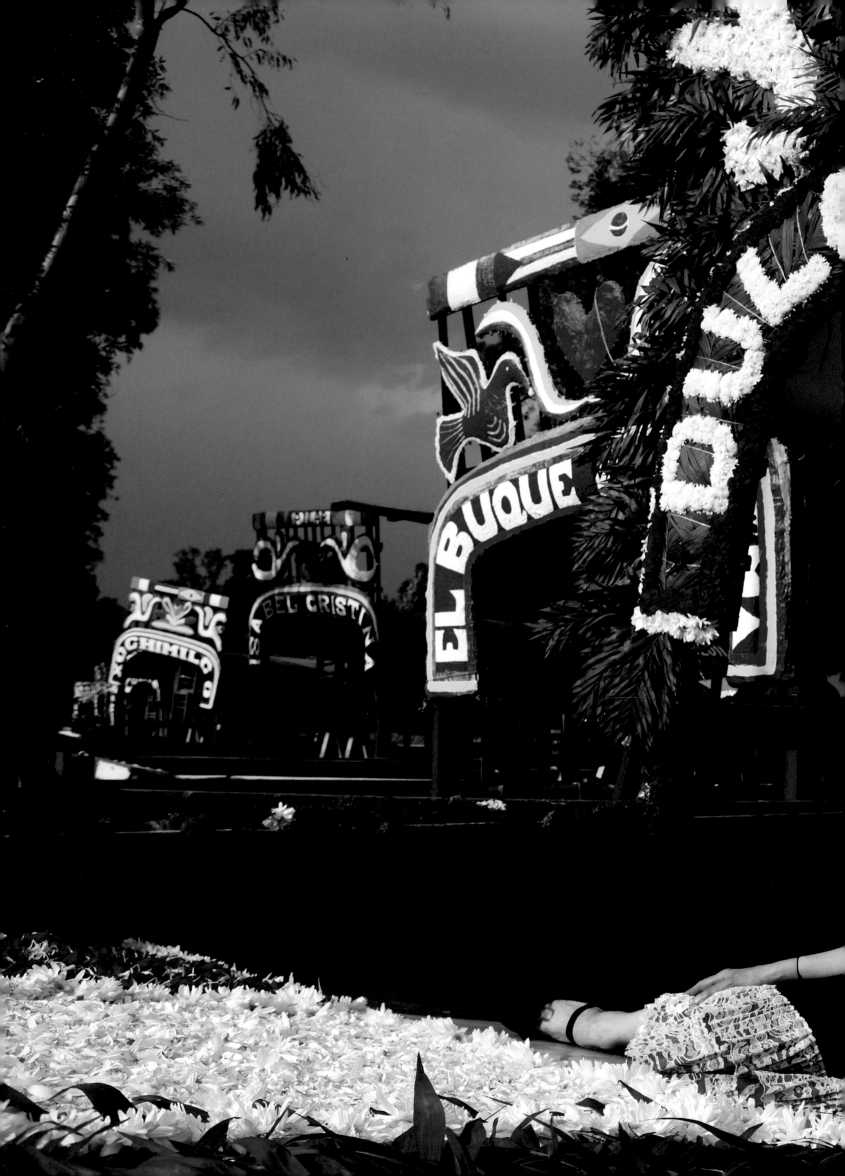

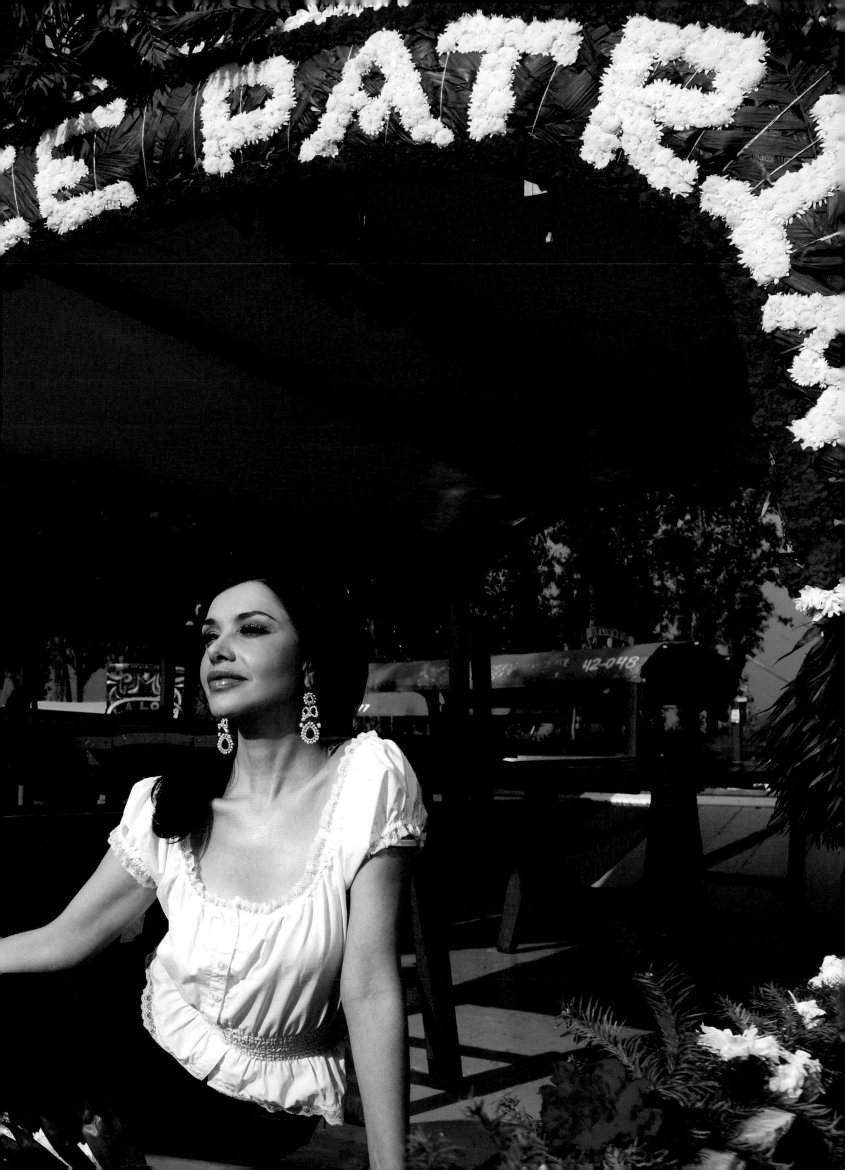

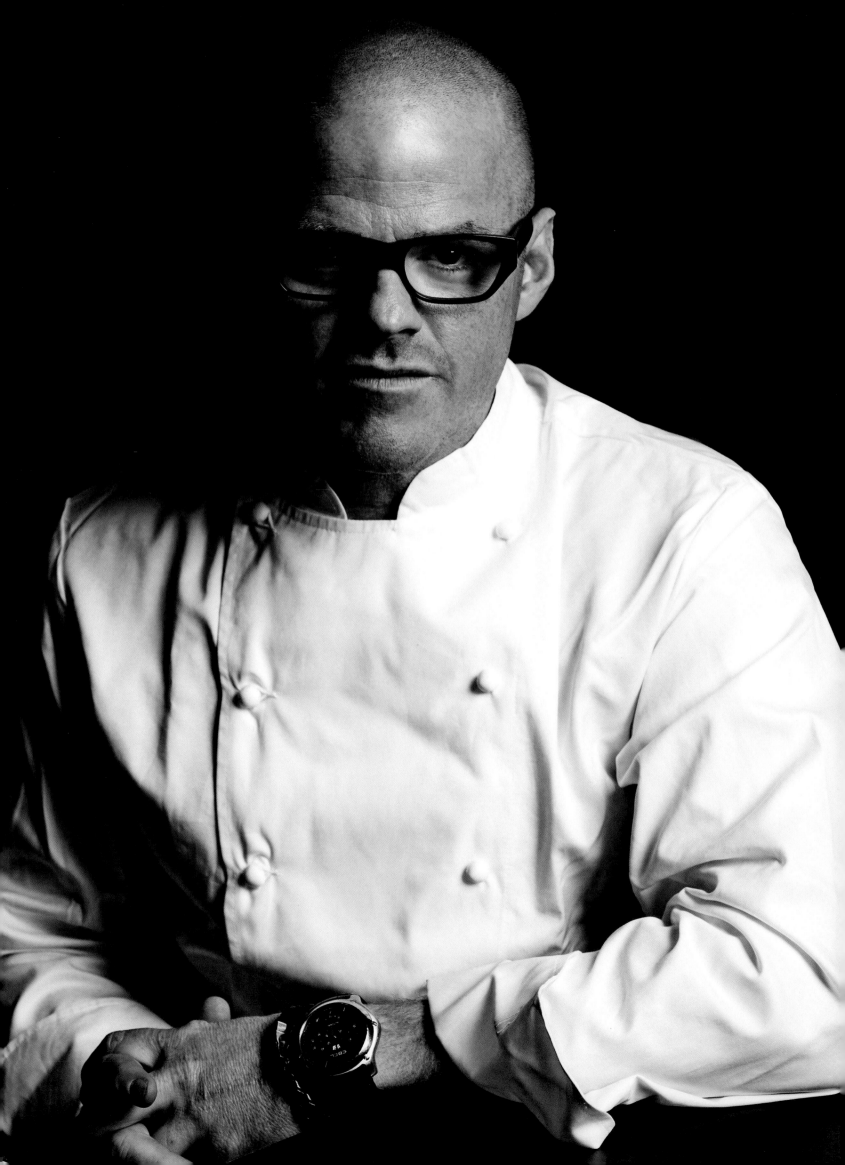

HESTON BLUMENTHAL

"I WOULDN'T DO THE WASHING UP, THOUGH."

What would be your last meal on Earth?
Sunday roast. It would be roast beef (you know the French call us *les rosbif*) with Yorkshire pudding, carrots confit with caraway salt, and runner beans with shallots, braised radishes, and chopped parsley. Roast potatoes, absolutely. Red wine sauce made with the roasting juices of the beef, red wine, and little pearls of rendered beef fat. Slices of bone marrow with some parsley bread crumbs gratinéed on the slice.

What would be the setting for the meal?
Up a mountain somewhere. I'd finish off by attempting to ski down as long a slope as there was.

What would you drink with your meal?
1990 Châteauneuf-du-Pape, Domaine Beaucastel Hommage à Jacques Perrin.

Would there be music?
Since I would be skiing, afterward I would want to listen to something a bit energetic. I'd probably play "The Effect on Me," by Mint Royale.

Who would be your dining companions?
Lunch with the family. Then we all would ski together really quickly down the slope.

Who would prepare the meal?
Me. I'd have to. I couldn't get someone else to make my last supper. I wouldn't do the washing up, though.

DANIEL PATTERSON

What would be your last meal on Earth?

The menu would depend on the season and the feeling we had at that moment. But in winter, we might start with oysters pulled from the water and eaten without condiments; grilled porcini with a salad of coastal plants; abalone sautéed with Meyer lemon and butter made by a friend; vegetables and meats cooked in the fireplace, served with wild herbs and new olive oil. Simple, delicious food. We'd cook at a languid pace, dishes ready from time to time, and people would eat at tables, in the kitchen, or in front of the fire.

What would be the setting for the meal?

It would start in the morning, with a walk through nearby beaches and forests to gather ingredients. Friends would arrive throughout the day, bringing vegetables and meats they'd grown and raised. The house would be on a hill at the water's edge near San Francisco, with a wall of windows facing the ocean. There would be a giant stone fireplace, big enough to cook in, and we'd build a fire, with comfortable chairs and pillows, a soft rug in front of it. The kitchen would be large and open to the rest of the house, with a big wood table in the middle where people could eat and hang out.

What would you drink with your meal?

We'd drink wines that meant something to us, ones made by people we knew or that marked important moments in our lives.

Would there be music?

There would be artwork by friends on the walls, and we'd all take turns choosing music. There would be kids running around, who would go to bed after a while, and since this is imaginary, my grandparents would be there. They'd come early and leave early. They wouldn't like the music, they wouldn't know any of my friends, but they'd be happy. Especially, I think, my grandmother, who taught me so much about cooking, but I never had a chance to cook for her.

Who would be your dining companions?

Since it's the last meal, it should last as long as possible, no? It would go into the early-morning hours, cooking and eating and drinking and talking and laughing all night. And then at the end, I'd take a bottle of champagne and go upstairs with my wife to our room, where our kids would be sleeping, and we'd get into bed next to them and watch the sun rise over the ocean.

Who would prepare the meal?

If I had a last supper, I'd want to cook and eat it with family and friends.

WOLFGANG PUCK

What would be your last meal on Earth?
Some good caviar. And then I would like to have some luxurious tapas. A little caviar, a little foie gras, Spanish ham. Depends on what time of year, but maybe something with white truffles. But the food should have all different kinds of tastes.

What would be the setting for the meal?
I would have it in my home.

What would you drink with your meal?
Drinking would be very important. So a magnum of a vintage cru would be good to start. Then a great Burgundy from 1985.

Would there be music?
I'd have Roger Waters and Pink Floyd come and play.

Who would be your dining companions?
The family is the most important. My four sons and my wife.

Who would prepare the meal?
I would have some of my chef friends prepare the meal. The people I really would like to see. A chef from France, one from Italy, one from Spain, one from America, and one from Japan.

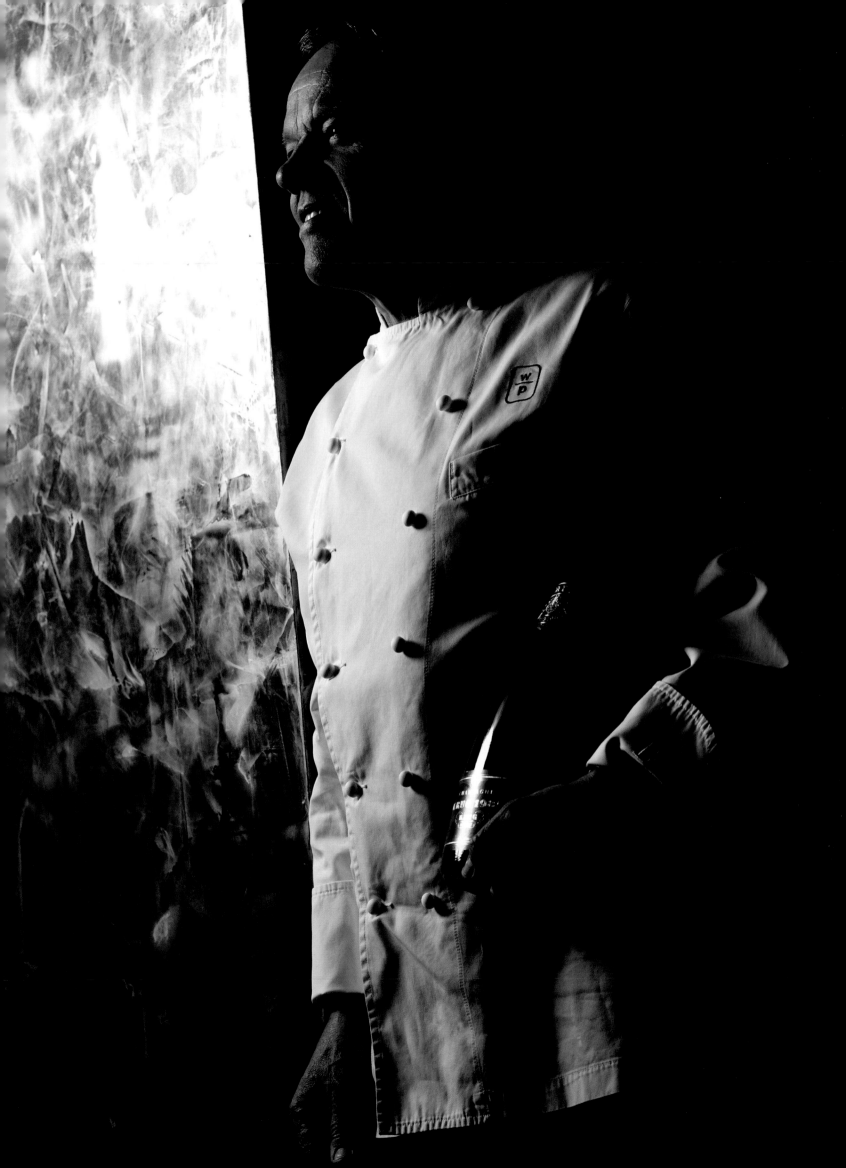

PATRICK O'CONNELL

What would be your last meal on Earth?
Instead of an actual meal, I would prefer to sip a meditative cup of aromatic white tea while reflecting on some of the more exquisite and memorable food experiences of my life—there have been many. I would also want to reflect on the mystery of my future. Tea always seems to clear my mind, calming and energizing me at the same time. It makes me feel that everything is going to be okay. I like to remain just a little bit hungry, anyway, so that I feel mentally nimble and not groggy. I would also be worried that if I were to order food for this final occasion, it might fall short of my impossible expectations or not measure up to my fantasies. That could be a serious disappointment. I know that I would not be able to shut down my critical faculty even as I tried to eat my last meal, and I would be critiquing the food and making corrections mentally. Somehow I would turn it into "work." A tea party is always fun and allows one to focus on the conversation rather than the food. Tea stimulates good conversation. Essentially this would be my last dialogue with another human being, and that would take precedence over what we were eating. Not to say that whatever morsels we consumed would not have to be exquisite; they very definitely would be. A few bites of fresh lychees, a couple of sections of clementine, and an almond or two would be all that was needed to complete this little menu, along a couple of fortune cookies. The fortunes would be especially significant in light of this being my last moments on the planet.

What would be the setting for the meal?
It would seem logical for my life to end in the city where it began—Washington, DC. The Lincoln Memorial offers a powerful, temple-like backdrop suitable for the occasion. I like that it is an open-air monument, offering shelter to and glorifying a simple man. Larger-than-life buildings with heroic proportions have always appealed to me. Humans need much more space than we are given in order to feel divine.

What would you drink with your meal?
Just tea, but if the fortunes in the cookies proved disconcerting, a bit of sake might be required.

Would there be music?
Only the sound of one hand clapping.

Who would be your dining companions?
Just the Dalai Lama.

Who would prepare the meal?
Mother Earth.

"JUST TEA, BUT IF THE FORTUNES IN THE COOKIES PROVED DISCONCERTING, A BIT OF SAKE MIGHT BE REQUIRED."

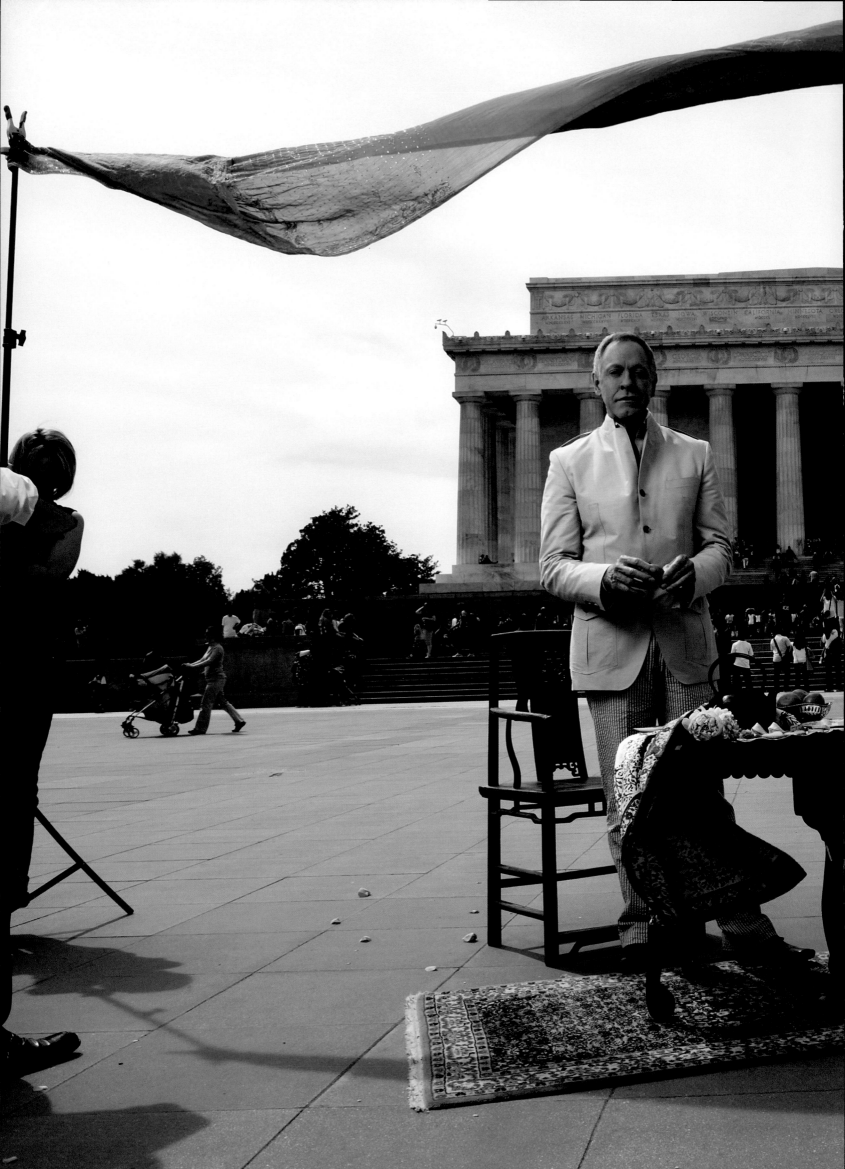

GRANT ACHATZ

What would be your last meal on Earth?
My last meal would consist of:

For passed canapés: toro nigiri, mini slices of wood-fired pizza, fish tacos, heirloom tomatoes with basil-fried bread, burrata cheese, Vietnamese spring rolls with dipping sauce.

For seated courses: "Oysters and Pearls"; agedashi tofu; a bowl of pork-belly ramen; torchon of foie gras with roasted figs and brioche; prawns and garlic à la plancha, served with the whole head and legs on; roasted chicken with lemon and thyme, with wilted spinach and wild mushrooms; sukiyaki of Japanese beef; and a giant bowl of Black Truffle Explosions. For dessert: the rice pudding from L'Ami Jean in Paris, followed by my mom's chocolate birthday cake with vanilla ice cream. How fitting would that be?

What would be the setting for the meal?
I imagine some ridiculously giant table on a cliff overlooking the ocean. It would be breezy but not out-of-control windy, and the turbulence of the water below would be the perfect parallel to both the romantic notion of the meal and the inevitable end.

What would you drink with your meal?
Krug Champagne and 1998 La Jota 17th Anniversary Cabernet Sauvignon, the wine that I helped make when I worked at the vineyard.

Would there be music?
I think my friend Nick would strum the guitar for a little while during the canapé service. But after that, it would be quiet so we could all chat.

Who would be your dining companions?
My girlfriend, Heather; my sons; parents; and closest friends and family.

Who would prepare the meal?
Everyone in attendance would help create the meal, because the act of cooking it together would be just as satisfying as eating it. Especially when I look at the guest list.

LAURENT GRAS

What would be your last meal on Earth?
Carpaccio of snapper with olive oil and basil.
Grilled sardines with fresh herbs.
John Dory baked over dry fennel and lemon.
Bouillabaisse of local fish and langouste.
For dessert, strawberries with whipped cream and vanilla ice cream, and an outstanding *pièce montée* [croquembouche].

What would be the setting for the meal?
The meal will be at the Hôtel du Cap, in the Cap d'Antibes in France. There is a terrace that faces the Mediterranean off the main restaurant. The meal will start before sunset, as the bay is beautiful at that time.

What would you drink with your meal?
We will drink Domaines e Ott rosé with the meal and Krug Champagne with dessert.

Would there be music?
Just the sound of the waves.

Who would be your dining companions?
My wife, parents, sister and her family, and friends from childhood to now.

Who would prepare the meal?
Chef Michel Poitou. He was the executive chef when I did my internship in 1982 in the cuisine of the Hôtel du Cap. It was my first restaurant job. He was an opera singer. In the morning, during preparation time, he would sing on the terrace, and all of the hotel would listen to him.

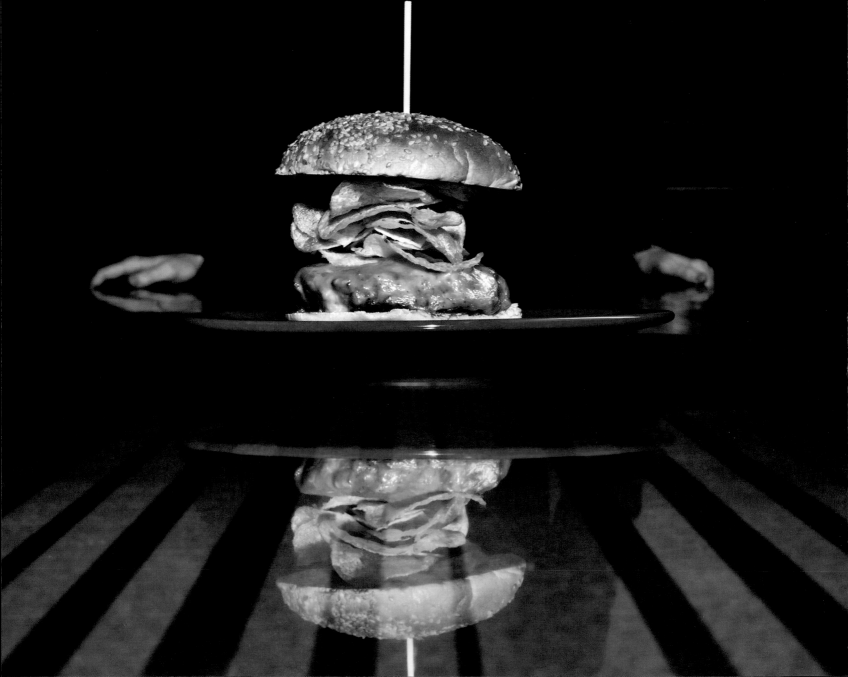

BOBBY FLAY

What would be your last meal on Earth?

My last meal on Earth would definitely be a cheeseburger "crunchified" with potato chips for salt and flavor, double American cheese, and just really simple as long as there was a contrast of texture. I like to use chipotle ketchup, plus maybe a couple of pickled jalapeños for heat. But I could either have those or not; if they're in front of me, I would put them on the burger. I would finish with an ice cream sundae. Ice cream is my single biggest weakness. When I eat ice cream, I go for gold. I have to have chocolate sauce or caramel sauce and a cherry; whipped cream I could do with or without. Calories would play an important part of my last supper.

What would be the setting for the meal?

If I had to answer right now, I'd have to say I'd be in my house in Amagansett. It's a place that I find myself to be the most peaceful and relaxed and happy and laid-back. And if I was there for three days, I'd have three days of stubble. I would definitely wear a suit for my last meal. If it were winter, there would be fires raging, and if it were summer, there would be grills raging.

What would you drink with your meal?

Interesting . . . what would I drink? You know, I grew up eating cheeseburgers with my dad, and we would always get a black and white milkshake. That would take dessert and beverage out of the equation. I would probably have a very good draft beer. Not even something too strong—something very light, like a Coors or something. Something crisp and very drinkable. But beer is not the important part of this meal.

Would there be music?

You know, I'm a guy who always enjoys a party. I love to dance, and I love music you can dance to. I don't mean the tango; I mean, I grew up in New York City, and I spent a lot of time hanging out on the street corner with my friends. Urban-style dancing music is what I'm into. I love Jay-Z; he's an amazing lyricist and great performer, and when his music comes on the radio, it gets me going. I wouldn't want him there to perform—he's too big and I don't want him to steal the thunder of my last meal. We'd just have him send a disc.

Who would be your dining companions?

Who would be there? Certainly my wife, Stephanie; my daughter, Sophie, my business partner and best friend, Laurence.

Who would prepare the meal?

Only problem with Laurence is he would try to cook the burgers. The one thing about my last supper is, I'm cooking it. I like cooking even more than I like eating. There are plenty of times that I'll cook some big meal and I'll taste the food as I go along, and I forget to eat sometimes. Not because I don't like to eat—I love to eat but also to watch things come to life on top of the stove. The very first time I actually remember cooking was a mighty fine chocolate pudding on top of the stove when I was five. I couldn't believe all I had to do was scald some milk and add some powder and it thickened up.

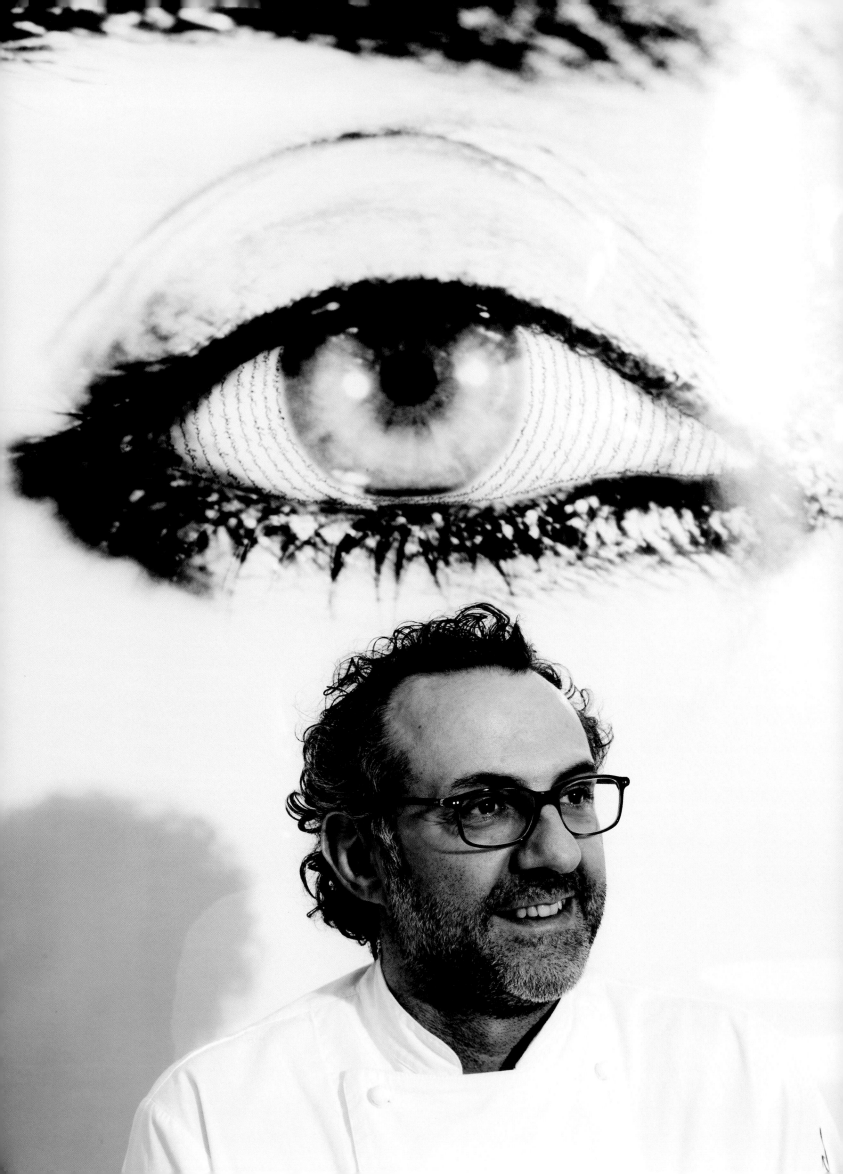

MASSIMO BOTTURA

What would be your last meal on Earth?
Tortellini from Modena. There would be capon broth on the stove top, but maybe we wouldn't even cook them . . . we'd just pop them into our mouths one by one, the way a kid steals them from the table while his grandmother's back is turned.

What would be the setting for the meal?
The kitchen. When I was a kid, the kitchen meant a table, under which I could hide from my older brothers. I was the youngest of five. I always ran into the kitchen for refuge, most often while my grandmother was rolling out pasta dough. And the setting for the meal would be just that: a large table with my kids and their cousins running around and under it. My mother, my wife, and I, along with my daughter, my brothers, and some friends, would be gathered around it, rolling out dough, folding and eating tortellini. Over the holidays we always prepare the family meal together. That is the most joyful part for me—the preparation. I don't actually want to sit down at the table and put a napkin on my lap at my last supper. When your hands are busy and you've got something to something else to do—like folding tortellini around your pinkie finger—somehow the stories just seem to flow, one into another.

What would you drink with your meal?
Everyone would bring a bottle of their choice to share with all.

Would there be music?
There is always music in my house. A mix of Johnny Cash, Bob Dylan, REM, and Billie Holiday could be just right to set the mood—reflective and soulful—with a solid beat.

Who would be your dining companions?
My closest family and friends, from the oldest to the youngest.

Who would prepare the meal?
All of us. No one is the protagonist at this meal. We are all in this together.

"IT REMINDS ME OF BEING A YOUNG PERSON, GOING AND EATING ON THE WEEKENDS AND DRINKING ROSÉ OUT OF A MAGNUM."

MICHAEL WHITE

What would be your last meal on Earth?

It would probably be completely seafood based and a simple meal, because the hallmark of Italian cooking is simplicity. So something as simple as grilled *langostinos* from the Mediterranean, or *aragosta*, which is spiny lobster that is split and grilled with just a bit of oil and lemon. But I also love eggs, so there might be a quick frittata with glass eels or some sort of seafood inside, but not overcooked eggs. And pasta. I am an absolute pasta person, so pasta would definitely be there—something like handmade garganelli. There would be great ciabatta that was lightly toasted. These are all the little things that I love to eat when I have the chance. If there was dessert, it would be something as simple as hazelnut gelato. I'm not a chocolate guy.

What would be the setting for the meal?

It would definitely be on the Mediterranean on a boat. I'd probably start in Cannes, Cap Ferrat, and I'd sail my way down to Campagna and Salerno. We would constantly be eating the whole way on the boat, stopping in Monte Carlo, and then go to Portofino, Cinque Terre, maybe Reggio. You can throw my ashes into the Mediterranean Sea after that . . . it's my last meal.

What would you drink with your meal?

I'm a Champagne guy. I would choose one from a small house of Champagne, like Gosset Grande Rosé. It reminds me of being a young person, going and eating on the weekends and drinking rosé out of a magnum. Best Champagne I've ever had.

Would there be music?

Definitely music. Not live music . . . A lot of the times it would be the air, the wind, and the sea, the salt spray in your face—nature's music. When I was young, I grew up on Lake Geneva in Wisconsin. We had a boat in Williams Bay. I grew up around water; I was a competitive swimmer. From there, we went to Lake Michigan and then to Port Washington, which is near Milwaukee. We sailed as a family, because my mom got sick and tired of listening to the engines, and so that's why I talk about the wind and things like that; those are really good memories of sailing. We were always eating on the boat. We would pack picnic lunches—simple lunches like pasta salad and cold chicken. But now that my palate is so developed, it would be a bit fancier.

Who would be your dining companions?

My wife, Francesca, and my daughter. All my close friends.

Who would prepare the meal?

I would prepare it myself because it's something that gives me great pleasure.

DAVID KINCH

What would be your last meal on Earth?
I am going to take the liberty and say it will be a meal that continues on throughout the day and into the evening. I would start with lunch at Sushi Mizutani in Tokyo because the experience there is incredibly emotional to me—how profound and delicious it is. My past meals there linger with me for months after, and it only makes sense to start my final day there. After lunch, I hop on a plane and fly to a beautiful warm beach, a secret spot in Mexico. When I land, it is the start of lunch on the very same day, having crossed the date line. So we continue . . .

We would all be on a beach with a big and gentle fire and progressively cooking throughout the day. Food that you can eat with your hands, to remind you of the basic need and the simple pleasures that it can provide. I want everything to be simple so the foods taste of what they are: oysters, ice cold on the half shell; roast chickens and lamb; whole fish; an array of vegetables cooked slowly by the fire or on embers; and bowls of the most fantastic fruit. Everyone would have to eat with their hands.

What would be the setting for the meal?
Tokyo, and then a secret tropical beach, a left-point break. We would eat and swim, surf and laugh and talk. And dance. And when the sun goes down, we would drift off on this final night, staring at the sky with a headful of stars.

What would you drink with your meal?
All my favorite wines, from memory, for a final taste. And cool springwater would be plentiful, because it is so satisfying on such a hot and physical day. But mostly Champagne. I mean, if one could drink only one thing in life, why would it not be Champagne?

Would there be music?
Of course! It would have to have a groove. Lots of island groove, reggae, soul, anything with the New Orleans swing. We want to dance and sway all night.

Who would be your dining companions?
My family, my closet friends, my amazing partner.

Who would prepare the meal?
I would, of course. Cooking has given me adventure and pleasure my entire life. All those in attendance would know this, and I am sure they would pitch in to help. But isn't that a part of the pleasure? It makes me happy. Why would I stop now?

ROY CHOI

What would be your last meal on Earth?
My last meal would be twofold. A full Korean New Year's feast filled with rice cakes, *banchan, kalbi jim,* soups, and kimchee. Then a trip to a taco stand by myself for some *al pastor* tacos.

What would be the setting for the meal?
A typical Asian living room with mismatched furniture, chandelier, cardboard boxes filled with stuff. Also, the street at night, empty gas station. The two meals are really one meal.

What would you drink with your meal?
I would drink rice punch in two forms: *shikye* and *horchata.*

Would there be music?
No direct music. Just music from the TV or the cars on the street or the small transistor radio playing Latin romantic *éxitos.*

Who would be your dining companions?
I would be eating with my wife, daughter, cousins, parents, sister, brother-in-law, nephew, niece, aunts, uncles, and Kogi family. Then I'd walk away alone to the truck to finish with my *al pastor* tacos, and the *taquero* would ask me, *"Es todo?"* I'd say *"Sí,"* then he'd pull out a 9mm handgun and say, *"Adiós"* and blast me. I'd fall in a pool of blood on the streets of LA, *horchata* flying out of my hand. My blood flows to the earth, and I'm done with this stage.

Who would prepare the meal?
My mom and a *taquero* with a machete and a red apron.

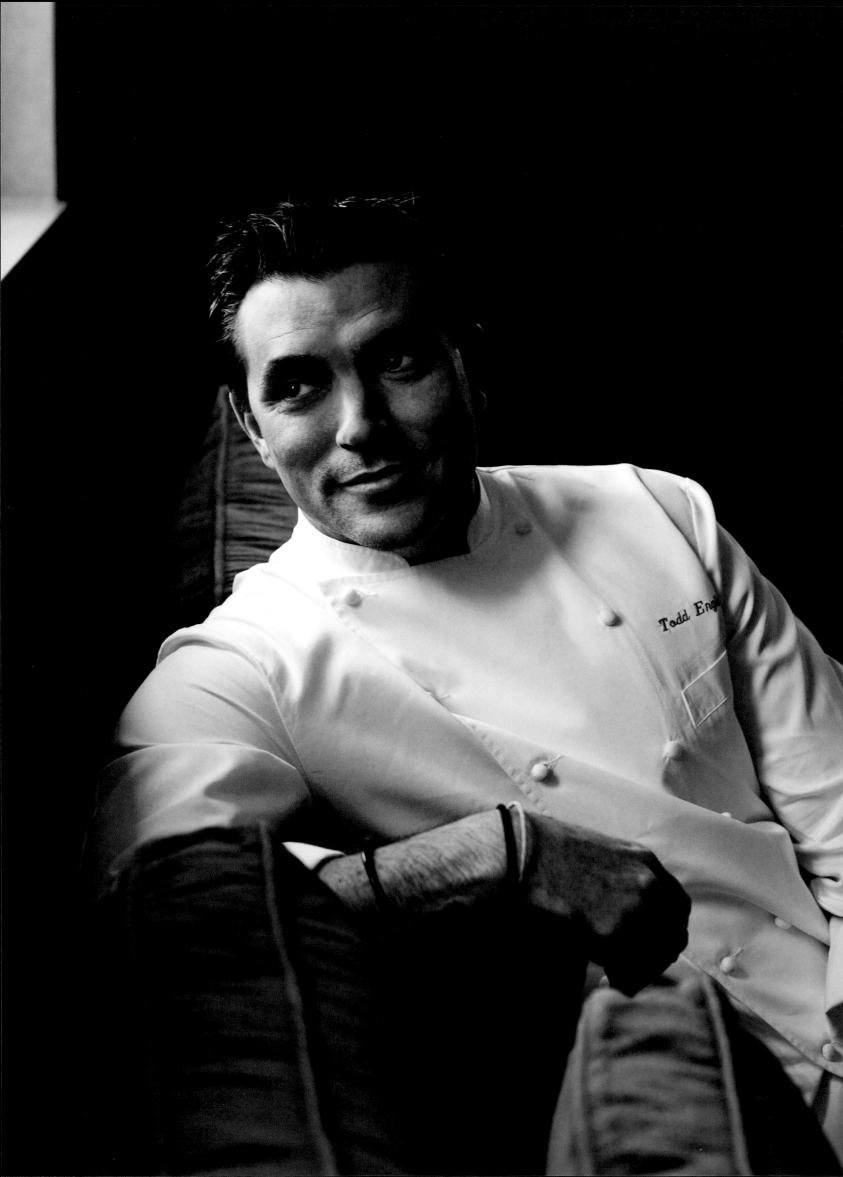

TODD ENGLISH

What would be your last meal on Earth?
I love the juxtaposition between classic ingredients and over-the-top food. Caviar represents the epitome of gastronomy. It's such a hedonistic thing. And fried chicken gives me that same feeling. I was raised in the South, so it reminds me of growing up. You can't eat caviar every day and can't eat fried chicken every day, either. You'd be a glutton. To me, a great piece of fried chicken is the same as a spoonful of caviar. I would also have bars of chocolate.

What would be the setting for the meal?
Breakfast in bed with a view of the ocean.

What would you drink with your meal?
Great Champagne. Jeroboam of Krug. A shot of tequila or two—1942 Don Julio.

Would there be music?
There would definitely be music. Anything from sultry and vocal to classical Mozart. Cello.

Who would be your dining companions?
Most likely with the one I love.

Who would prepare the meal?
The caviar would be high quality, from Iran or Russia. The chicken would be prepared by a housekeeper, Pat, who used to work for us. She was a big black woman who made chicken like I would never forget. She would put chunks of smoky bacon in the fat when she made it, and if you were lucky, she'd give you that piece, too. It was like heaven.

BEN SHEWRY

What would be your last meal on Earth?
It would be a hangi, the traditional cookery method of the New Zealand Maori, where you light a large bonfire with wood and volcanic rocks above a pit in the earth, and when the fire dies down, you lay the food—wild pork, kumaras [sweet potatoes], potatoes, cabbage, onions, carrots—in the pit and then cover the pit with earth before digging it up and eating several hours later.

What would be the setting for the meal?
On my parents' old farm, up the Awakau Road in Awakino, Northern Taranaki, North Island, New Zealand. It is a very isolated place, where I grew up with my family. It has an amazing, harsh kind of beauty. The farm was 2,500 acres, and 1,500 of those were wild native bush. It is a constant source of inspiration and where many of my ideas on life, nature, and cooking were formed. I don't know if you have seen Jane Campion's film *The Piano*, but the bush scenes were actually filmed on our farm. It would give you a strong sense of the place. I grew up in that bush and on those desolate beaches. We lived a quiet, simple life in isolation, without shops or television (until age 12) or close neighbors. And I went to a school of seven, where two of the other students were my sisters, and my mother was the school teacher, principal, and administrator.

I would hold it on the edge of the bush, at the start of a gully or natural small amphitheater. A private little place with the tortured native trees on one side and the bulrushes and manuka on the other.

What would you drink with your meal?
As a child, I would often help my father on the farm as he battled the scrub with his chain saw or built new fences. He is an incredibly hard worker, and at the end of the day, he would sometimes reward himself with a cold bottle of Taranaki Ale, which he had tied a piece of string to and dangled it in the nearby stream to chill (the streams in Taranaki are icy cold). He would have these bottles set up around the farm so he could have an ice cold beer if he felt like it!

So, with those thoughts in mind, that's what we would drink—cold beer chilled by a nearby stream.

Would there be music?
Possibly. Both my uncles would be there, and they are excellent folk musicians in their own right. My uncle Kerry has run the much-loved Tahora Folk Festival for the past 35 years on his backcountry farm, so it would be a definite possibility.

However, the bush has a music of its own, with the sounds of the ancient trees creaking and native New Zealand birds calling, and that, combined with good conversation, would probably be enough.

Who would be your dining companions?
My family, including my wife, Natalia, and our three children, Kobe, 5, Ella, 3, and Ruby, 7 months; my parents, Kaye and Rob; and sisters, Tess and Tamie; as well as my extended family—brother-in-law, Glen, and parents-in-law, Ann and Murry. All of my cousins and uncles and aunties would be there. And, of course, my closest friends. It would be a large gathering of about 80 people. Hangis are an excellent method of feeding the hordes.

Who would prepare the meal?
We would prepare it all together. My father and uncles would head into the bush to hunt for a wild boar or pig. Others would dig the pit, and some would find suitable firewood. The kids could peel the potatoes and other vegetables.

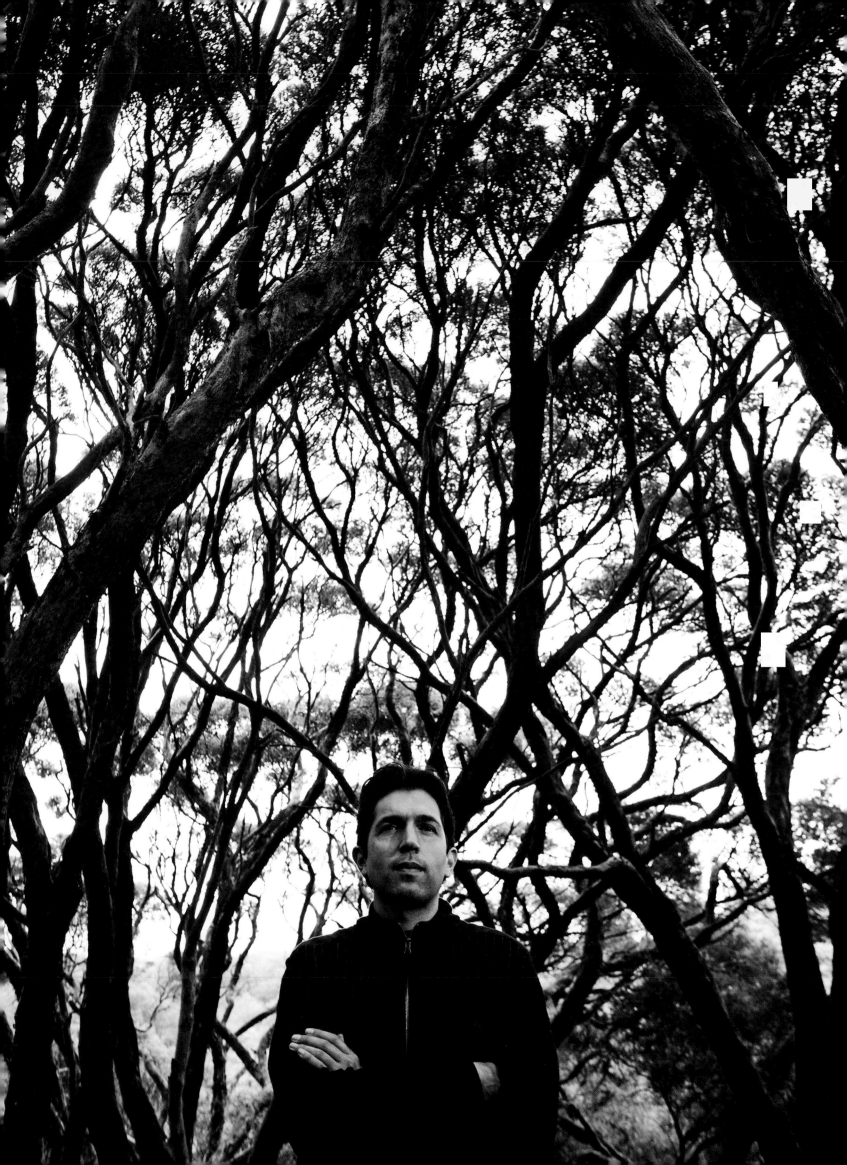

DANIEL HUMM

"THE ROLLING STONES WOULD PLAY."

What would be your last meal on Earth?
I know it would be family style. Simple food, really delicious. There would be plenty of it.

What would be the setting for the meal?
It wouldn't be in a restaurant. It could be outside. If it's outside, it could be in a garden with all trees. I could imagine two scenarios. During the summer, in a Provence-type garden setting outside, with the trees, big tables. And, in the wintertime, maybe in an old, beautiful, big house—and the food would obviously be much more decadent: black truffles, foie gras, braised meats. It would be in a house in the mountains. It could be in America, but I grew up in Switzerland, so maybe in the Swiss Alps. Or even in a castle-type house. There would be lobsters and oysters. There would be a lot of desserts, too. In the summer, the food would be Ibérico ham, melons, heirloom tomatoes, maybe a roast chicken, some roasted lamb, stuffed zucchini, zucchini blossoms. The dessert would be a lot of ice creams, almonds, pistachio cookies, fruits. And in the winter, it would be more chocolate, caramel.

What would you drink with your meal?
There would be wine. There would be white burgundy and red burgundy.

Would there be music?
The Rolling Stones would play.

Who would be your dining companions?
Friends and family. (I don't care about celebrities that much.)

Who would prepare the meal?
I would prepare it but not serve it.

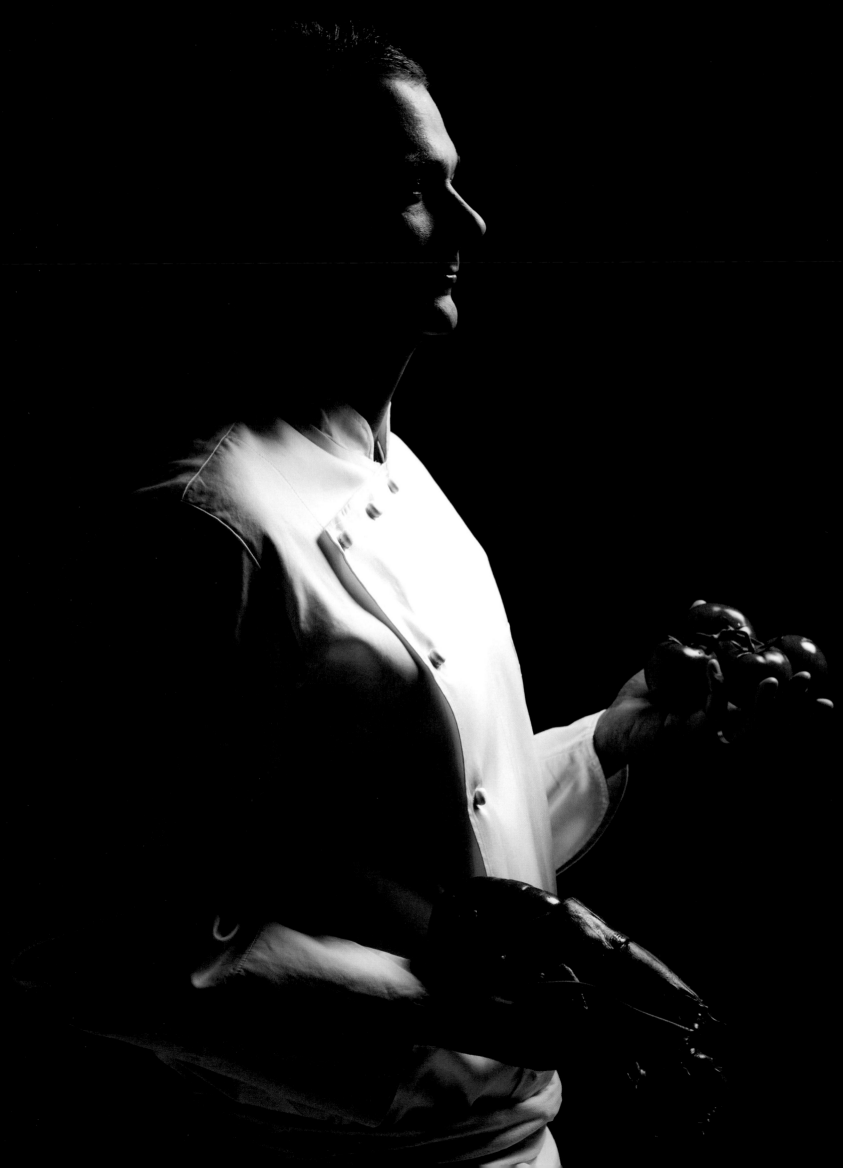

"TODAY I FANCY THIS, TOMORROW THAT."

PAUL LIEBRANDT

What would be your last meal on Earth?

It changes from minute to minute. Today I fancy this, tomorrow that—there isn't one particular thing that I'm like, yep, that would be it. Today it would be a royal Thai banquet. But tomorrow it could be like a kai sake tasting. Or it could be, ya know, like an Indian banquet. I think probably it would have to be something more ethnic. It wouldn't be English food, although I did grow up with that as a kid (beans on toast, Marmite sandwiches).

If I had a royal Thai banquet, there would be beautiful freshwater shrimp and minced pork cooked with fresh mint and then packed together cold and wrapped in a spring roll paper and flash fried so they were really, really crispy. They'd be served with like a sweet and sour sauce, but very spicy. The mint and the pork are just very simple but, wow, amazing.

Obviously pad Thai, a classic, but done really well. A really good pad Thai is amazing. What else? Mango sticky rice. A dish with crab . . . a big saltwater crab baked with fried glass noodles and chiles and limes, and all the flavor from the crab broth cooks in there, and you eat the crab and the glass noodles and it's amazing. Also, freshwater shrimp satay with fresh kambava grated over the top and dried kaffir leaves.

What would be the setting for the meal?

So we're eating our royal Thai banquet, drinking our 1962 Billecart-Salmon, our 1923 Pol Roger–Grauves, drinking from our Holy Grail, and you know where? We are orbiting Earth. Because it's somewhere I'll never go. I love to travel, but it's one place I'll never go. So it would be orbiting Earth, looking down at Earth while eating and just kind of thinking, wow, we're kind of small in the whole grand scheme of things really, aren't we? Looking out into space—we're just there. We're floating, we're watching Earth, we're looking at the cosmos, looking at the rest of the universe, our universe and beyond. We can travel everywhere, but how many of us are actually gonna travel into space?

What would you drink with your meal?

This could be anything? It would have to be—what is the greatest champagne ever?—a '62 Billecart-Salmon or 1923 Pol Roger–Grauves. One of those two, and two goblets of it. And it would have to be the Holy Grail that I was drinking from. Yeah, a bottle of one of those each, drunk from the Holy Grail.

Would there be music?

Of course. We would probably have something by the Cure playing, because I'm British. They would be playing, just off to the side. Robert Smith would be doing something, like a version of "A Forest."

Who would be your dining companions?

My wife. My dog would be hopping around. I think I'd like a peaceful moment like that. The people and things that bring joy.

Who would prepare the meal?

Dead or alive? If I say something like William the Conqueror, it's so esoteric; it doesn't mean anything to anybody. It's like, "Who?" It would have to be William the Conqueror, William of Normandy, who led the Norman invasion of 1066; before that, England was small tribes. He was the first person ever to invade England. The Romans invaded later, but he was the first. And it's because he changed the course of that country forever. Because everyone who lived in England was ruled by the French. It's a very important thing, the Battle of 1066. I love history; I'm a history buff. He defeated King Harold. He changed the course of history forever. Would he cook it? No, he's French and from Normandy—what the hell does he know about Thai food? I just would like him to be there, to, like, do his thing.

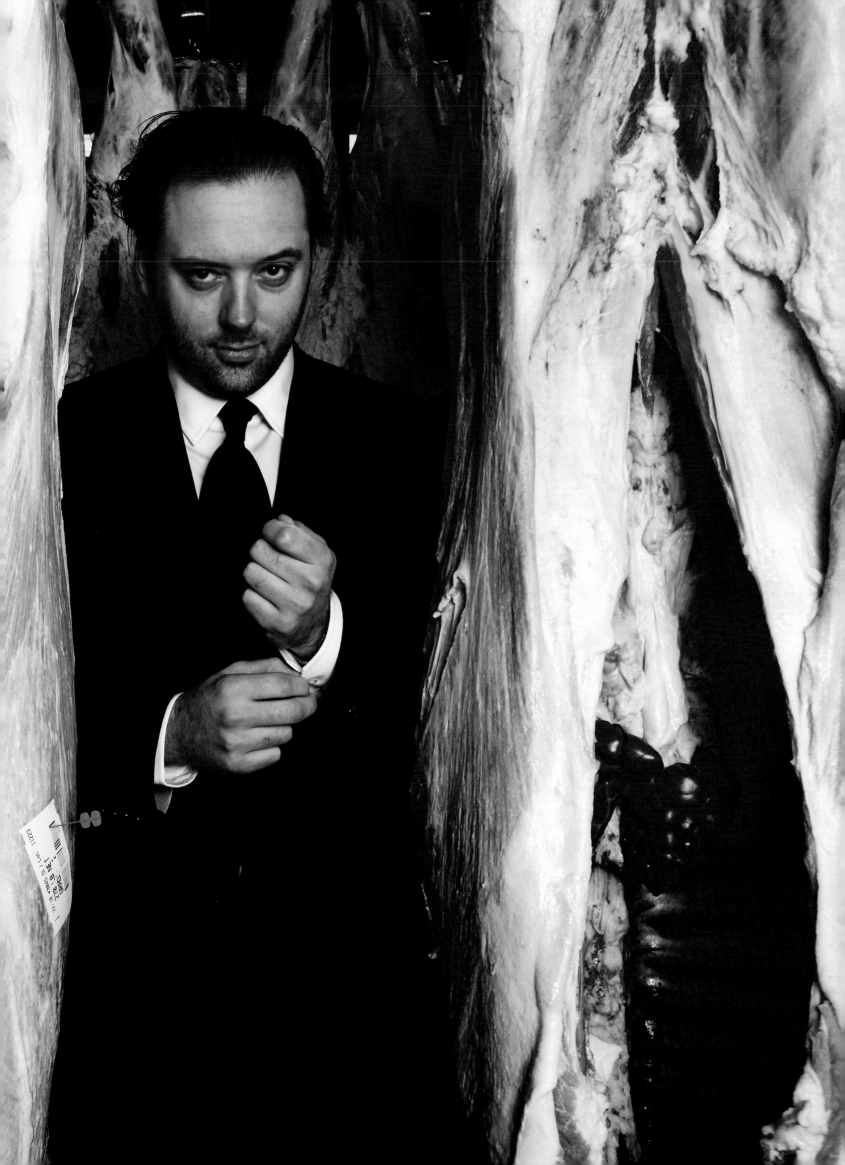

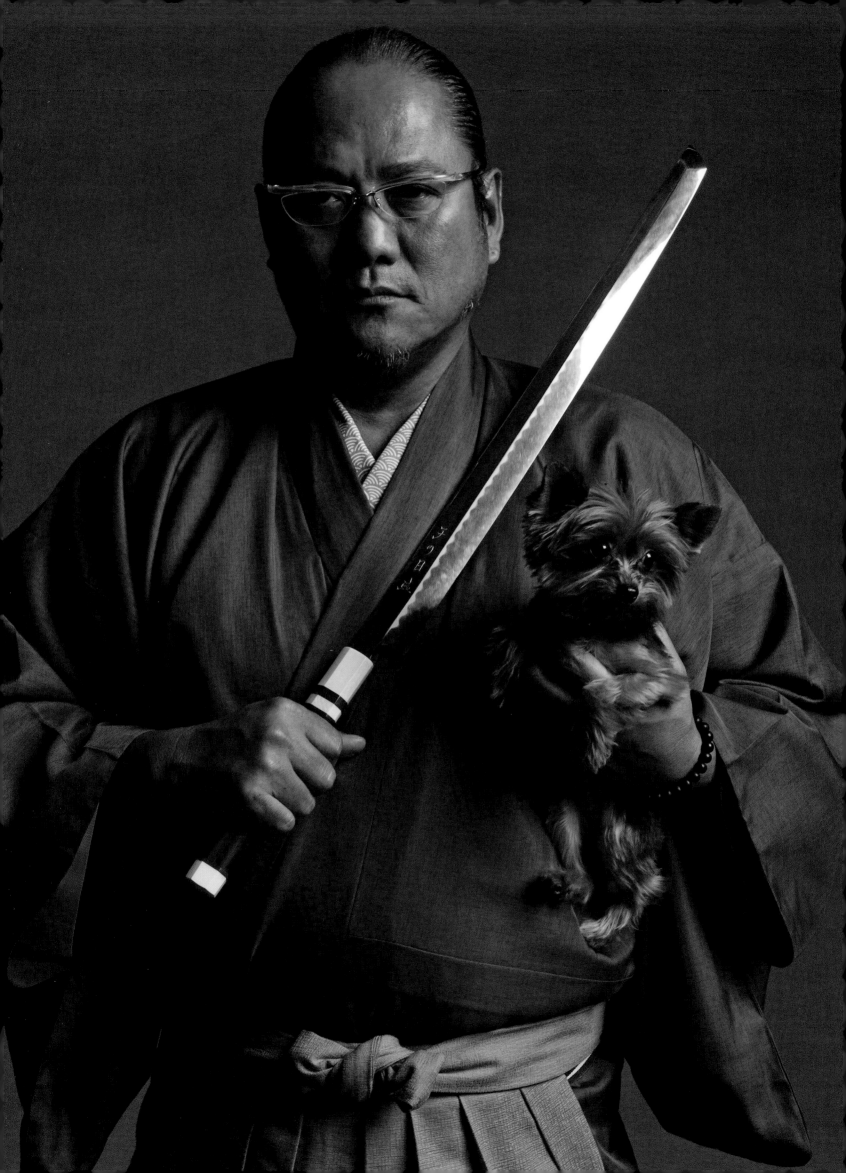

MORIMOTO

What would be your last meal on Earth?
My last meal would consist of white rice, miso soup, tuna sashimi, and pickles.

First of all, I would polish rice in a milling machine. And from the milled rice, I would select only the pieces exactly the same size and pick them up with tweezers. Then I would wash the rice and cook it with water over burning binchotan charcoal. To make dashi for my miso soup, I would use bonito flakes from Makurazaki of Kagoshima, Japan, and rishiri-kombu from Hokkaido. I would shave the kombu myself. I would use miso paste made of whole soybeans and fresh tofu, which I make using high-grade soy milk. For my tuna sashimi, I would use sustainable tuna and eat it with wasabi from a three-year-old wasabi root from Shizuoka and three-year-fermented soy sauce. Lastly, I would place pickled vegetables in season on a bed of rice bran left over from milling the rice.

What would be the setting for the meal?
In a room of a hilltop inn, from which I can see the ocean.

What would you drink with your meal?
Junmai sake.

Would there be music?
No music but the distant sound of a sea breeze, ocean waves, fishermen's boats, and seagulls.

Who would be your dining companions?
My wife and my dog.

Who would prepare the meal?
Myself.

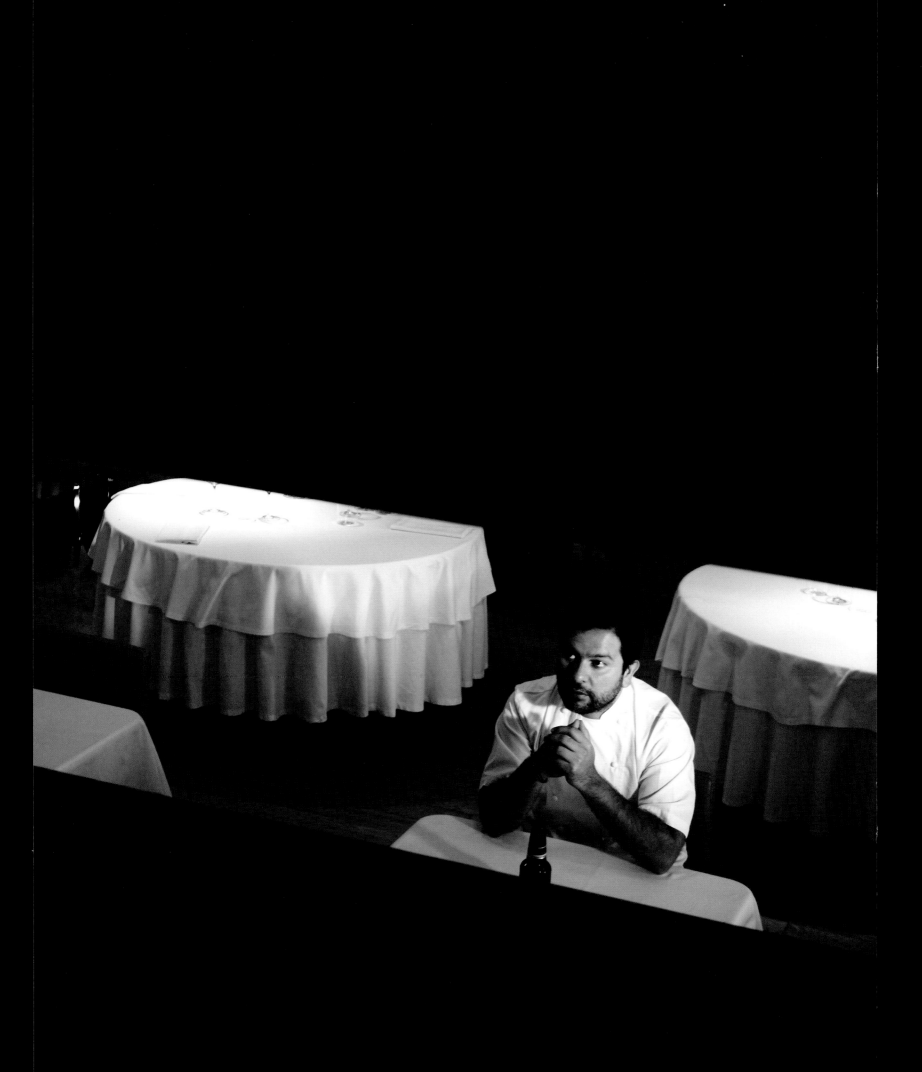

ENRIQUE OLVERA

"TEQUILA AND BEER. LOTS OF IT!"

What would be your last meal on Earth?
Mole negro.

What would be the setting for the meal?
Family style, to share in an old hacienda.

What would you drink with your meal?
Tequila and beer. Lots of it!

Would there be music?
Marimba.

Who would be your dining companions?
Family and friends.

Who would prepare the meal?
My staff from Pujol.

EMERIL LAGASSE

What would be your last meal on Earth?
I would have to have a menu with pasta. I would have to have truffles. I would have to have dry-aged meat. I would have to have game birds. I would not regret eating a whole piece of banana cream pie.

What would be the setting for the meal?
I would want to get it all fussed up with beautiful flowers. Over the years, my wife and I have collected several china arrangements for certain courses for when we entertain at home, so I would do it up. I'd bring out the silver chalice water goblets and all the crystal.

What would you drink with your meal?
I would drink till the cows came home. I would stick with one region and pick Burgundy and start with white and end with red. Then I'd finish with either really good brandy or really great grappa. Madame Lalou Bize-Leroy: I'm a huge fan of hers. She's known for the DRCs in Burgundy. I love wines from the Willamette Valley, so I would definitely have some of them. Some big Cabernets from California, like Caymus.

Would there be music?
Gotta have music. Music and food go together. I would have an assortment of jazz. Jeremy Davenport's music kinda makes you feel good. It's not too loud, so it'd be perfect for dining and eating. It's probably the way to go.

Who would be your dining companions?
That's a very difficult question. It would be some of my very close friends. It would be the Batali family. My close friends here in New Orleans. My wife. My kids. The dogs.

Who would prepare the meal?
I would probably pick a dozen of my closest chef friends and let them do the meal; then they could sit down too. Eric, Daniel, Mario, Charlie, Wolfgang. I'd have all of them do a great course with those ingredients that we talked about, and I would do one as well. We'd have a blowout.

"IN THE CENTER OF THE TABLE, THERE WOULD BE A SINGLE DISH FILLED WITH OLIVE OIL FOR COMMUNAL DIPPING."

MASSIMILIANO ALAJMO

What would be your last meal on Earth?
Bread and Sicilian extra-virgin olive oil. Everyone around the table would be able to reach and dip the bread.

What would be the setting for the meal?
A round table would be set at the end of a glass pier leading out to the sea. In the center of the table, there would be a single dish filled with olive oil for communal dipping.

What would you drink with your meal?
An old red wine. Perhaps a 1979.

Would there be music?
No music. Just the sounds of the waves washing ashore, voices of the people at the table, and the breaking of bread.

Who would be your dining companions?
My friends and family.

Who would prepare the meal?
I would.

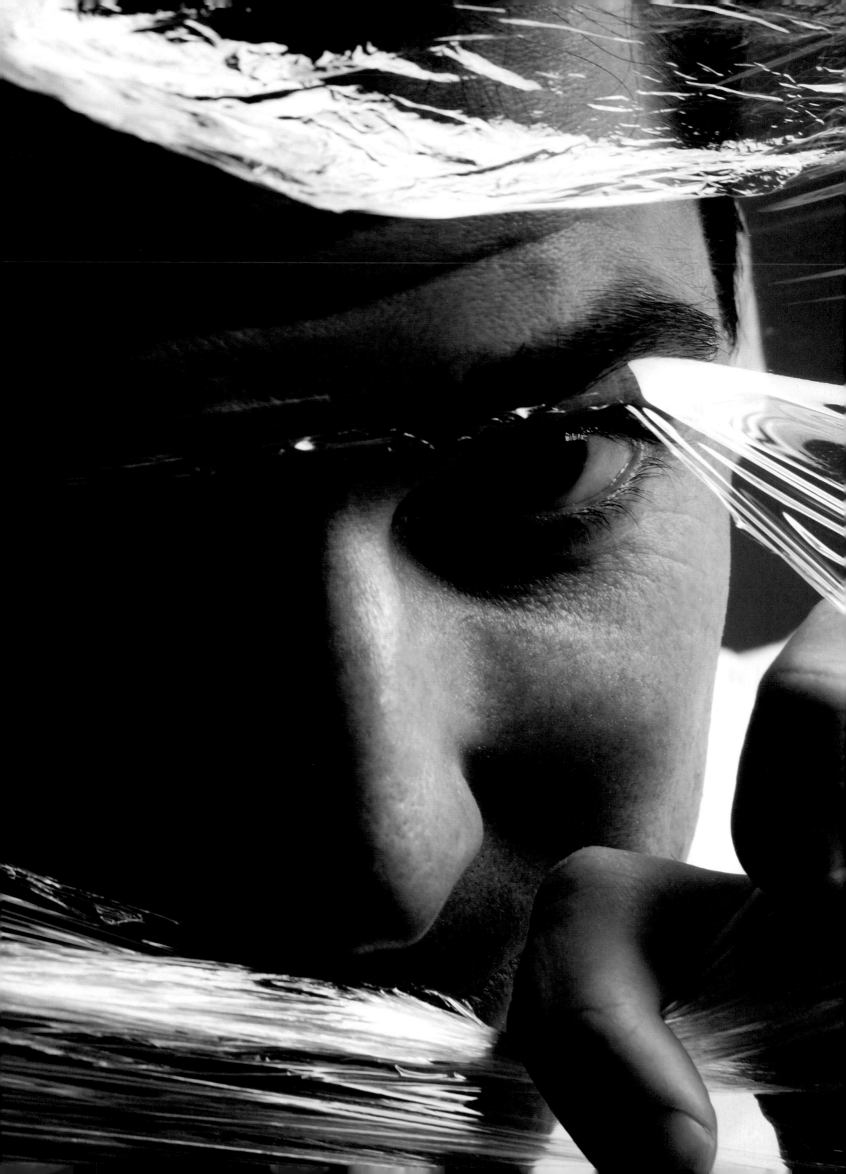

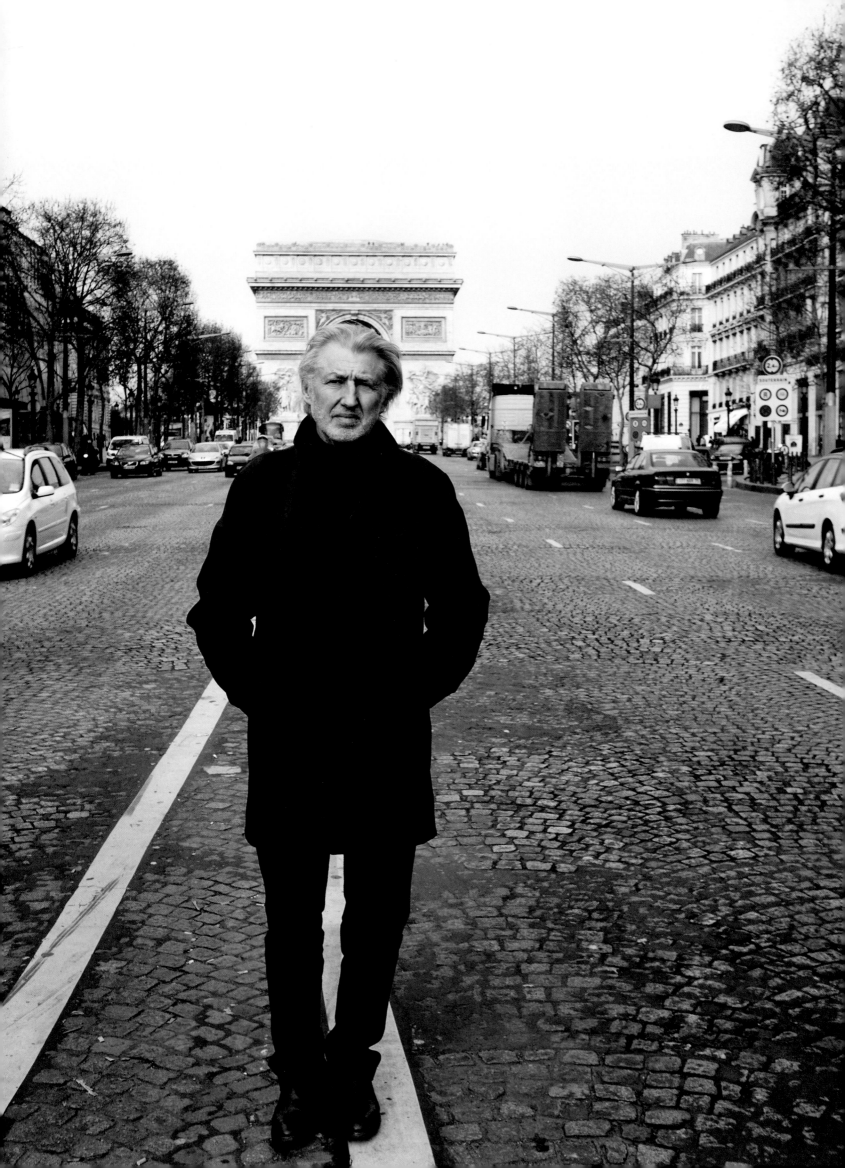

PIERRE GAGNAIRE

"IT'S IMPOSSIBLE TO SAY WHAT THE PERFECT MEAL WOULD BE."

What would be your last meal on Earth?
I can't answer this question, because death, fortunately, is not something we plan. Death is what renders life beautiful, marvelous, and unjust. And this is just! No matter who you are, whether you're rich or poor, whether you're powerful or unknown, death takes you when she wishes. That's why life is great. Because we all have difficult moments, and when we're at the bottom of the pool, something happens and pulls us up, and when you're being pulled back up, that is when death takes you! So, it's impossible to say what the perfect meal would be.

I think that I'm like a lot of people. My life has been made of meetings, of random events, and we don't control our destiny. We simply try our best to manage what destiny has assigned to us, and we have to accommodate it. We have a path that we aren't really masters of. We pass some things by, and then other things pass in front of us, and then the force of man is whether he takes it or he doesn't.

What would you drink with your meal?
White Burgundy. The year is of little importance, because I can never know what year I'll die. Without wanting to sound pretentious, we wouldn't even drink Montrachet. It could be a pretty Roulot Meursault, or it could be a Meursault-Charmes.

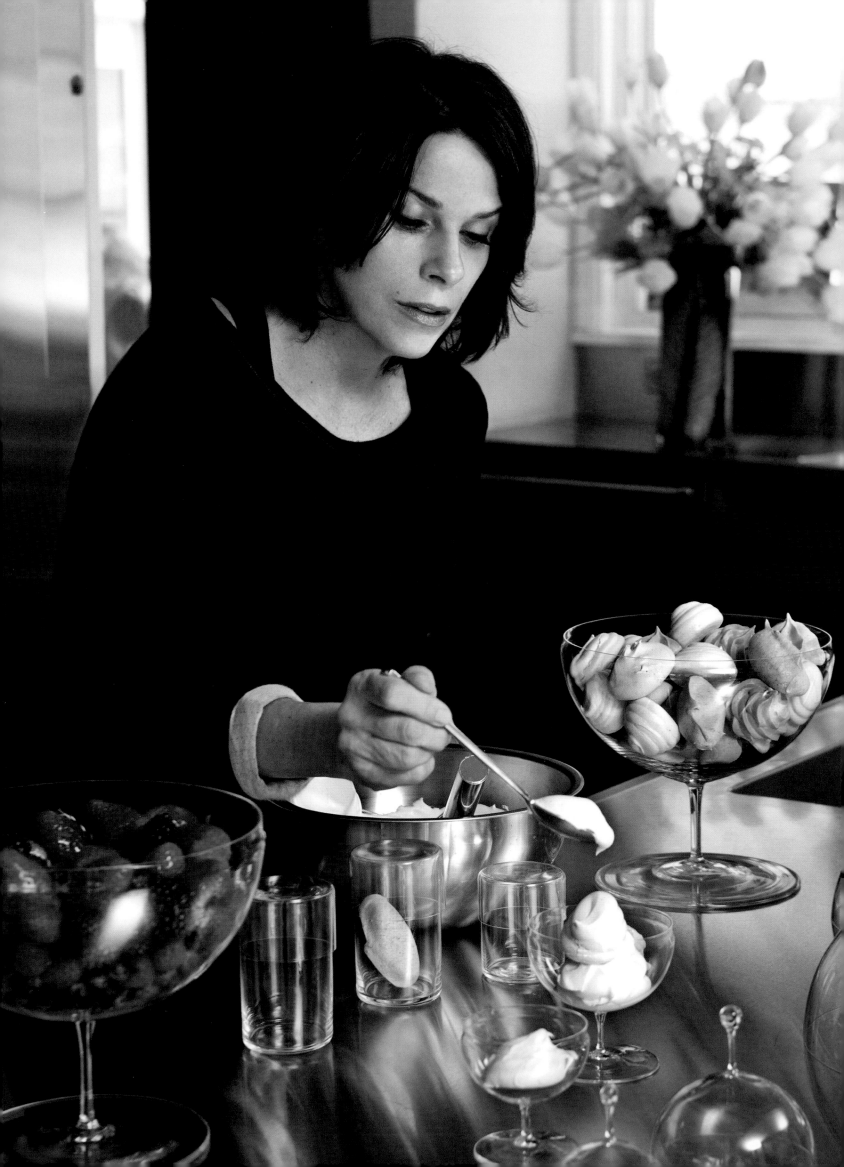

BARBARA LYNCH

What would be your last meal on Earth?

My last meal will probably sound fairly decadent, but I'm always watching what I eat and trying to be healthy, so if this is it, I'm going out with a bang! I would begin with Iranian caviar, and lots of it! This would be followed by terrines of foie gras set out for all of us to help ourselves to, along with mountains of toasted brioche and seasonal fruit gelée. I'd also have squab salad served at this point—why not, right?

The next course would be sweetbreads with chanterelles; I absolutely love sweetbreads. The first time I saw them was when I was 17 and working as a server at a very exclusive private club in Boston's Back Bay. All the other waitresses thought the idea was disgusting, but I loved seeing them served under a cloche. And when I finally got to taste them, I was hooked. For me, they represent grandeur and decadence . . . and they are so delicious with gorgeous chanterelles!

Whenever I'm asked what my favorite food is, I usually say, "duck." So for my last meal, it would absolutely have to be a beautiful roasted duck with gloriously crispy skin and all that rich meat. I adore duck, so this was the easiest decision!

After all of this incredibly rich food, I would end with an *affogato*. When I was visiting chef Marc Vetri in Philly, his kitchen presented us with the most perfect *affogato*—strong espresso over sweet, creamy, and intensely vanilla gelato with a dollop of gently whipped cream . . . a brilliant close to a brilliant meal.

What would be the setting for the meal?

I would probably gather with friends up in Vermont. It's just far enough away to feel like an escape and absolutely beautiful. We would set a long table with crisp white linens, and lovely, heavy silverware, and lots of gorgeous stemware outside at a friend's old farmhouse in late summer, when the evenings are just starting to get cool. There would be white candles to light as it begins to darken, and it would be the perfect combination of rustic and elegant. I'd want something festive and special but really comfortable so we can all relax and enjoy ourselves.

What would you drink with your meal?

We would drink wine from all of my favorite winemakers. We would start with lots of Champagne, what else would we drink with lots of caviar? And we would definitely have Lucien Crochet's Sancerre Rouge—one of my favorites—and for this occasion we would also have to have one of the incredible Burgundies from Romanée-Conti.

Would there be music?

Absolutely. I think opera would be fitting for the drama and weight of the occasion—it's romantic, elegant, emotional. We would begin the dinner with that, though I'm sure by the end, my iPhone playlist would make an appearance when we were all sitting around, talking, drinking, and laughing.

Who would be your dining companions?

All of my daughter Marchesa's "aunties," an incredible group of smart, talented, funny, creative women that I've gotten to know over the course of my life. Some I've known for 25 years and some for 5, but they are all amazing. And in addition to becoming great friends, they have also become honorary aunties to my daughter. Marchesa has such great examples of strong women, and they have been very inspirational to me!

Who would prepare the meal?

We would all cook together. That would be part of the fun! We often cook now when we get together, and it's so natural to gather in the kitchen. We'd start cooking in the afternoon, and the champagne and caviar would probably come out pretty quickly. Early evening, we'd sit down for the foie gras terrine and spend the rest of the evening relaxing and eating and drinking. Long after dinner is over, we'd stay at the table talking and laughing and, hopefully, would stay up until the sun rises.

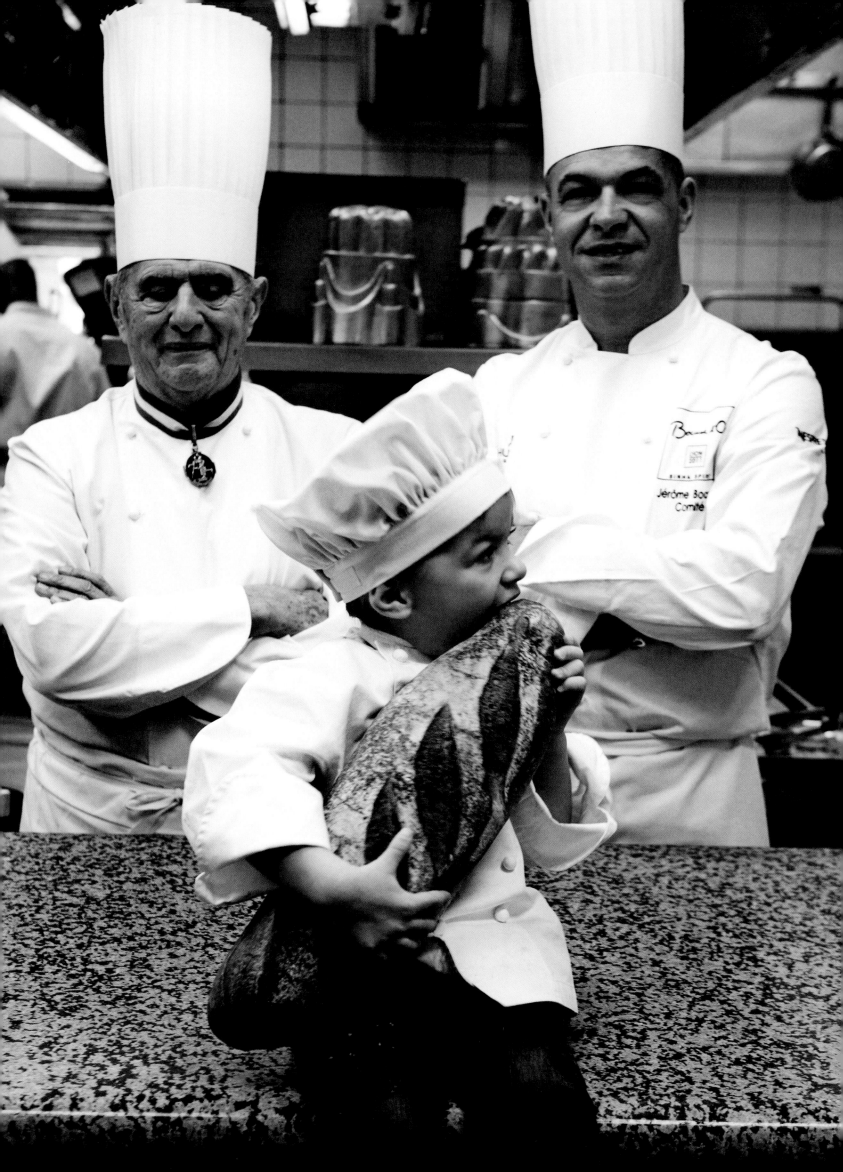

JÉRÔME BOCUSE

What would be your last meal on Earth?
A dish from my childhood in Lyon, a traditional macaroni and cheese called *gratin de macaroni*. Very simple. The macaroni that is cooked in milk, then gratin. Sometimes a simple dish is the best. I like to have a single dish and to finish with a fromage blanc, fresh cheese, also typical from growing up.

What would be the setting for the meal?
In the mountains, in a chalet, snowing outside, warm and cozy inside. I love skiing. I loved skiing growing up.

What would you drink with your meal?
To drink, Petrus 1969 from the year of my birth. No point in saving it any longer—might as well drink it.

Would there be music?
Very mellow loungey music from "The Ballad of Sacco and Vanzetti."

Who would be your dining companions?
My parents, wife, and child.

Who would prepare the meal?
My father.

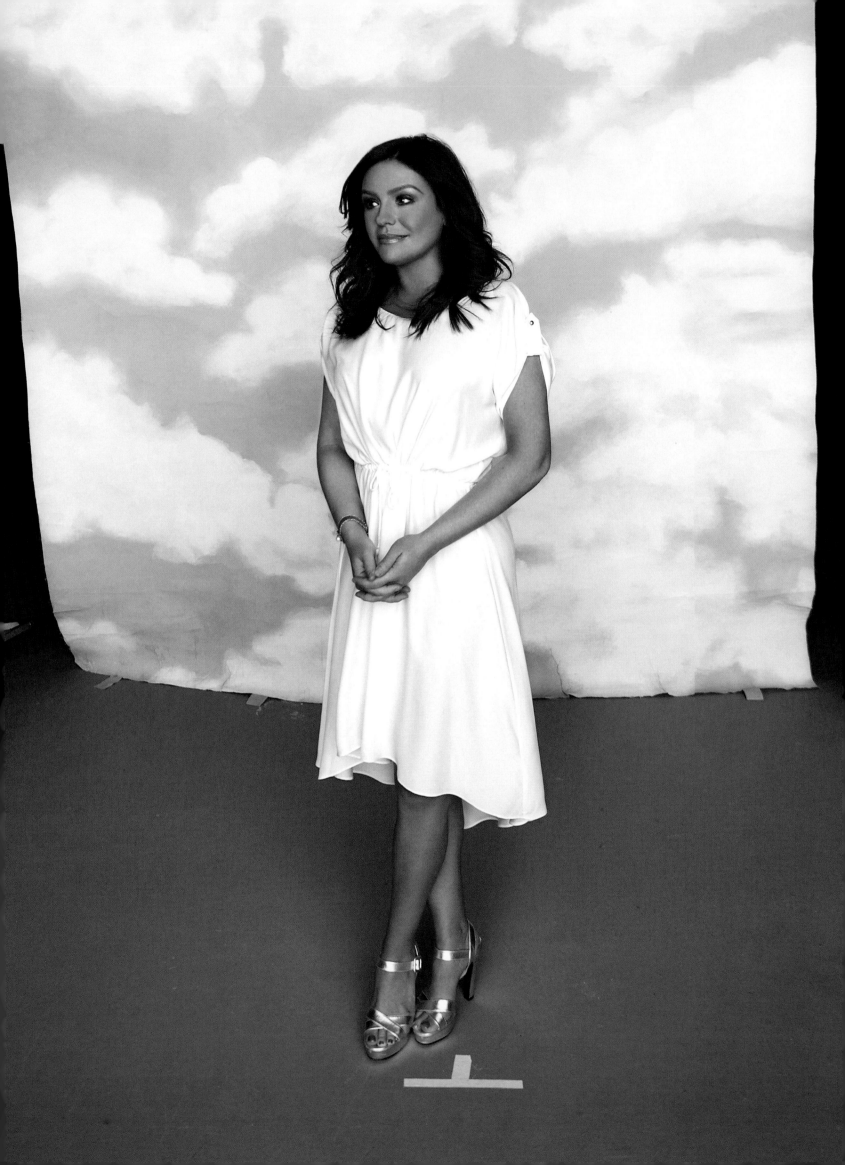

RACHAEL RAY

What would be your last meal on Earth?
I really wouldn't want to know what my last meal was, because I certainly wouldn't enjoy it, so it's a very difficult thing for me to answer. Generally speaking, food is about connection to family, loved ones, or even places that have shaped and formed me. I have so many vivid and lovely memories tied into food that I don't know how I would ever pick one. If anything happens to you after you kick, I do know what my first meal in the next world would be. I would want to be reunited with my grandfather and my pitbull, Boo. I would want to eat *spaghetti aglio e olio*, heavy on everything: anchovy, garlic, parsley, chili, and of course, EVOO. Boo would be having butternut squash. Grandpa would be pulling a whole fish in a black, bubbling cast-iron pot out of a wood-burning oven and would jam lots of torn bread down into the pan juices. The fish would be layered with paper-thin potatoes, tomatoes, onions, and garlic and be doused with wine and lemon.

What would you drink with your meal?
We would drink Sicilian wine. After dinner, we would dip hard cookies in Vin Santo.

Would there be music?
My grandfather played the concertina, so he might play for us. I love mandolin music. I would want a strolling mandolin or strolling troubadours, like when I used to go to Mama Leone's when I was a little girl.

Who would be your dining companions?
Grandpa would smoke his pipe, and we would play cards. Boo would fall asleep on my stomach.

"I WOULD DRINK BUD LIGHT IN THE BOTTLE. JUST GET ME DRUNK."

DAVID CHANG

What would be your last meal on Earth?
I've been asked that question a thousand times, and I actually don't even have a good answer. I know who'd I want to cook it. [See last question.]

The problem is that I don't want just one last supper. I want it all—literally everything. It wouldn't be just one thing. It's going to be one fucking long meal. I am gonna want something from every place I have traveled. Like in Beijing, I want the fucking Peking duck. Of course, I would want barbecue, fried chicken, steamed crabs, and I will gorge on langoustine. Honestly, I have too many food memories and so many things.

What would be the setting for the meal?
Ideally, I would be in the Rockies, in Jackson Hole. You might also find me in the river, fly-fishing, or maybe at Blackberry Farm.

What would you drink with your meal?
I would just get drunk. I would drink Bud Light in the bottle. Just get me drunk. I might have some bourbon, too, patented and illegal. No Burgundy or Bordeaux. Everyone tries to pick out that big year; nope, no wine.

Would there be music?
Music would be good. There has to be music, and it has to be good music. As long as it's good, I don't really care.

Who would be your dining companions?
It depends if I am doing a float with a guide, but probably with a couple of friends at least or a guide. I don't like fly-fishing alone too much anymore because I'm scared of fucking bears. Bears scare the shit out of me.

Who would prepare the meal?
I want Pascal Barbot to cook my last meal, because he's the man. He makes his flavor combinations, and what he does, no one else comes close.

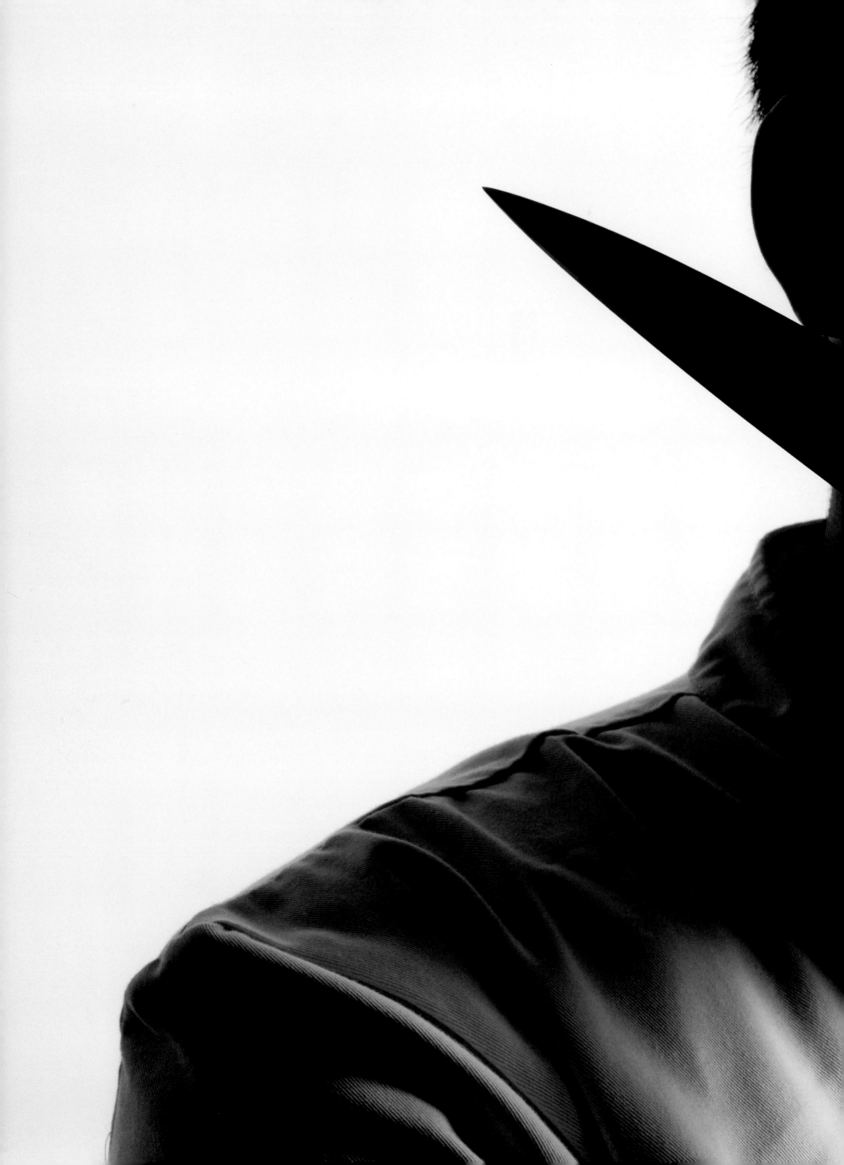

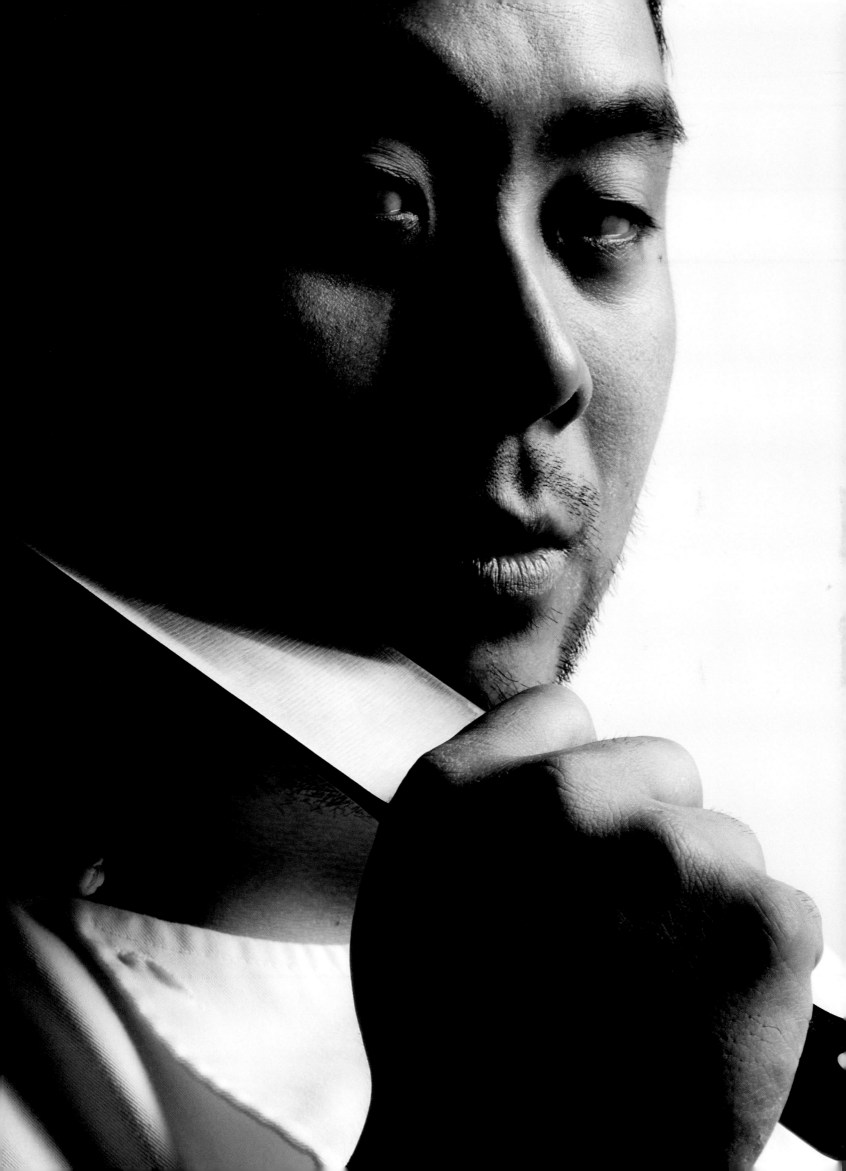

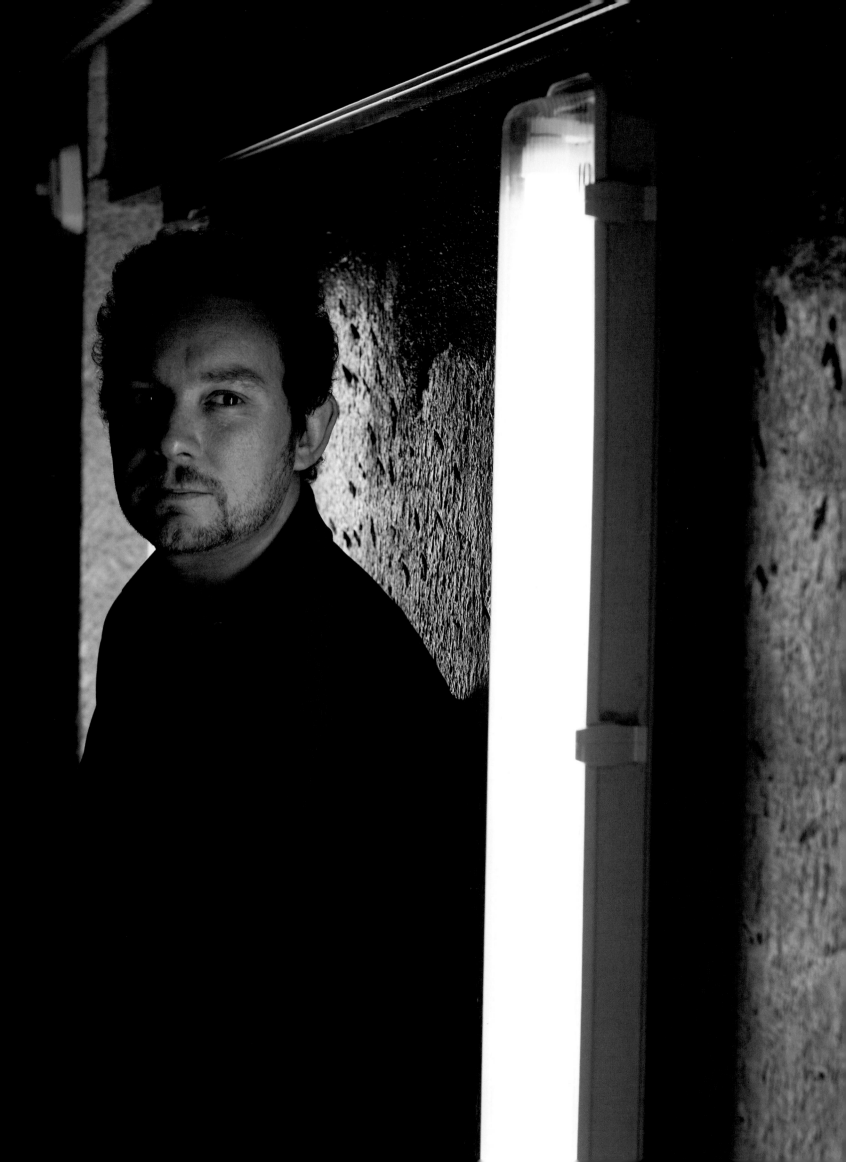

ALBERT ADRIÀ

What would be your last meal on Earth?
Aperitif with vermouth, clams, mussels, and canned cockles
Albino caviar
Eel *a la bilbaina*
Lágrima de costa beans *à l'espagnole*
French fries with egg and black truffles
Caramelized puff pastry with custard
Pizza Margherita with buffalo mozzarella and white truffles
Natural mango

What would be the setting for the meal?
A large table on a Caribbean beach with white sand covering me up to my knees.

What would you drink with your meal?
Cold beer, to start
Negroni cocktail
One glass of sherry
Rosé Champagne
Gin and tonic

Would there be music?
To begin with, "Mediterraneo" by Joan Manuel Serrat, followed by Gene Kelly's "Singin' in the Rain." Later, Monty Python's "Always Look on the Bright Side of Life," and ending with "Stairway to Heaven" by Led Zeppelin and "The End" by the Doors.

Who would be your dining companions?
Clowns and beautiful girls, of course, all of them really drunk. There would be about 10 people, including my wife and my son.

Who would prepare the meal?
I would prepare it myself. It would not take more than half an hour, and all the food would be ready so that we could all eat together.

"IT WOULD BE A COMBINATION OF MARVIN GAYE, BILLIE HOLIDAY, AND MILES DAVIS."

PETER GILMORE

What would be your last meal on Earth?
A meal of eight perfect courses that celebrate nature's diversity.

What would be the setting for the meal?
A beautifully set table on top of a mountain with a view over the hills of Tuscany.

What would you drink with your meal?
Mainly Burgundy, both white and red, and I would definitely finish the meal with a single-malt Scotch whisky.

Would there be music?
Not necessarily, but if there was, it would be a combination of Marvin Gaye, Billie Holiday, and Miles Davis.

Who would be your dining companions?
My family and close friends.

Who would prepare the meal?
In a perfect world, there would be two courses prepared by Michel Bras, two by René Redzepi, two by Andoni Aduriz, and two of my own dishes.

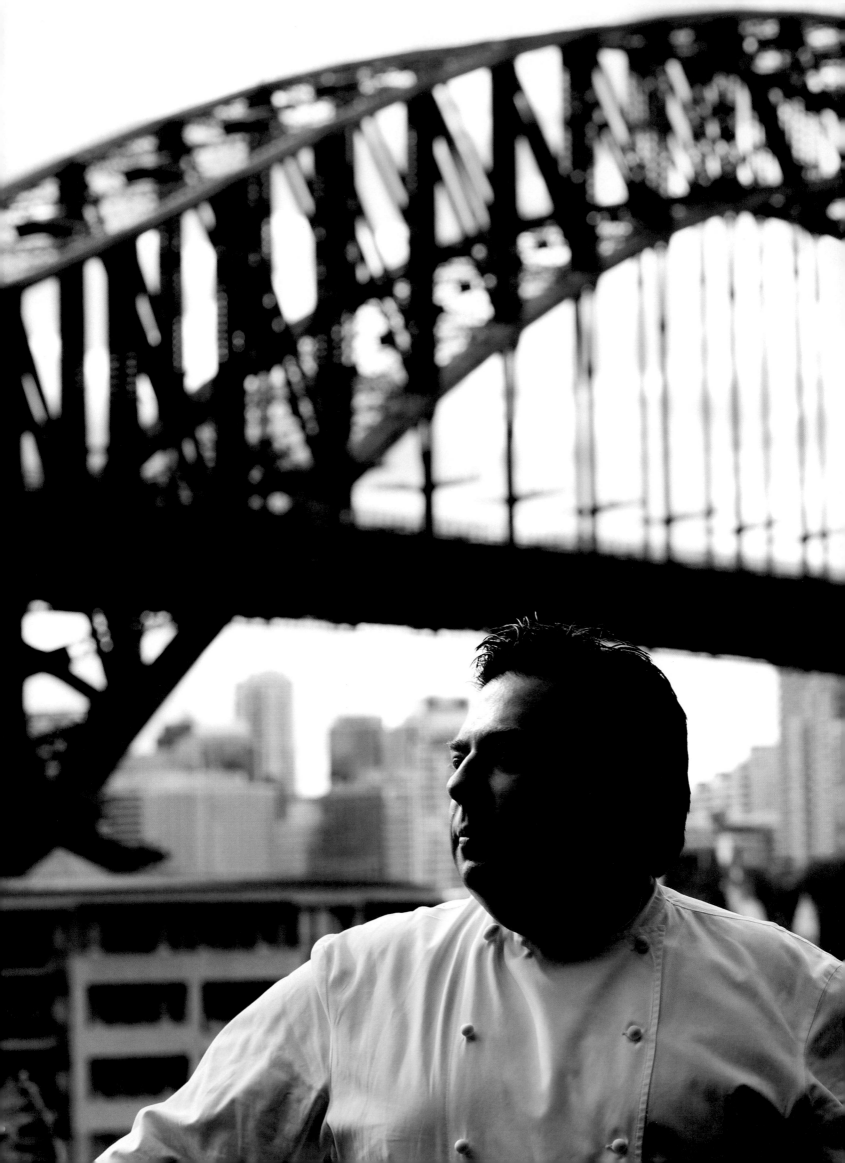

DAN HUNTER

"WE'D DRINK QUALITY RAINWATER AND GOOD WINE."

What would be your last meal on Earth?
It would be something simple—probably some type of banquet or tasting menu composed of raw or just-cooked seafood, organic grass-fed protein cooked over wood or charcoal, and organic simply prepared vegetables. It would definitely include good-quality natural leaven bread and an unpasteurized recently churned butter. A fruit-based dessert, even a perfect example of a piece of fruit, would be in the cards also.

What would be the setting for the meal?
Indoors at a wooden table with a fireplace and a view of nature.

What would you drink with your meal?
We'd drink quality rainwater and good wine. Something white, something red, something sweet.

Would there be music?
Absolutely.

Who would be your dining companions?
My wife, Julianne.

Who would prepare the meal?
A really good cook with serious respect for produce and processes. A Japanese background would probably help.

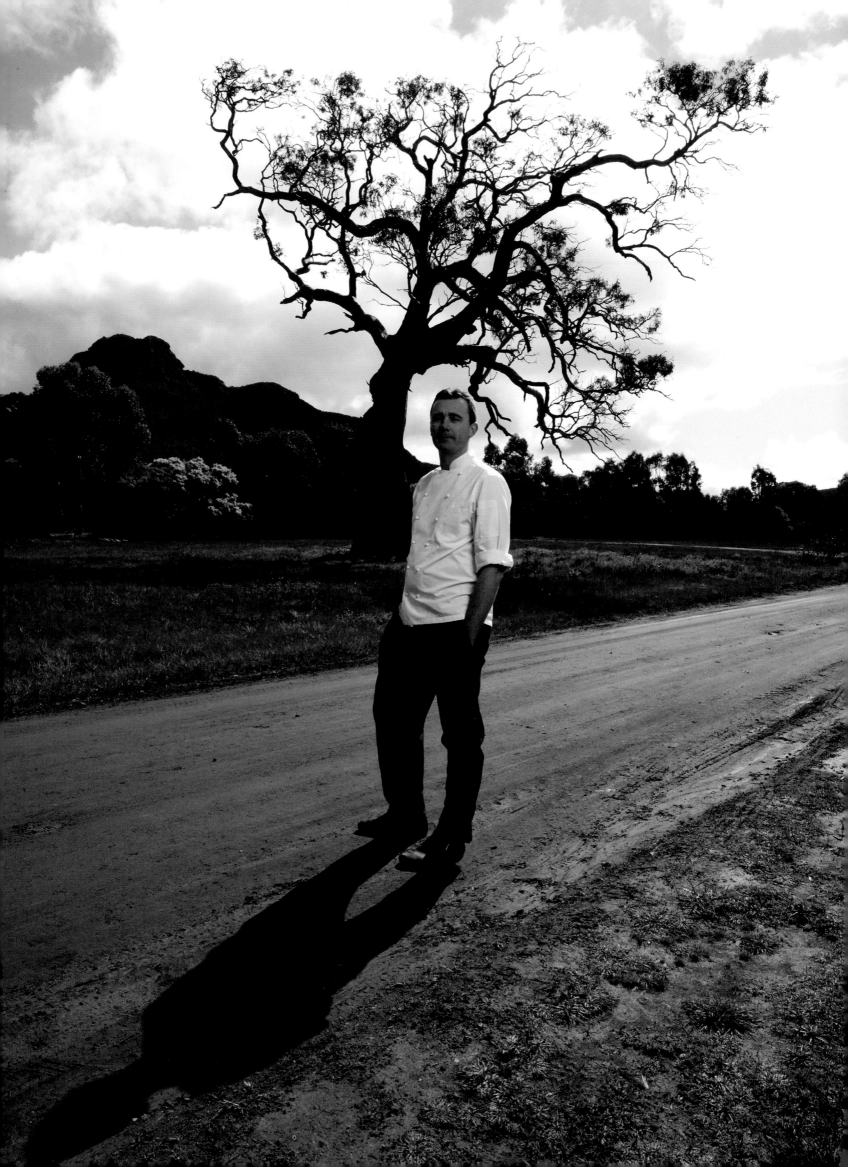

MICHAEL SYMON

What would be your last meal on Earth?
Burger, pasta, pork, chicken.

What would be the setting for the meal?
In my family room, sitting on the floor in front of the fireplace.

What would you drink with your meal?
Jolly Pumpkin La Roja beer and a Ninth Street [Chelsea Market espresso shop] macchiato.

Would there be music?
Yes—Zepplin, Van Halen, Stevie Ray Vaughn, the Stones, and Mellencamp.

Who would be your dining companions?
Liz.

Who would prepare the meal?
Burger—Bobby Flay
Shrimp tamale/pasta—Marc Vetri
Beet ravioli/pork—Paul Kahan
Suckling pig/chicken (with frites and salsa verde)—Jonathan Waxman

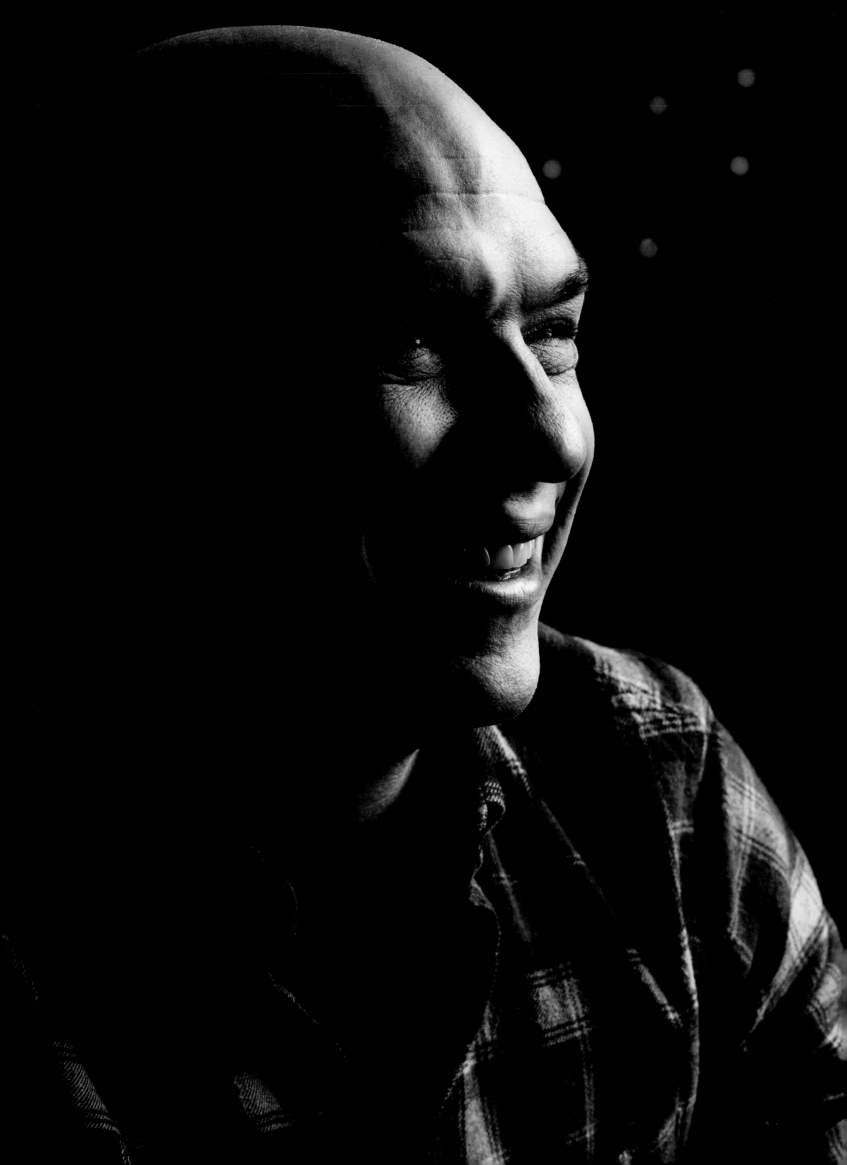

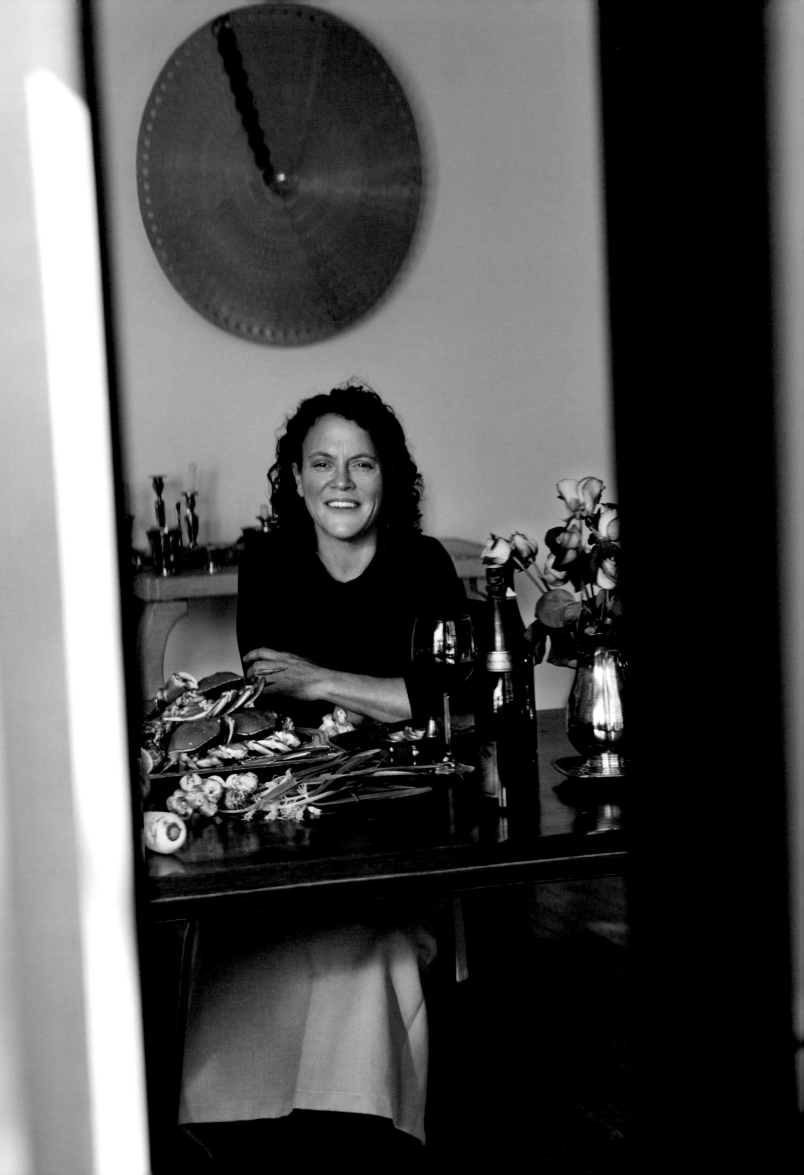

TRACI DES JARDINS

What would be your last meal on Earth?
Truffle-roasted chicken with farmers' market produce and roasted potatoes.

What would be the setting for the meal?
My good friends' loft space, where we gather with family and friends for delicious meals.

What would you drink with your meal?
Vintage Champagne and red and white Burgundy.

Would there be music?
Not a key element for me.

Who would be your dining companions?
My closest loved ones: friends, family, my son.

Who would prepare the meal?
I would—who else? Maybe a few of my chef friends would be there to cook together; nothing's better than that.

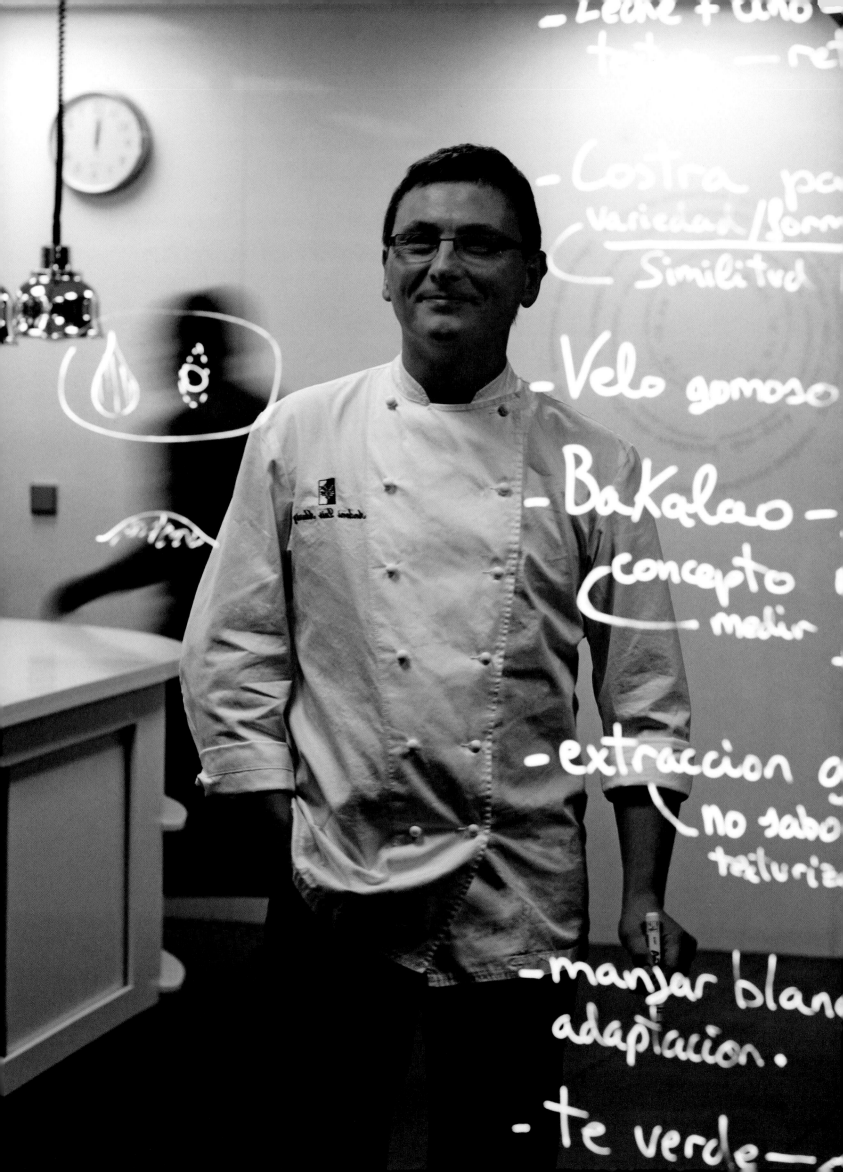

ANDONI LUIS ADURIZ

What would be your last meal on Earth?
A menu designed by Hiroyoshi Ishida, accompanied by the know-how of Tomiko Ishida.

What would be the setting for the meal?
I would give the chefs room to make selections, but I would ask them to choose a place near to my home. They are very spiritual people, and they would look for (and I am sure that they would find) a forest, temple, or suitable meadow. After the meal, I would go to my home, to my bed (very important).

What would you drink with your meal?
Water from some symbolic Basque spring and wines selected by Alvaro Palacios.

Would there be music?
Alos Quartet, *txalaparta,* and the Easo Choir. Also, there would be periods of silence to listen to the sound of the leaves, the wind, and the water.

Who would be your dining companions?
My wife and my little son.

Who would prepare the meal?
The team at Mibu restaurant. They are marvelous and sensible chefs.

"THE MENU WOULD BEGIN WITH TERRINES OF WOODCOCK THAT WE'D HUNTED."

JOHN BESH

What would be your last meal on Earth?
A generous jazz brunch of my favorite foods with my favorite people, in my favorite place with my favorite music. The menu would begin with terrines of woodcock that we'd hunted and foie gras; sweet Lake Pontchartrain blue crab ravigote with roasted heirloom beets; bisque of Louisiana white shrimp, complete with a dash of Armagnac; salad of sautéed veal sweetbreads with truffles and crawfish; slow-cooked wild boar grillades and creamy McEwen's grits; Karl Josef Fuch's warm quark tart with *frais du bois.*

What would be the setting for the meal?
A large table laid out under the live oaks in my backyard, overlooking Bayou Liberty and the moss-laden cypress trees that surround it.

What would you drink with your meal?
We'd begin with 1976 Spätburgunder Trokenbeerenauslese and end with a magnum of 1996 Krug Champagne, hitting all the high notes of Burgundy along the way. A 1990 Romanée-Conti would certainly not be missed, nor would I miss the opportunity to serve a Montrachet of the same vintage.

Would there be music?
Oh, yes, there would be the most wonderful music. Wynton Marsalis and his orchesta would be there, playing "Congo Square."

Who would be your dining companions?
Jenifer and my four boys, along with my closest friends and family, which means 20 or some odd number of my closest souls.

Who would prepare the meal?
I'll cook with my friends and family. My chef and mentor, Karl-Josef, will help. However, we won't clean!

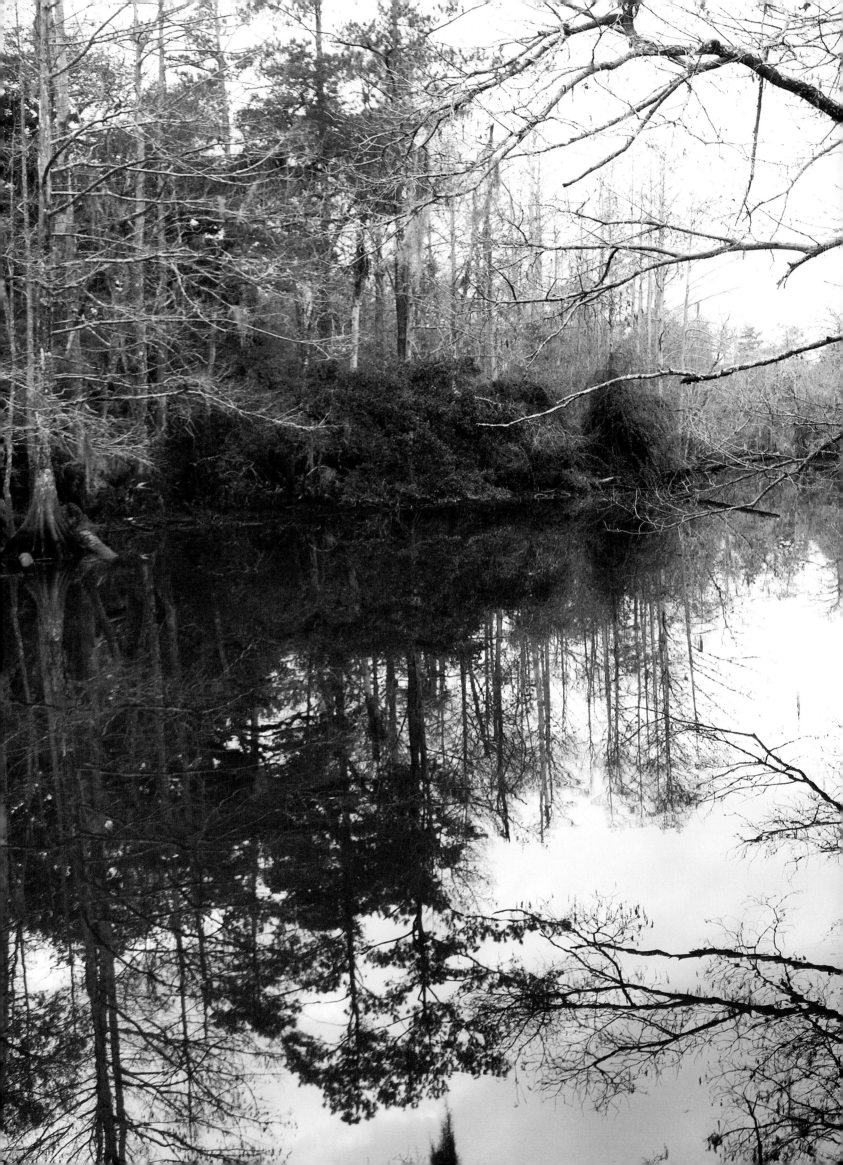

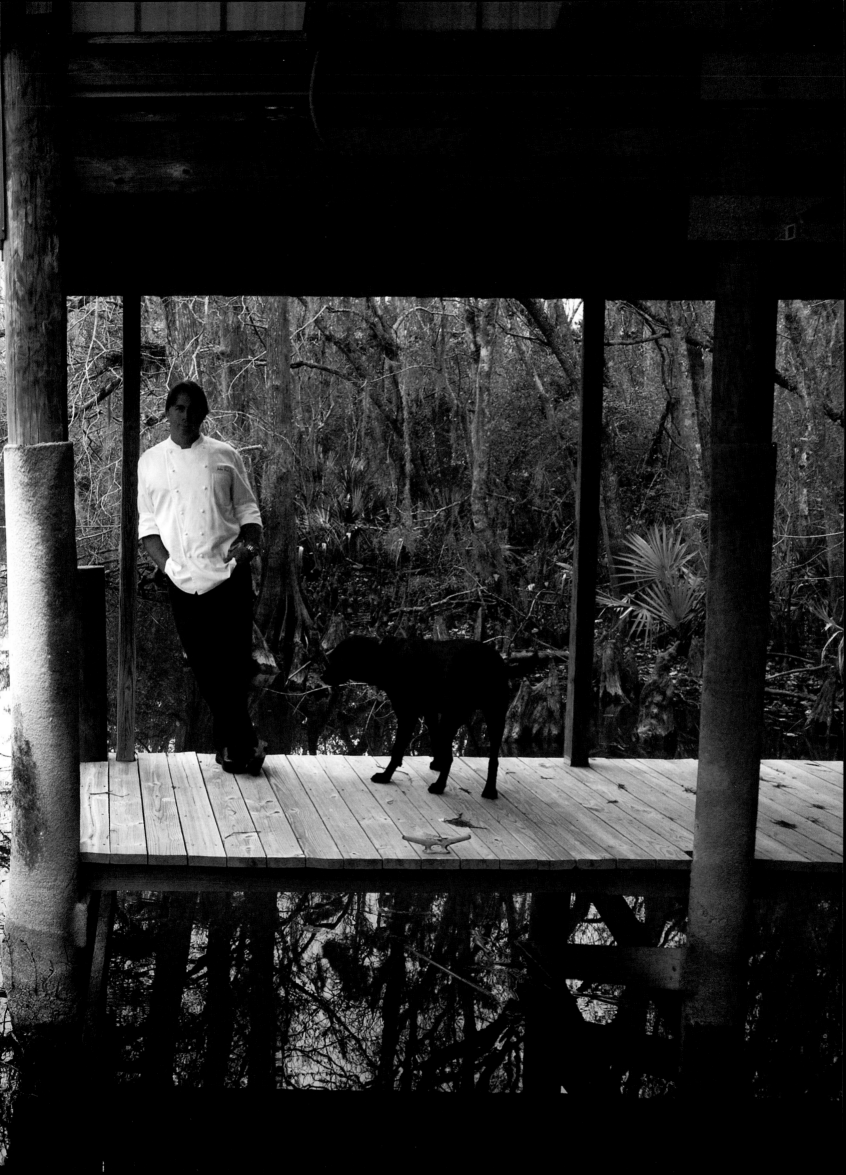

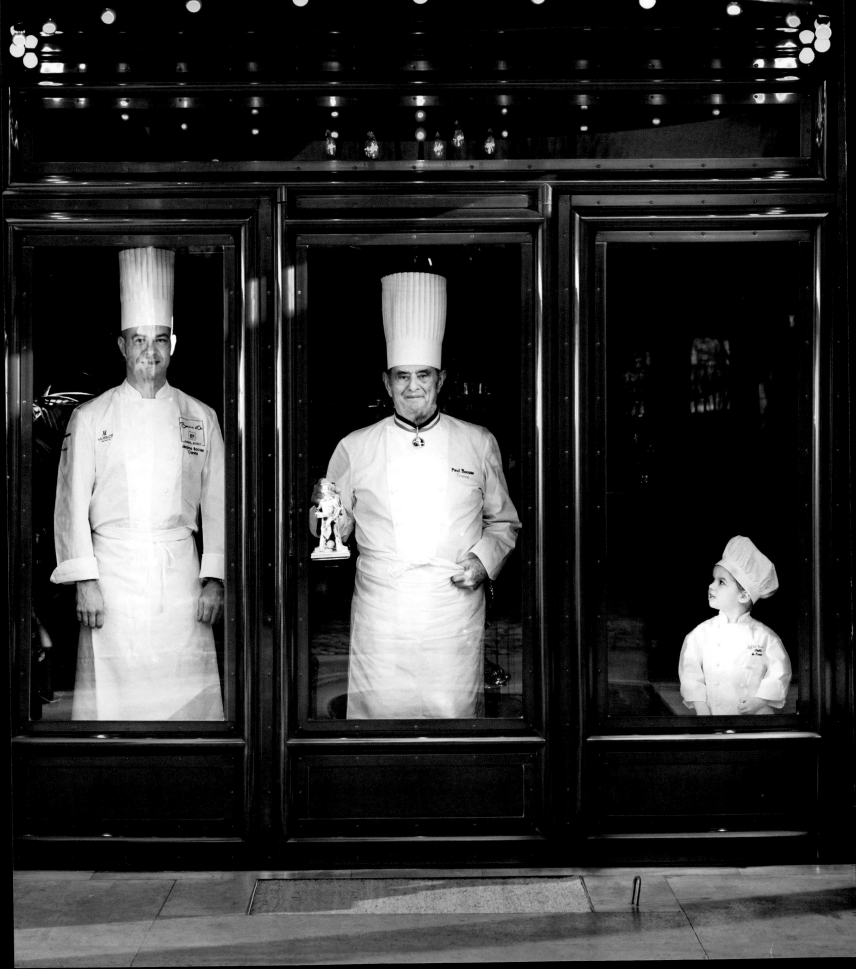

PAUL BOCUSE

What would be your last meal on Earth?
My perfect meal would be a single course, a pot-au-feu and a true county-style bread with a good sausage from Lyon. Afterward, a good Saint-Marcellin, because in Lyon, you can't consider a meal without cheese. Finished off with a good brioche with a crème chocolate.

What would be the setting for the meal?
Lyon. All the food must come from Lyon; that's the most important thing.

What would you drink with your meal?
I would have something from the region, a good Beaujolais. Maybe a cru from Saint-Amour, the vintage from the most recent year.

Would there be music?
No. Just conviviality with the guests—and no talking politics at the dinner table!

Who would be your dining companions?
What's important to me is sharing. I would not want to be alone but to be with friends. I would probably be hunting in the countryside with dogs, friends, and family.

Who would prepare the meal?
The food would be cooked in a wood-burning fireplace. You know, with a chimney, you can cook anything.
Voilà. Bon appétit!

"A LOT OF WINE, A LOT OF FOOD. THE MOST DECADENT FOOD. A 15TH-CENTURY ROMAN BANQUET OR FEAST. I SEE MYSELF EATING A LOT WITH MY HANDS."

CESARE CASELLA

What would be your last meal on Earth?
I want a lot of food, a bonanza, because it is the last. I don't think you want to have only one thing to eat. You want to have a food orgy, because after that . . . well, it's the last supper. A lot of wine, a lot of food. The most decadent food. A 15th-century Roman banquet or feast. I see myself eating a lot with my hands.

What would be the setting for the meal?
I have this vision of this last supper with a big table, lots of herbs, rosemary, and flowers. This table is precious with rich fabrics and fancy silverware. A very good, unexpected place, such as in a church or a place that gives you the sense of something different, something important.

What would you drink with your meal?
Champagne, on the rocks. In a big glass.

Would there be music?
There would be live musicians walking around. The music is a complement to the food, but it's in the background. Something more classical, like a quartet or an orchestra. Happy, classical Baroque-like Bocelli—like that, but heavy.

Who would be your dining companions?
I'd share with the people close to me. You want people who are happy and fun, and not people who don't eat or drink. You want the people who love eating and drinking.

Who would prepare the meal?
Not me. I don't work at my last supper. I want to enjoy it. I want my meal cooked by people with passion and soul, not by a catering company. I want it prepared by three or four people who enjoy the food and what they are doing because they think you'll taste that the food has soul. Maybe they won't be the best chefs, but since they enjoy what they do, they cook with passion and soul.

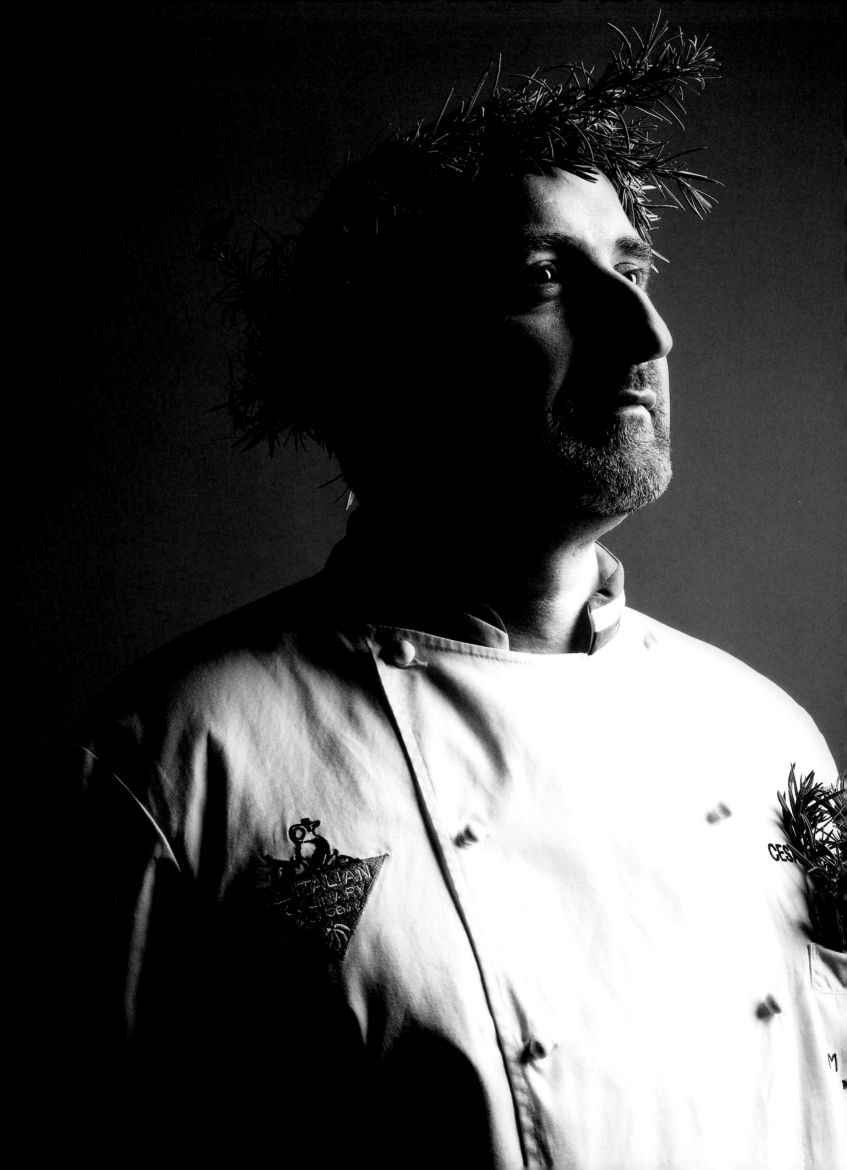

DANI GARCÍA

What would be your last meal on Earth?
I think that everything in your gustatory memory is ultimately food from your childhood that your mother or your grandmother cooked. I live, and I was born, in Marbella, a sea town, so for me it's any type of fried fish. So something like smooth clam and shrimp to begin. I would then turn to fried fish, which is something I've cherished all my life, something very *malagueño*—small fried fish, goby. And for dessert, I would have *torrija*. It's a very traditional Andalusian dessert, normally served during Holy Week, a religious festival. It's a bread that you normally put in milk with sugar, eggs, and cinnamon. It's very typical, but we have a new version with coconut milk and white chocolate.

What would be the setting for the meal?
Truly where one really feels the most comfortable is home, and if you can see the sea from home, even better. I can do that at home, so it would be my home.

What would you drink with your meal?
I am a strange chef, because I don't drink alcohol. I always drink Coca-Cola.

Would there be music?
Yes, of course. Spanish music, Spanish singers, and Spanish guitar. They would play Spanish guitar music, but a little bit more modern, and with the sound of a singer in the background. It would be truly what I like the most, what I feel the most passion for, and what makes me have the most fun when I listen to it.

Who would be your dining companions?
My family. I have two small girls, and that, for me, is the best in the world, my best recipe. Your closest relatives are the people that stay with you. You have all the people from work that you really love, that you adore, and they come to form part of your life. But truly the important people in your professional life and in the important events that have occurred to you are your family. So I would want my babies, my wife, my mother, and my sister to be there.

Who would prepare the meal?
That would be me, because I love to cook. And since it's the last meal with your favorite people, that I would have to cook.

"SOMETHING FRESH FROM THE GARDEN, DRIZZLED WITH GREAT OLIVE OIL, VINEGAR, AND FLAKY SALT."

MARC VETRI

What would be your last meal on Earth?
Something fresh from the garden, drizzled with great olive oil, vinegar, and flaky salt.
Some kind of pasta.
Something with mint and chocolate.

What would be the setting for the meal?
Our family table in the kitchen.

What would you drink with your meal?
A Barbera from Italy.

Would there be music?
Yes.

Who would be your dining companions?
My wife and children.

Who would prepare the meal?
Me and my kids.

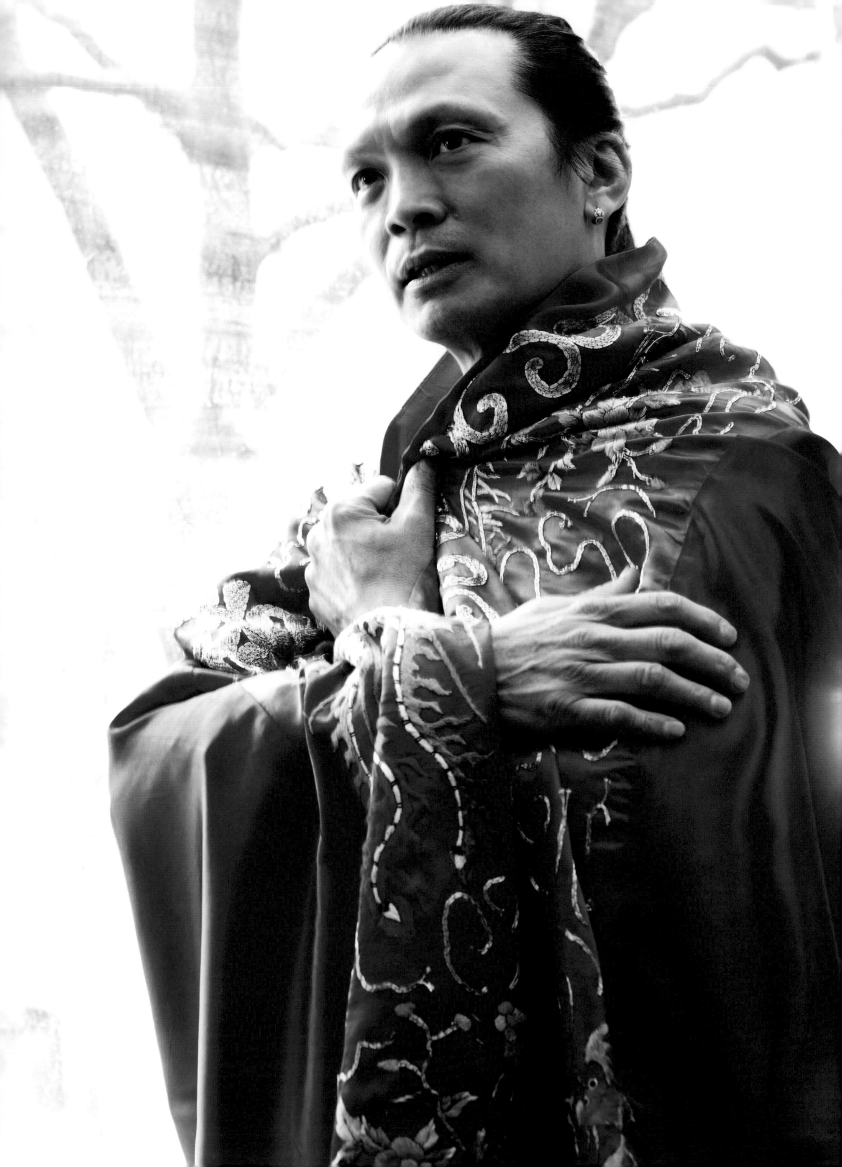

SUSUR LEE

"HONG KONG–STYLE
WONTON NOODLES
FROM MY CHILDHOOD."

What would be your last meal on Earth?
Hong Kong–style wonton noodles from my childhood.

What would be the setting for the meal?
My old house, where I grew up in Hong Kong.

What would you drink with your meal?
A grape Fanta.

Would there be music?
No.

Who would be your dining companions?
My family—mom, dad, sisters, and brothers.

Who would prepare the meal?
My favorite street vendor, who made the best noodles around—it was a husband-and-wife team.

GEORGE MENDES

What would be your last meal on Earth?
The day would have to start with really good coffee and a bagel toasted with cream cheese. Fresh-squeezed OJ as well. Lunch would have to be a sandwich of some sort of sea urchin containing wasabi or mustard oil. Then—the final meal—a dry-aged rib-eye steak with a black truffle red wine sauce. A really well-executed baby greens salad with slivers of aged Parmesan and a side of roasted potatoes with olive oil, paprika, and rosemary.

What would be the setting for the meal?
It would be out on some mountain range, overlooking endless hills on a bright, sunny day. We'd eat at a table under a tree with hammocks hanging around, livestock grazing in the distance.

What would you drink with your meal?
As we mingled, Billecart-Salmon Rosé Champagne, then great sparkling and still water (perhaps from nearby spring), then a bottle of 1986 Corton-Charlemagne and a bottle of 1990 DRC Richebourg.

Would there be music?
Yes, lightly playing in the background. An eclectic mix.

Who would be your dining companions?
My girlfriend (or wife), mom, dad, sister, and close chef friends.

Who would prepare the meal?
Thomas Keller. Although I never worked for him, he has always been an enormous inspiration for me.

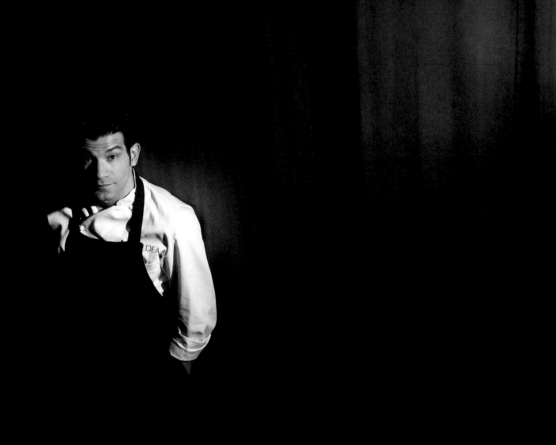

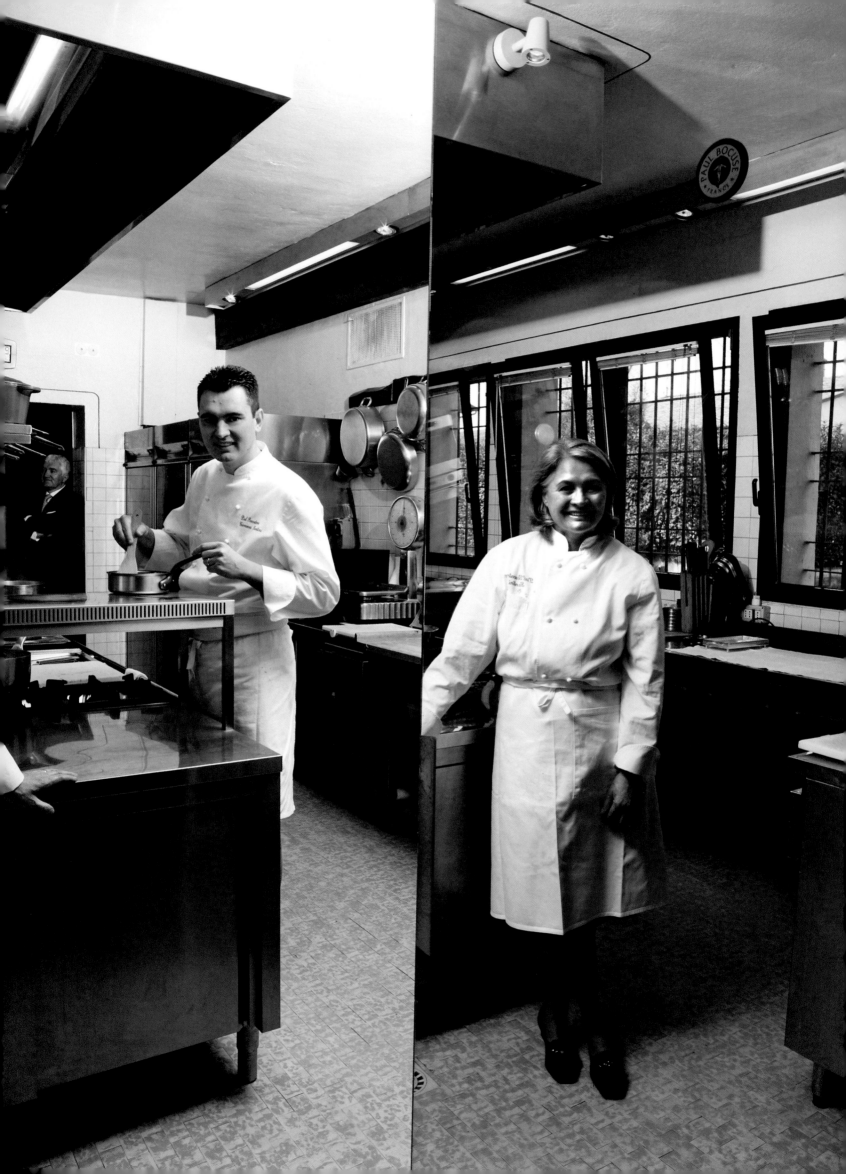

THE SANTINI FAMILY
GIOVANNI, NADIA, & ANTONIO

What would be your last meal on Earth?
GS: Bread, Mantovan salami, coppa piacentina, and Parmigiano-Reggiano cheese.
NS: Foie gras with a cherry sauce.
AS: Oysters in champagne gelatin with malosol caviar.

What would be the setting of the meal?
GS: During a motorcycle trip on the Italian Alps.
NS: In complete relaxation, sitting at a table in the countryside.
AS: At Paul Bocuse's restaurant, with him sitting at the table.

What would you drink with your meal?
GS: Gaja Barbaresco.
NS: Champagne or Franciacorta Brut.
AS: La Tâche Romanée-Conti.

Would there be music?
GS: Yes, Mark Knopfler.
NS: "Emozioni" by Lucio Battisti.
AS: Tchaikovsky's "Capriccio Italiano."

Who would be your dining companions?
GS: After seeing the aftermath . . . it's better to be alone. But if somebody would insist . . .
it's better to choose those who are not very superstitious.
NS: The family.
AS: The most cherished friends.

Who would prepare the meal?
GS: I.
NS: I.
AS: My favorite chef at the moment.

"I WOULD LOVE THE MEAL TO TAKE PLACE WHERE I HAD MY FIRST RESTAURANT IN CARLTON. JUST SO I COULD REMEMBER ALL THE HARD WORK."

SHANNON BENNETT

What would be your last meal on Earth?

It would just be a piece of beautifully steamed fish that I caught myself. Turbot is not something that's found in Australia, and when I was cooking in London, John Burton Race would never allow me to bone the turbots. So basically I always wanted to touch one but never could. And because it was so expensive, I never actually ate a turbot. So the first time I ate it, it was like this revelation. I always just remember it being beautifully steamed with a parsley vinaigrette. And the memory is just brilliant. So I've always thought I would just love to catch one and then eat it, and really respect it.

What would be the setting for the meal?

I would love the meal to take place where I had my first restaurant in Carlton. Just so I could remember all the hard work. You forget about that from day to day—the great stories we build up under all that pressure and intense scrutiny. You realize that life shouldn't be taken so seriously. I had a really good customer named Andrew Darbyshire who had a daughter who died of a neurological disease when she was young. And so he sold his business for a lot of money and just started doing charity work. I always drew inspiration from him. When I got frustrated or he'd see me ready to explode in the kitchen, he'd say, "Hey, Shannon, remember rule number six." And rule number six is: Never take yourself seriously. And now you're asking, well, what's rule number seven? And there isn't any other rule. It's just number six, and you always remember it.

What would you drink with your meal?

It would have to be Le Montrachet from Domaine de la Romanée-Conti 1981, because that's a wine that I'd be so scared to drink because it costs so much money. And I do love great wine, but for me, it would need to be something I could appreciate, and I would have to build up my palate. I need that last supper to be at least 30 to 40 years from now because I need to build up my palate to appreciate that wine.

Would there be music?

Yes. David Helfgott playing the piano; he's a mate. He was in the film *Shine*. He and Gillian, his wife, could sit down as well. David wouldn't eat with us; he would eat at midnight like he always does. Gillian would know what that means. He's an eccentric and amazing character. When you see the film, you sort of understand. It captures him so well, just how eccentric he is. But he always has so much energy, so he would play the piano while we're eating, and we would have to wrap up some turbot for him. We would have to serve that to him when everyone else has gone to bed. That's normally when he eats.

Who would be your dining companions?

Definitely my wife, Madeline, and our kids. My two-year-old would need to be restrained and strapped to a chair. In terms of people I would really like to meet, definitely Anthony Hopkins. He just seems to be so intelligent. And then I would love to invite some guy, a complete stranger, from off the street. We have this perception of everyone we walk past on the street, whether it's because we're defensive or we always think the negative before the positive. Do you ever walk past someone on the street and actually say, "I bet you he's a nice guy?" You never do. Hey, that's life; let's turn it around.

And I would have my dad because he's just *so* not a foodie. He's the only guy I know who sends a chicken breast back to the kitchen because it's not cooked enough. He's actually my worst nightmare to cook for. And I've never actually been able to take the time to sit him down and actually try to give him a course on etiquette of dining and how things should be. I would actually spend the first 10 minutes of that dinner working on my father.

Who would prepare the meal?

Maybe Eric Ripert. He would be the ultimate at preparing that turbot.

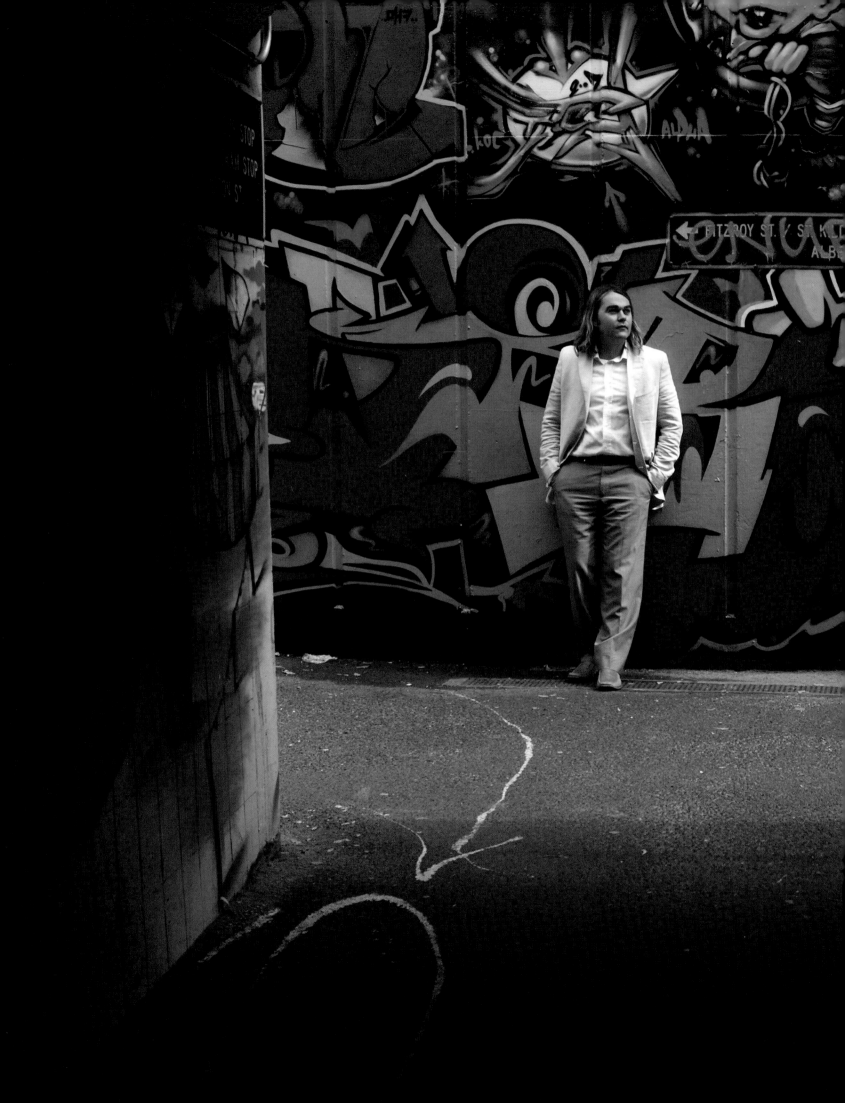

PAUL BARTOLOTTA

What would be your last meal on Earth?
If I knew this was really it—my last meal!—then with God's permission (and Melanie's OK, of course), I would squeeze in two last meals, one lunch and one dinner. They would be about the people—both living and dead—who are important in my heart and to whom I have a genuine debt of gratitude.

What would you serve for your last lunch?
When I was a boy, my father would take me down to the seafood markets on Brady Street in Milwaukee. He would buy all this seafood and spend the whole weekend cooking. We never had access to the Mediterranean seafood that I now do, so for the last lunch, I would treat them to Ligurian octopus salad, a mountain of boiled langoustines (I want my family to taste "the best langoustine on the planet," which I discovered only after both my mother and father passed away), and lastly, spaghetti with clams, which was one of my mom and dad's favorite dishes.

What would be the setting for the lunch?
There is nothing quite like being on a sailboat in the Mediterranean, eating seafood. I had always hoped to treat my parents, my brother, Joe, and my two sisters, Maria and Felicia, to this magical experience. This would be my chance.

What would you drink with your lunch?
Falaghina, Falaghina, and some more Falaghina. That would be followed by a nap, up on deck, snuggling with my wife and daughter in my arms, with the cool breeze of the Mediterranean passing over us and the sea gently rocking us to sleep.

Who would be your dining companions for lunch?
My immediate family and their families. I would like my mother and father to see how all their children and grandchildren have grown up. I know they would be so proud.

Who would prepare the lunch?
My wife, Robbi, who is the real chef of our household, my daughter, Giulia, and me. We would do all the cooking as a family, as is our custom, and as it should be.

What would you serve for your last dinner?
Fettunta (grilled Tuscan bread drizzled with Paolo Pasquali's super premium olive oil), the best salumi in Italy (*Culatello di Zibello, Salame di Felino, Prosciutto Toscano del Contadino, Mortadella di Bologna, Cicciolata di Parma, Coppa Piacentina, Finocchiona,* and *Rigatino Toscano*) with *Piadine Romagnolo* (Romagna flatbread), *tajerin con tartufo bianco* (thin Piedmontese ribbon pasta with white truffle), *tortellini al ragú, fiorentina di Chianina alla griglia* (grilled Chianina beef porterhouse steaks), *costole di maiale alla griglia* (grilled fresh pork ribs with garlic and rosemary), *scotta ditto d'agnello alla griglia* (grilled baby lamb chops with garlic and rosemary), *piccione al forno a legna* (wood-roasted squabs), *funghi porcini trifolati* (porcini mushrooms), *patate arrosto* (roast potatoes), *frutta, gelati, sorbetti, e granité.*

What would be the setting for the dinner?
A hilltop town just outside Montalcino. We'd eat at a dining table nestled beneath a rustic pergola covered in vines and overlooking the bucolic valley and abbey below. We would begin to nibble in late afternoon while cooking, lighting the candles out on the pergola table just before sunset.

What would you drink with your dinner?
We would imbibe our favorite bubbles, Champagne Gosset, all afternoon while cooking. At dinner we would drink a fun assortment of great mature vintages of Barolo, Barbaresco, Chianti, and lots of Brunello di Montalcino. And near the end of the night, most likely just before sunrise, we would sip a most delicious antique Madiera and illycaffè espresso.

Would there be music at dinner?
Yes, the music of human voices. Everyone telling stories, talking over each other all night long, chuckling and laughing, with the backdrop of the crackling wood-fired grills, the sounds of the Italian countryside at night, and the Gregorian chants echoing up from the abbey below.

Who would be your dining companions for dinner?
Everyone from lunch would also be present at dinner along with all my extended family. I would also want the chefs and managers who have made and served my food throughout the years to have the night off, and I would cook for them!

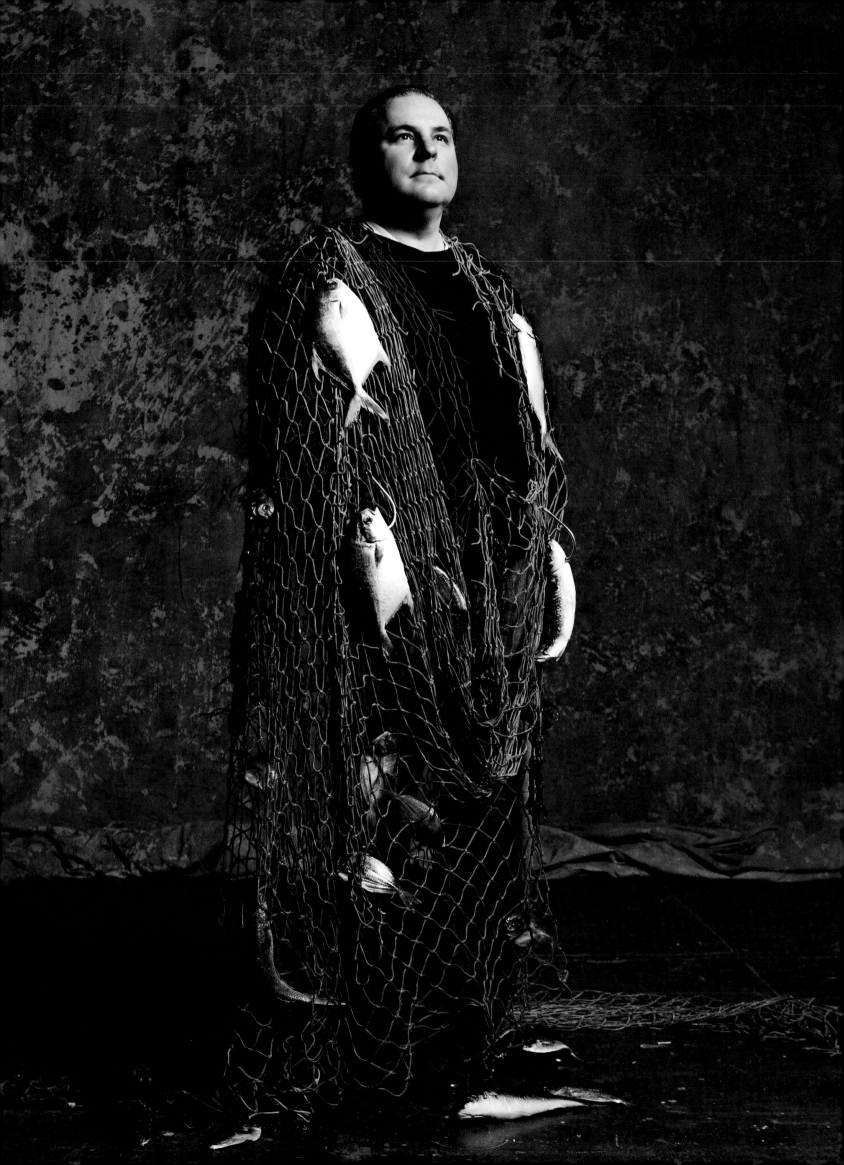

DAVID McMILLAN
(Joe Beef)

What would be your last meal on Earth?

It goes without saying that this is a frightening thought. I understand the exercise, but I hope for my death to come suddenly in my sleep and only once my precious daughters no longer need my guidance. There is nothing in the world more dear to me than my girls, Dylan and Lola. That said, to those invited, clear your schedules, as my last meal might very well be your last meal too. Here we go.

The lot of us would, of course, start with several dozen Malpeque oysters and small quahogs shucked and sourced by no other than shucking legend John Bil. No sauce or lemon, just plain.

As a second course: large oval Le Creuset serving dishes of real hot, garlicky Burgundy snails in the shell and oak boards of thinly sliced, jellied parsley ham, as well as little hot baguette toasts generously buttered and covered with heaps of gray Burgundy truffles. Yum.

Third course: I've had many great meals and could come up with so many fantastical tales, but the truth is, nothing makes me happier than mustard-braised rabbit, Comté-stuffed raviolis in cream, and overcooked brussels sprouts with salted butter. Epic.

All of these dishes would be accompanied by delicious bread from the Niemand bakery in the village of Kamouraska.

For dessert, I would have cheese: Riopelle from L'Isle-aux-Grues, Noyan from the Townships, Pied-de-Vent from the Magdalen Island, and old cave-aged Gruyère. A dessert signifies the end, time to go, therefore I will not have dessert and will go on quietly eating cheese and drinking Vin Rouge. No dessert for me!

What would be the setting for the meal?

My family owns a small cottage in Kamouraska, a small village along the shore of the St. Lawrence River, where the water becomes salty. The cottage is the old wharfmaster's house that has been moved from the wharf onto a rock outcropping called Cap-Taché, which has a great view over the river to the Kamouraska archipelago islands and on to the hills of Charlevoix. It is the place I prefer to be, always! The cottage is small and sits among hundreds of 60-year-old lilacs, which bloom in the spring. I have never seen anything more beautiful. We would eat there on the path near the outdoor fireplace. When I do die, bring my ashes here and scatter them among the lilacs.

What would you drink with your meal?

With the oysters and clams: A large bottle of Molson Export because it tastes like winning and Montreal Canadiens hockey. Go, Habs, Go!

With the snails and parsley ham: magnums of 2007 Norman Hardie County Chardonnay, Prince Edward County, Canada; magnums of 2009 Alderea Pinot Gris, Duncan, Vancouver Island, Canada; and magnums of 2005 Domaine d'Auvenay Auxey-Duresses Les Clous, France.

With the rabbit: I would still ponder some whites but bring out some favorites: magnums of 1999 Volnay 1er cru Taillepieds from the De Montille family, France; magnums of 2007 Thierry Allemand Cornas Reynards, France; and magnums of 2009 Morgon, Marcel Lapierre, France.

Served by sommeliers Ryan Gray and Vanya Filopovic because they have to be there.

Would there be music?

I love music, but I believe at my last meal that I would just like to listen to my wife's voice speaking to my girls, my friends' crass jokes, the wind, and the sound that the fire makes.

Who would be your dining companions?

Tough question. My lovely wife, my gorgeous children, my immediate family, and finally, everyone I've ever had dinner with or shared a bottle of wine with. You're all invited, and you mean a lot to me, so come!

Who would prepare the meal?

I think on my last day, I would like to be in the kitchen. I've spent most of my professional life there, although in the last years, as you get older, you kinda get pulled out and pushed into the dining room, like a rite of passage. I long for the days when I held a station. I would like to prepare my last meal with people I've worked with in the past and with all the chefs I worked for. The kitchen and the work I've done there hold so many positive memories. To be paid to prepare food for those who love it can be a beautiful career!

FRÉDÉRIC MORIN
(Joe Beef)

What would be your last meal on Earth?

First, foremost and realistically, I hope I will be old by then, and, in a very selfish way, that I'm not the last among my clan to depart (nor the first!).

To eat, I can think of nothing other than a couple dozen Portage Island oysters from New Brunswick—the water is cold there, and the sea is a bit rougher so the oysters grow slow and thick. I had them a couple times from a "forgotten" lease, so they grew without the hurry and constraints of profitability. Delicious!

Next to them, on ice, langoustine from Brittany, poached and chilled, with rye loaves and crazy French butter, just like at la Coupole, in Paris.

Then, a small *canette* [female duck], a whole one for me, cooked way too long with thyme and red wine, in a cocotte sealed with bread dough.

If it's in the spring—although, as Jacques Brel would sing, "C'est triste de mourir au printemps"—tons of green peas in broth.

A savarin, for dessert, endless helpings of it, with soft-serve ice cream and tiny strawberries.

Quelques petits cigares de la Havane.

A pear from my tree.

What would be the setting for the meal?

I wouldn't want to be anywhere else than my home. I don't want to dress up for my last dinner, nor am I washing dishes! Just like in the old Time-Life French provincial cookbook, there would be a wrought-iron table deep into the backyard, almost in the raspberry bushes. There'd be lanterns on the pear tree branches.

What would you drink with your meal?

Campari with soda.

Ice-cold dry Xeres.

A Grand Vin de Bordeaux.

Many eau-de-vie, from many places, with the little cigars and tight coffees.

Would there be music?

Probably not to start, but Campari would trigger the unbearable urge for many repeats of "The Wreck of the Edmund Fitzgerald"!

Who would be your dining companions?

If things follow a natural order, then my parents, grandparents probably won't be there. Simply my wife, Allison, my boys, Henry and Ivan. David, Julie, and his girls. My brother, Ben, and his family. The Bondurands and John Bil.

Who would prepare the meal?

Me.

BILL TELEPAN

What would be your last meal on Earth?

The best times of my life, as far as eating, have always been about the people more than the food. That said, there would be some slow-roasted pork cooked over a grill or in a pit. We would wrap some briskets in foil and leave them over coal and grill some corn. This one time we grabbed fava beans and threw them all on a grill, and we were just shucking them, eating them like that, taking the tomatoes and zucchini off the grill and making salads. We'd pull onions from the ground and just chop them.

The pig would be rubbed with a lot of cumin, a lot of chili powder, and paprika, and oranges, lemons, and garlic. It would sit for, like, five days salted and then cook slow, so that the skin has that golden color and it's just kind of crackling, and you lift up the skin and it has that beautiful fat. And you just sort of grab it with a pair of tongs or forks, and you're just sort of pulling it off the pig. The brisket's seasoned with a barbecue spice, and you wrap it in foil, and you let it go really slowly, and it comes out tender and juicy, and people are just slicing it off and eating it with bread, or not. And you know when you pick corn and throw it on the grill, within 15 minutes on the grill it's supersweet, and everyone's just ripping it open.

I love dessert, so I'm thinking that I've got someone in the back churning some vanilla ice cream, and we've got a blueberry crumble going. And if there's a little ice cream left over, we can make hot fudge sundaes, because I would definitely have to have a hot fudge sundae if it were my last day on Earth.

What would be the setting for the meal?

I picture this giant farm, with a softball field and a couple of games going on, and a nice little pond that the kiddies could jump into. I would too if it was hot. And then just a couple of grills going and lots of big tables under this big sky.

What would you drink with your meal?

People are arriving at all different times, and, you know, we've got pitchers of tequila lemonade going. You're out in the sun—I'm thinking a tequila cocktail. I like to make lemonade or even watermelonade, so this way the kids could have that, you know, and we could put a little tequila in it for the grown-ups.

Would there be music?

I love Radiohead, so of course Thom Yorke would have to be there. And I'm a Jersey boy through and through, so Springsteen would have to be there. My wife introduced me to Stevie Wonder, and we both love him, so I have this vision of Stevie, Bruce, and Thom Yorke playing in a band. And I play a little, so I'd bring out my bass and play my bass. We'd start off with "Reckoner," go on to "My Surrender," and then—what's that one Stevie Wonder song I love? "Higher Ground." And it would just continue—they would trade off songs. Can you imagine? We would be eating, and they would play a few songs and come off and go back on—or we would go back on, I should say.

Who would be your dining companions?

I would have my wife and my daughter, my parents, my siblings and their spouses, a bunch of friends I went to cooking school with, my childhood friends I still remain in contact with, all the people I've worked with over the years. And then, since it is my fantasy and my last supper and I love old movies, I would want to have Steve McQueen there. And my wife and I can recite every line in *The Godfather*, so we'd have to have the entire Corleone family there just hanging out with us. Will Ferrell should be there, because he's one of the funniest guys that I like right now. And I could imagine, as far as historical figures, I'd like to have the Roosevelt boys there: Teddy Roosevelt would be hanging out, talking to Will Ferrell, and FDR talking to Thommy Yorke—like, you know, given what FDR went through in the World War, and Teddy's just this wild guy and did so much. And to sort of bring it all together, I'd have Abraham Lincoln going over and just shaking everyone's hand and giving them words of wisdom.

Who would prepare the meal?

I would cook at my last meal because I enjoy it so much. I get such pleasure out of it all the time that I would want to have this time where we're all just sort of hanging out together, cooking together, picking from the garden.

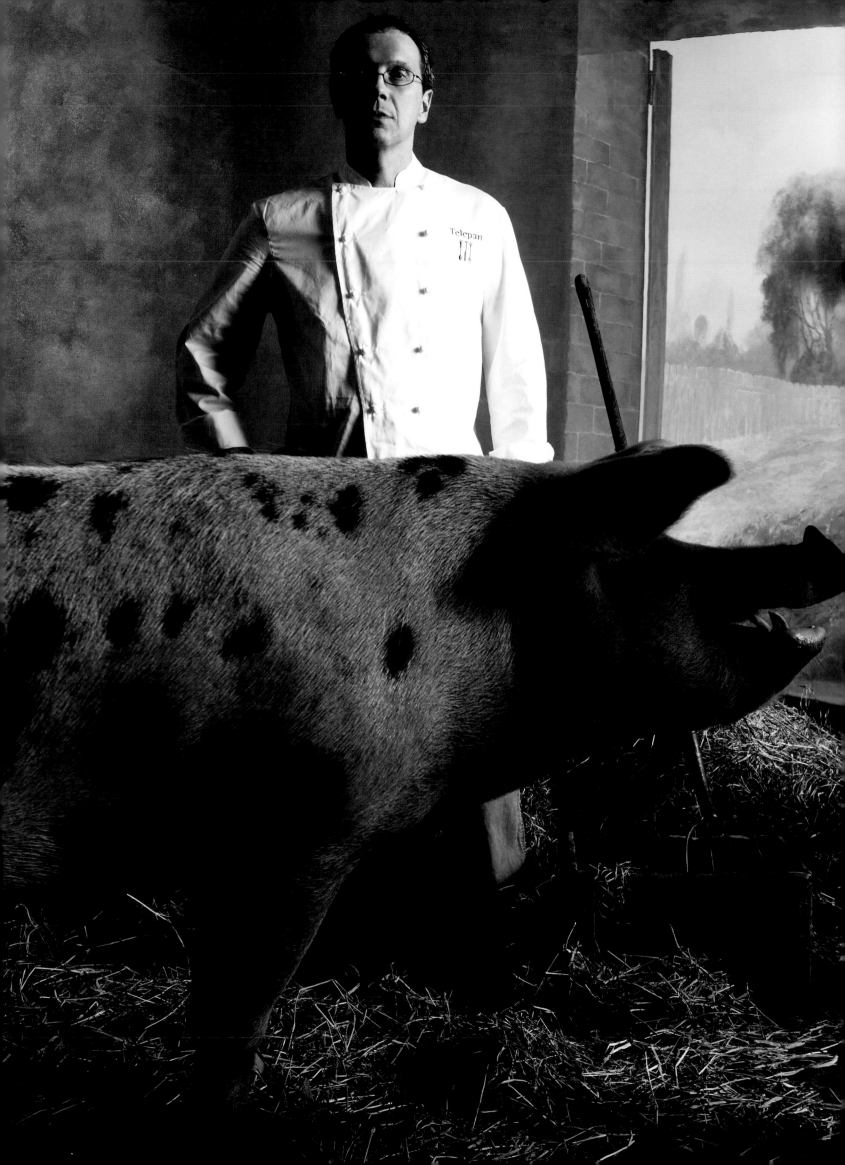

"I LOVE SILENCE FAR TOO MUCH."

GUALTIERO MARCHESI

What would be your last meal on Earth?
God only knows. A great bread.

What would you drink with your meal?
Pure water.

Would there be music?
No. I love silence far too much.

Who would be your dining companions?
Nobody.

Who would prepare the meal?
I'd do it myself.

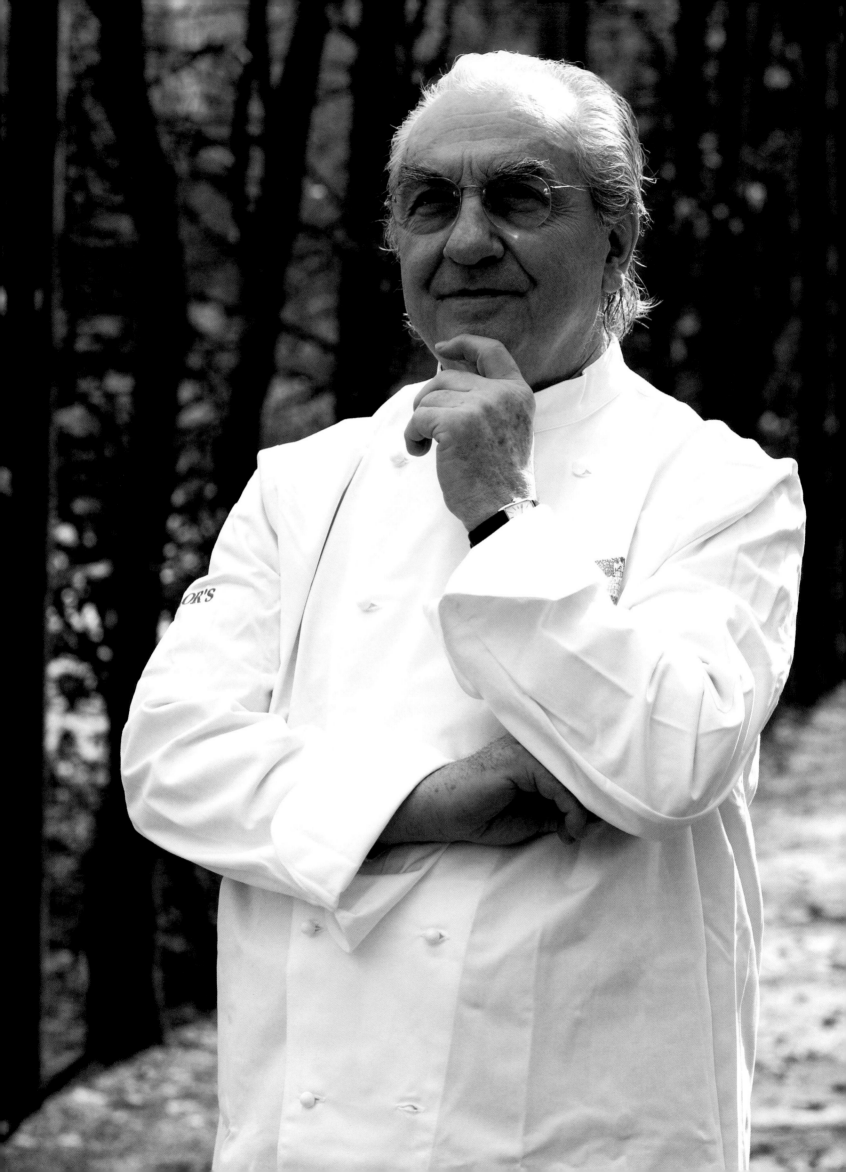

RECIPES

GRANT ACHATZ

MOM'S CHOCOLATE BIRTHDAY CAKE

Serves 12

Chocolate Cake

½ cup solid vegetable shortening (Crisco)
1¾ cups sugar
1 teaspoon pure vanilla extract
3 eggs, separated
2½ cups sifted cake flour
½ cup unsweetened cocoa powder
1½ teaspoons baking soda
1 teaspoon salt
1½ cups cold water

Fluffy White Frosting

4 heaping tablespoons all-purpose flour
Dash of salt
1 cup milk
8 tablespoons (1 stick) unsalted butter
1 cup sugar
1 teaspoon pure vanilla extract

To make the cake: Preheat the oven to 350°F. Grease and flour two 8 × 1½ inch round cake pans.

Cream shortening and 1 cup of the sugar until light. Add the vanilla and egg yolks, one at a time, beating well after each addition.

Sift together the flour, cocoa powder, baking soda, and salt. Alternate adding the flour mixture and the water to the shortening mixture, beating after each addition.

Beat the egg whites until soft peaks form; gradually add the remaining ¾ cup of sugar, beating until stiff peaks form.

Fold the whites into the batter, blending well. Divide the batter between the cake pans and bake for 35 to 40 minutes.

To make the frosting: In a small saucepan, combine the flour and salt. Stir in the milk and mix until smooth. Cook over medium heat until thick, 5 to 7 minutes. Let cool to room temperature.

In a medium bowl, cream the butter, gradually adding the sugar and vanilla. Add the flour mixture, a tablespoon at a time, beating until fluffy.

(Previously published in *Better Homes and Gardens***)**

ALBERT ADRIÀ

CAVIAR PIZZA

Serves 20

Dough
4 cups plus 6 tablespoons bread flour
1¼ cups ice-cold water
3½ tablespoons olive oil
1 teaspoon salt
1 scant teaspoon (3 grams) dry yeast

Topping
1 pound mozzarella cheese, shredded
Dried oregano
Virgin olive oil
2¼ ounces beluga caviar

To make the dough: Mix all the ingredients in a mixer at low speed for 20 minutes. The dough can be refrigerated for up to 2 days.

Preheat the oven to 450°F. Roll out the dough as fine as possible for bite-size mini pizzas.

To make the pizzas: Sprinkle each pizza with some of the mozzarella, some oregano, and a sprinkle of virgin olive oil. Bake for 3 minutes.

Top each pizza, straight out of the oven, with about ¼ teaspoon of caviar. Eat quickly.

ANDONI LUIS ADURIZ
OCTOPUS SOUP WITH TAGETES

Serves 4

14 ounces octopus
14 ounces whole fresh sardines
African marigold (*Tagetes erecta*) buds

Bring a large pot of water to a boil. Add the octopus and blanch for a few seconds. Immediately refresh it in a bowl of ice water.

Prepare a charcoal grill. Cook the octopus until it turns golden brown. Set it aside.

Preheat the oven to 450°F. Clean and gut the sardines. Rinse them under cold water, drain, and arrange them neatly on a baking sheet lined with parchment paper. Roast them in the oven for 10 minutes.

In a stockpot, combine the octopus and sardines (careful to break them up as little as possible). Add 12 cups of water, bring to simmer, and cook for 2 hours, until the broth is concentrated.

With a fine-mesh sieve set over another bowl, strain the soup. Then pass the resulting broth through a paper filter to remove fat from the surface.

Remove the petals from the African marigold blossoms and let them sit in a bath of cold water for several minutes.

Drain the petals and divide them among the serving bowls. Pour the hot broth into the bowls in front of the guest and wait a few seconds until the petals are mushy to eat.

MASSIMILIANO ALAJMO

WHOLE WHEAT BREAD

Symbol of sharing and peace, it holds the mysteries of the profession. The manuality turns into ritual and food into nutriment.
Yeast, with its generating function, confers flavor, form, and significance.
We serve bread in large formats, because the gustative development is higher; we tend to leave out condiments
and to keep the dough very hydrated, to better express the best of each kind of grain.
The bread container, made out of wood, is to elevate the bread, not hide it.

Makes 3 loaves

First Rise
3 cups (740 grams) water
2 tablespoons (40 grams) mature natural yeast, refreshed three times
1 teaspoon (2 grams) brewer's yeast
6½ cups (640 grams) bread flour
2¾ cups (360 grams) whole grain soft wheat flour
1½ cups (150 grams) all-purpose flour
1 cup (90 grams) rye flour
1 cup (90 grams) bran flour
½ cup (70 grams) buckwheat flour

Final Kneading
¾ cup (200 grams) water
About 1 teaspoon (4 grams) malt powder
¾ cup (70 grams) all-purpose flour
½ cup (60 grams) white pastry flour
2 tablespoons (30 grams) salt

For the first rise: Mix the water with the yeasts in a stand mixer with a dough hook attachment for 5 minutes, forming a foamy mass.

Add all the flours and work the mixture for at least 8 minutes until a smooth, compact dough is formed. Let the dough rise at 46°F for 8 to 10 hours.

For the final kneading: Place the risen dough in a stand mixer with a dough hook attachment and mix for 4 minutes. Add the water and malt powder and mix until the liquids are absorbed. Add both the flours and mix. Mix in the salt.

When the dough easily comes off the sides of the bowl, transfer it to a bucket and let it rise at 86°F with 30 percent humidity for 3 hours.

For the last rise: Form the dough into 3 balls. Sprinkle with white pastry flour and let them rise, covered, for 1 hour.

Preheat the oven to 450°F. Make crosshatches on the tops of the loaves and bake for 10 minutes. Reduce the temperature to 350°F and continue baking for another 40 minutes.

Hint: When making large quantities, the dough comes out best using a twin-arm mixer.

Suggestion: Rip up the bread right from the oven and drizzle it with just-pressed extra-virgin olive oil.

(From self-published book)

ALEX ATALA

RICE AND BEANS

Serves 4

Rice

1 small onion
Rapeseed oil
1 bay leaf
2 garlic cloves, minced to a paste
1 2/3 cups white rice (do not rinse)
2½ cups hot water
Juice of ½ lime
Salt

Beans

14 ounces dried red beans, picked over
Half a pig's foot, deboned
1¾ ounces bacon skin
1 bay leaf
3 1/3 cups water
2 tablespoons rapeseed oil
3 ounces bacon, cut into 1/16 × ¼-inch dice
1 medium onion, chopped
3 garlic cloves, minced
Salt and ground black pepper
Chopped fresh chives

To make the rice: Chop the onion until it turns into a paste. Heat a splash of oil in a medium saucepan.

Add the onion and bay leaf and stir for 2 minutes. Add the garlic and stir for another minute.

Add the rice and stir until coated and well heated. Add the hot water and the lime juice; season with salt to taste.

Cover the pan and leave it on high heat. As soon as it starts to boil, reduce the heat to low. Let it cook until all the water has been absorbed and the rice is tender, about 20 minutes.

To make the beans: Combine the beans, pig's foot, bacon skin, bay leaf, and water in a pressure cooker.

After the pan reaches pressure, cook the beans for 15 minutes (maintaining a steady hiss).

Remove the cover and continue to cook over medium heat until the broth thickens.

Heat the oil in a large skillet and cook the bacon until crisp. Add the onion and garlic and sauté for 10 minutes over low heat.

Add a soup ladle of the cooked beans with some broth to the skillet and let it cook for 2 more minutes. Transfer the contents of the skillet to the pressure cooker.

Season to taste with salt and pepper. Finish the dish with the chopped chives.

PAUL BARTOLOTTA

SPAGHETTI ALLE VONGOLE (SPAGHETTI WITH CLAMS)

Serves 4

8 ounces thick spaghetti
6 tablespoons extra-virgin olive oil
2 garlic cloves, sliced
1 pound manila clams (about 30)
Pinch of red pepper flakes
1 cup dry white wine
2 tablespoons chopped parsley
Salt

Bring a large pot of salted water to a boil. Add the spaghetti and cook until al dente, about 8 minutes.

Meanwhile, in a large skillet, heat 3 tablespoons of the oil over medium heat. Add the garlic and cook until translucent but not browned.

Add the clams, pepper flakes, and wine and cook until the alcohol has evaporated and reduced by half and the clams steam open.

When the pasta is ready, drain it and add to the clams. Toss gently, adding the parsley and the remaining 3 tablespoons of oil to finish.

Season with salt to taste and serve hot.

SHANNON BENNETT
TURBOT WITH PARSLEY VINAIGRETTE

A simple serving suggestion is steamed slices or chunks of fennel bulb, shaved raw baby beets, and steamed baby Yukon Gold potatoes tossed in a local inland salt (such as Hawaiian black salt) and butter.

Serves 4

1½-pound turbot, scaled and gutted
Salt and pepper
8 tablespoons butter
2 tablespoons apple cider vinegar
2 bunches flat-leaf parsley (about 6 cups), chopped

Season the turbot well with salt and pepper. Place the fish on a piece of parchment paper and enclose. Bake in a 350°F oven for 10 minutes or steam for 10 to 15 minutes in a bamboo steamer.

Test for doneness with a toothpick: If the toothpick moves through the flesh without resistance, it is ready; any hesitation means that it will need further cooking.

In a saucepan, heat the butter until it starts to foam. Reduce the heat to low and cook off the solids. Stir in the vinegar. Remove from the heat and transfer to a blender.

Add the parsley and blend until the sauce is green.

Season the sauce with salt and pepper and serve over the fish, with fennel, beets, and buttered Yukon Golds on the side.

DAVID McMILLAN
AND FRÉDÉRIC MORIN

(JOE BEEF)

LAPIN À LA MOUTARDE AUX LARDS FUMÉS (MUSTARD RABBIT AND BACON)

Mustard rabbit is a classic, almost basic recipe. It's a delicious and versatile dish that can be dressed up fancy style or real casual. I learned how to make it in a small restaurant near Meursault, Burgundy. Its simplicity and family-dinner appeal stay the course and have served me well over the years. I occasionally serve thin slices of chilled, jellied parsley ham on top of the hot rabbit, garnished with tiny crisp-fried fresh morels; sometimes I use the pulled meat of the mustard rabbit as stuffing for cabbage leaves—I call them, to the delight of my children, "cabbit" rolls! I hope you like this old recipe! Serve the rabbit with sides of buttered egg noodles or spaetzle, or fresh peas and ham, or morels and Parmesan on toast.—D.M.

Serves 4

3-pound rabbit, cut into 8 pieces
1 tablespoon flour
2 tablespoons olive oil
2 tablespoons butter
1 medium onion, finely diced
1 garlic clove, minced
½ cup strong Dijon mustard
2 cups hen broth
1½ cups white Burgundy wine
4 cups heavy cream (35% fat)
¼ cup Dolin dry vermouth
2 tablespoons mixed chopped chervil, tarragon, and parsley
Celery heart leaves, truffle, and fresh chives, for garnish (optional)
4 slices smoked bacon, chopped, for garnish (optional)

Preheat the oven to 375°F.

In a large bowl, dust the rabbit pieces with the flour until coated. In a large Dutch oven or cast-iron pot, heat the oil and sear the rabbit pieces until golden; remove and set aside.

Wipe out the Dutch oven and add the butter, onion, and garlic. Cook until golden. Return the rabbit to the pan and add the mustard, broth, and wine. Cover and bake for 45 minutes. Uncover and bake for 30 more minutes.

Transfer the rabbit pieces to a large oval enameled baking dish; Keep them warm.

Stir the cream and vermouth into the Dutch oven. Place the Dutch oven over heat and cook until the sauce coats the back of a spoon. Stir in the mixed herbs.

Pour the sauce over the rabbit. Garnish (if desired) and serve.

JOHN BESH

CRABMEAT RAVIGOTE

Serves 4 to 6

2 tablespoons sherry vinegar
1 tablespoon olive oil
1 tablespoon horseradish
1 minced shallot
2 tablespoon chopped chives
1 teaspoon sugar
Juice of 1 lemon
⅔ cup Blue Plate mayonnaise
1 teaspoon Zatarain's liquid crab boil
Dash of tabasco
Salt and fresh-cracked black pepper
1 pound jumbo lump crabmeat

In a bowl, mix the vinegar, oil, horseradish, shallot, chives, sugar, lemon juice, mayonnaise,
crab boil, tabasco, salt, and pepper.
Gently fold in the crabmeat.

HESTON BLUMENTHAL

ROAST POTATOES WITH GARLIC AND ROSEMARY

The secret to perfect roast potatoes is sharp corners (rounded potatoes will not get as crispy as those with right angles), then precooking the potatoes until they are almost falling apart. The generous amount of oil in the roasting pan makes for an extra-crispy crust.

Serves 6

2¾ pounds Maris Piper potatoes
Olive oil
8 cloves garlic, smashed with the blade of a knife
2 tablespoons (30 grams) rosemary
1 tablespoon (15 grams) thyme
Salt

Preheat the oven to 350°F.

Peel and quarter the potatoes. Place them in a bowl and put them under running water for 5 minutes to wash the starch off.

Transfer to a large saucepan with water to cover. Bring to a boil and cook until very soft and almost falling apart; drain gently into a colander and set aside to cool.

Pour ¼ inch of olive oil into a roasting pan large enough to hold the potatoes in a single layer. Add the potatoes and garlic to the pan and stir to coat them in the oil. Bake for at least 1 hour, gently turning every 20 minutes.

After 1 hour, add the rosemary and thyme to the pan and return it to the oven until the potatoes are golden brown and crispy all over, 15 to 20 minutes longer. Drain them on paper towels and season with salt.

PAUL BOCUSE

POT-AU-FEU

Leftovers from the pot-au-feu can be used for different dishes in the days to follow:
hachis Parmentier, stuffed tomatoes, jellied beef, and so on.
Preparation time: 4 hours

Serves 12

7 ounces (200 grams) steak bones
3 pounds (1.5 kilograms) beef shanks
1 pound (500 grams) beef ribs
1 pound (500 grams) flank steak
1 pound (500 grams) chuck steak
1 pound (500 grams) oxtails
1 pound (500 grams) veal shanks
Bouquet garni (made with bay leaves, parsley, chervil, thyme, and leek tops)
5 marrow bones, 1 to 1½ inches (3 centimeters) long
About 3 pounds (1.5 kilograms) poultry
Peppercorns
½ pound (250 grams) onions, studded with cloves

1 head garlic, peeled
10 ounces (300 grams) leeks
10 ounces (300 grams) carrots, peeled
2 celery heads
10 ounces (300 grams) round turnips, peeled
1 fennel bulb
1 parsnip, peeled
Coarse sea salt
1 pound (500 grams) sirloin steak
3 large tomatoes, quartered
Ground black pepper
Pickles, mustard, and toasted bread (for serving)

Place the steak bones in the bottom of a large stockpot. Then add, in order, the beef shanks, ribs, flank steak, chuck steak, oxtails, and veal shanks.

Add cold water to completely cover the meat. (Do not season with salt yet.)

Cook over a high heat without covering. After 20 minutes, use a ladle to skim off all the foam that has risen to the surface.

Reduce the heat and cook for another 20 minutes. While the meat is cooking, prepare the bouquet garni by tying together bay leaves, parsley, chervil, thyme, and leek tops.

Wrap the marrow bones in cheesecloth. Truss the poultry. Add the peppercorns and poultry to the stockpot. Then add the bouquet garni and the onions studded with cloves. Add the garlic, the leeks tied in a bundle, and the carrots, celery, turnips, fennel, and parsnip.

Skim once again, then allow to simmer for 1 hour. Season with salt. Take out the vegetables gradually as they cook, checking whether they are ready with the help of a pointed knife or a kitchen needle. Keep the vegetables warm, dousing them with two ladlefuls of broth.

Take out the poultry as soon as it is cooked, keeping it warm in the same way as the vegetables. Place the vessel contain-ing the vegetables and poultry on the stove at a low temperature.

Allow the meat to cook for another 30 minutes, skimming the broth from time to time, then remove the veal shanks, which should be kept warm with the vegetables and poultry.

Add the sirloin and attach it to the handle of the stockpot. Allow the remaining meats to cook gently for 1 hour.

Add the marrow bones and tomatoes. Do not forget to skim. Allow the sirloin to cook for 15 to 20 minutes, depending on its thickness.

Remove the remaining meats and arrange them on a serving platter.

To warm up the meats taken out first, immerse them in the hot broth for 5 minutes, then arrange them on the platter along with the vegetables and marrow bones.

Serve at the table with coarse sea salt, black pepper, pickles, and mustard. Serve the broth alongside in bowls accompanied by toasted bread.

Note: To embellish the meat and vegetables, you can also prepare a simple sauce made up of a soupspoonful of wine vinegar; four soupspoonfuls of walnut oil, sea salt, ground black pepper; and two soupspoonfuls of shredded chervil.

MASSIMO BOTTURA
TORTELLINI IN CAPON BROTH

There is a Modenese expression, La pasta bein mneda l'e meza tireda, *which means "Pasta dough, properly kneaded, is half rolled." It is very important to knead the dough well to create elasticity, but you need to do it quickly or else the pasta will dry out.*

Makes 50 tortellini

Pasta Dough
1½ cups pasta flour
½ teaspoon salt
3 egg yolks
1 egg

Filling
½ pound pork
½ pound veal
Olive oil
½ pound prosciutto from Modena (aged at least 24 months), finely chopped
2 ounces mortadella, finely chopped
10 ounces grated Parmigiano-Reggiano (aged 30 months)
Salt

Capon broth

To make the pasta dough: Sift the flour and salt onto a large work surface. Form a well and add the egg yolks and whole egg.

Mix the eggs with a fork, then work into the flour with your hands. Work the dough until it is smooth and even. Form it into a ball and cover it with a dish towel. Let it rest for 30 minutes.

To make the filling: Chop the pork and veal finely. In a skillet, cook the meats in a drop of olive oil until lightly browned, about 10 minutes.

Remove from the heat and set aside to cool. Then stir in the prosciutto and mortadella. Mix in the cheese.

Pass the mixture through a meat grinder a couple of times. Taste and add salt if needed.

Keep the filling cool while you roll out the pasta.

To make the tortellini: Roll out the dough on a wooden surface with a rolling pin. Turn the dough over often to get it as even and thin as possible.

Once the pasta is rolled out into a thin sheet, use a sharp knife to cut it into 1-inch squares.

On each square, place a drop of filling and close the square around your pinky finger to achieve the smallest tortellini possible.

Place them, one by one, in an orderly fashion on a cardboard tray. Work quickly or the pasta will dry out and become difficult to fold.

Freeze the tortellini for future use (up to 1 month) or keep them cool in refrigerator for up to 24 hours.

To cook the tortellini: In a large pot, bring a rich capon broth to a boil. Reduce the heat.

Add the tortellini slowly. When the tortellini begin to rise to the surface, turn off the heat; the tortellini should never be left floating in the broth for long.

Place the broth and tortellini in a tureen with a cover and ladle. Serve immediately.

CESARE CASELLA

MACCHERONCINI WITH TOMATOES, THYME, AND PECORINO

(MACCHERONCINI, POMODORI)

Serves 2

Sauce
6 tablespoons extra-virgin olive oil
6 cloves garlic, peeled and crushed
1 cup chopped red onion
1 carrot, chopped
1 stalk celery, chopped
½ teaspoon red pepper flakes
1 cup sliced fresh basil
3½ pounds plum tomatoes, cut into pieces
Salt
Ground black pepper

Maccheroncini
1½ tablespoons salt
12 ounces fresh egg pasta, cut into 2 × 2-inch squares
10 ounces sauce
1 tablespoon chopped fresh thyme
6 tablespoons grated Tuscan or Romano pecorino cheese
3 tablespoons extra-virgin olive oil

To make the sauce: In a large saucepan, heat the olive oil. Add the garlic, onion, carrot, celery, red pepper flakes, and ½ cup of the basil and cook over medium until the carrots are tender, about 25 minutes.

Add the tomatoes and cook for 40 to 50 minutes.

Add the remaining ½ cup of basil and remove from the heat. Transfer the mixture to a food processor and puree. Return the sauce to the saucepan and cook for another 30 minutes.

Season with salt and black pepper to taste. If the sauce seems too thick, add a little water.

To make the maccheroncini: Bring 3 quarts of water to a boil in a large pot.

Add the salt and the pasta squares and cook until very al dente. (If you use fresh pasta, it will only take a few minutes.)

Drain the pasta and return it to its pot along with the sauce, ¾ tablespoon of the thyme, and 1½ tablespoons of the pecorino. Mix and cook over medium heat for 3 minutes.

Add the olive oil and stir. Spoon the pasta onto plates and serve with the remaining thyme and pecorino sprinkled on top.

DAVID CHANG
MOMOFUKU FRIED CHICKEN

Serves 2 to 4

Pickled Chiles

1 cup water, piping hot from the tap
½ cup rice vinegar
6 tablespoons sugar
2¼ teaspoons kosher salt
4 cups Thai bird's-eye chiles or other small
(no longer than 2 inches) fresh hot chiles

Octo Vinaigrette

2 tablespoons finely chopped garlic
2 tablespoons chopped fresh ginger
¼ teaspoon finely chopped pickled chiles
(or 1 fresh Thai bird's-eye chile, seeded and chopped)
¼ cup rice vinegar
¼ cup usukuchi (light soy sauce)
2 tablespoons grapeseed or other neutral oil
¼ teaspoon toasted sesame oil
1½ tablespoons sugar
Freshly ground black pepper

Chicken

4 cups lukewarm water
½ cup sugar
½ cup kosher salt
1 whole chicken (3 to 3½ pounds), cut into 4 pieces
(2 legs, 2 breast halves with wings attached)
4 cups grapeseed or other neutral cooking oil

To make the pickled chiles: Combine the water, vinegar, sugar, and salt in a bowl and stir until the sugar dissolves.

Pack the chiles into a 1-quart container. Pour the brine over the chiles, cover, and refrigerate. You can eat the pickles immediately, but they will taste better after they've had time to sit—3 to 4 days at a minimum, a week for optimum flavor.

To make the octo vinaigrette: Combine the garlic, ginger, pickled chiles (or fresh chile), vinegar, soy sauce, grapeseed oil, sesame oil, sugar, and a few turns of black pepper in a lidded container and shake well to mix. This will keep in the fridge for 4 to 5 days and is good on everything except ostrich eggs, which is really more the ostrich's fault than the vinaigrette's.

To make the chicken: Combine the water, sugar, and salt in a large container with a lid or a large freezer bag, and stir until the sugar and salt dissolve. Add the chicken to the brine, cover or seal, and refrigerate for at least 1 hour and no more than 6.

Set up a steamer on the stove. Drain the chicken and discard the brine. Put the chicken in the steamer basket (if you are using a stacking Chinese-style bamboo steamer, put the legs in the bottom level and the breast on the top). Turn the heat to medium and set the lid of the steamer ever so slightly ajar. Steam the chicken for 40 minutes, then remove it from the steamer and put it on a cooling rack to cool. Chill it in the refrigerator, preferably on the rack, for at least 2 hours or overnight. Take the chicken out of the refrigerator at least 30 minutes before you fry it.

In a deep skillet, heat the oil (enough for the chicken to be submerged) to 375°F. Working in batches, fry the chicken, turning once, until the skin is deep brown and crisp, 6 to 8 minutes. Transfer to a paper towel–lined plate to drain.

Cut the chicken into serving pieces: Cut the wing from the breasts, cut the breasts in half, cut through the knee to separate the thigh from the drumstick. Put the pieces in a large bowl, toss with the octo vinaigrette, and serve hot.

(Reprinted from *Momofuku* by David Chang and Peter Meehan. Copyright © 2009. Published by Clarkson Potter, a division of Random House.)

ROY CHOI
SPICY RICE CAKES AND MARINATED SHORT RIBS

Serves 6 to 8

Short Rib Marinade
4 cups soy sauce
2 cups maple syrup
2½ cups sugar
2½ yellow onions, quartered
¾ bunch scallions, coarsely chopped
¾ cup garlic cloves, peeled
1 kiwifruit, peeled
½ Asian pear, peeled and cored
1 can (12 ounces) 7-Up
1 cup fresh orange juice
¾ cup mirin
¾ cup toasted sesame oil (pure)
½ cup toasted sesame seeds
1 teaspoon ground black pepper

Spicy Magic Sauce
12 cups short rib marinade
4 cups kochujang (Korean chili paste)
1 cup kochukaru (Korean chili flakes)
6 jalapeño peppers, halved
1 cup sugar
1 cup garlic cloves

2 cups short rib marinade
2 pounds boneless short ribs, cut into 2-inch squares
¼ cup canola oil
1 cup thinly sliced yellow onion
1 cup minced scallions
2 pounds rice cakes (rice ovalettes), soaked in warm water
for at least 5 minutes
2 cups Spicy Magic Sauce
1 heaping tablespoon butter
1 cup fresh peas
1 cup torn fresh perilla leaves or shiso leaves
Toasted sesame seeds
Cooked short-grain rice, for serving

To make Spicy Magic Sauce: Puree all the ingredients in a blender until smooth and well incorporated.

To make the short rib marinade: Puree all the ingredients in a blender until smooth and well incorporated.

Massage the marinade into the short ribs, imagining that the flavor is transferring from your hands to the meat as you massage. Marinate the short ribs in the marinade for at least 2 hours.

Heat a large skillet. Add the oil and then the onion and scallions and cook until slightly wilted and fragrant.

Drain the water from the rice cakes and add them to the skillet, mixing well. Add the Spicy Magic Sauce to the skillet.

In a separate pan or grill pan, cook the short ribs until they're medium-rare or charred on the outside but tender inside. Add to the rice cakes.

Fold in the butter and peas, and adjust with a splash of water. Bring to a slight bubble and reduce to a light simmer.

Finish with the perilla leaves and toasted sesame seeds. It will be blood red and thick like lava but radiant with colors and warmth. Serve over rice and begin your life.

TOM COLICCHIO

CLAMBAKE

Nobody knows much about the origins of the New England clambake, but there are a couple of things that I can say with certainty: that humans have been cooking in big holes in the ground since the first discovery of fire, and that we get too few opportunities to do it anymore these days.

My introduction to a proper New England clambake came in 2001 in Little Compton, Rhode Island. The father of my business partner, Katie Grieco, hosted an annual clambake at his house there, and he took the tradition seriously.

The process began on the beach in the morning at low tide. A dozen of us began by digging a pit the size of a compact car, lining it with a lattice of firewood and large rocks, which we then topped with a generous mound of firewood and kindling. That finished, we wandered down the beach to collect seaweed—rockweed, to be specific, a coarse, brown variety that forms air-pocketed tentacles. We hauled the rockweed back to our makeshift beach "kitchen" and kept it wet in a bucket of saltwater.

Someone lit the fire, and as we waited for it to burn down, we prepared our raw materials: clams, of course, and whole lobsters, corn (shucked down to one layer of husk), potatoes wrapped in tinfoil, and spicy sausages stuffed in paper bags.

The food was loaded into a great wire cage, and by this point, the rocks were red-hot, little radiators that, once coated in seaweed, would create enough briny steam to cook our feast through.

We swept the ashes down among the rocks, covered them in seaweed, lowered the cage into the pit, and sealed the whole thing with more seaweed and a big, wet canvas tarp. And then we waited.

When our dinner finally emerged from the pit about an hour later, it was to thoroughly whetted appetites. The food was spectacular, steamed to perfection and tasting of smoke and sea air.

TRACI DES JARDINS
TRACI'S TRUFFLE-STUFFED ROASTED CHICKEN

*For extra-crispy skin, prepare the chicken a day ahead and allow it to sit uncovered
in the refrigerator overnight before roasting.*

Serves 4 to 6

1 whole chicken (4 pounds), preferably free-range and organic
8 tablespoons (1 stick) unsalted butter, at room temperature
1 Périgord black truffle (about 2½ ounces)
3 teaspoons kosher salt
2 teaspoons ground black pepper
1 onion, quartered
1 lemon, quartered
2 cloves garlic
6 sprigs thyme
3 fresh sage leaves
2 bay leaves
Olive oil

Preheat the oven to 450°F.

Rinse the chicken and pat dry, inside and out, with paper towels. With the chicken breast-side up, fold back the chicken wings and tuck them beneath the body. From the bottom end of the chicken cavity, work your hands beneath the skin. Continue to separate the skin from the breast up to the neck, taking care not to tear the skin. Work your hands to the top part of the wing bone and around the thighs and down the legs. Rub 2 tablespoons of the butter beneath the skin and along the breast.

Using a mandoline, shave the truffle into ⅛-inch slices (reserve any scraps for other uses or slice very thinly by hand). Gently layer the truffle slices beneath the skin of the chicken, lining the breast.

Season the interior of the chicken cavity with 1 teaspoon of the salt and 1 teaspoon of the pepper. Stuff the cavity with the onion quarters, lemon quarters, garlic, thyme, sage, and bay leaves. Any truffle scraps can also be added.

Rub the remaining 6 tablespoons of butter on the exterior of the chicken, taking care not to shift the truffle slices beneath the skin. Season the exterior of the chicken with the remaining 2 teaspoons of salt and 1 teaspoon of pepper.

Roast the chicken on a rack until it is nicely browned, about 30 minutes. Reduce the oven temperature to 350°F and cook until the meat at the thickest part of the breast is 160°F, 30 to 40 minutes longer. Let the chicken rest for 20 minutes before serving.

TODD ENGLISH

SOUTHERN FRIED CHICKEN

Serves 4 to 6

Chicken

10 cups lard
1 pound smoked slab bacon
1 quart buttermilk
½ cup plus 3 tablespoons chopped parsley
1 roaster chicken (3 pounds), hacked into 8 pieces
1 cup all-purpose flour
Kosher salt
Ground black pepper
1 tablespoon Hungarian paprika
1 to 2 teaspoons cayenne pepper

Gravy

4 cups chicken stock
2 tablespoons butter
1 cup chopped onions
¼ cup bourbon
2 tablespoons all-purpose flour

To make the chicken: Melt the lard in a large and deep cast-iron skillet. Simmer the bacon in the lard for 30 to 40 minutes.

Remove the bacon from the lard and drain. When cool enough to handle, slice the crisped layer of fat off the bacon and cut the meat into ½-inch cubes; set both aside for the gravy.

In a large bowl, combine the buttermilk, ½ cup of parsley, and the chicken.

In a separate, shallow bowl, combine the flour, 1 teaspoon of salt, 1 teaspoon of black pepper, the paprika, and cayenne.

Remove the chicken from the buttermilk and dredge the pieces in the flour mixture for a generous coating. Place them back in the buttermilk, then back in the flour.

Heat the lard up to 250°F. Add the chicken, in batches if necessary, to the hot lard and cook at a gentle "rolling" boil for 15 to 20 minutes.

Turn the chicken and cook for 12 to 15 minutes on the other side. Remove the chicken from the pan with a slotted spoon and drain on paper towels. Season with salt and black pepper to taste.

To make the gravy: While the chicken is frying, heat the chicken stock in a medium saucepan.

In a separate medium saucepan, melt the butter over medium-high heat. Add the onions and cook until they begin to turn clear.

Add the reserved cubed bacon meat and the bourbon and cook for 2 to 3 minutes. Sprinkle with the flour, stir well, and cook for 4 to 5 minutes.

In 2- to 3-tablespoon batches, whisk the bacon roux into the chicken stock. Simmer to reduce by half, about 20 minutes.

To serve: Place the chicken pieces on a serving platter. Spoon the gravy over the top. Slice the reserved crisped bacon fat and scatter on top.

BOBBY FLAY

CAJUN BURGER

Serves 4

Rémoulade Sauce

½ cup mayonnaise
1 heaping tablespoon Dijon mustard
1 heaping tablespoon whole-grain mustard
½ teaspoon Frank's RedHot sauce
5 cornichons, finely diced
2 scallions, white and pale-green parts only,
finely chopped
Parsley
Kosher salt and freshly ground black pepper

Blackened Burger

1 tablespoon paprika
1 teaspoon dried thyme
½ teaspoon garlic powder
½ teaspoon onion powder
½ teaspoon cayenne pepper
Kosher salt and freshly ground black pepper
1½ pounds ground chuck
3 tablespoons canola oil
4 slices (¼-inch-thick) pepper Jack cheese
4 slices (¼-inch-thick) tasso ham
4 buns, split and lightly toasted
Frank's RedHot sauce

To make the rémoulade sauce: Whisk together the mayonnaise, both mustards, hot sauce, cornichons, scallions, and parsley in a small bowl.

Season with salt and pepper. Cover and refrigerate for at least 1 hour before serving to allow the flavors to meld.

To make the burgers: Stir together the paprika, thyme, garlic powder, onion powder, cayenne, 2 teaspoons of kosher salt, and 2 teaspoons of black pepper in a small bowl.

Form the meat into 4 patties. Season both sides of each patty with salt and pepper.

Season one side of each patty with the spice mixture, making sure to rub the spices into the meat.

In a cast-iron skillet or griddle pan, heat 2 tablespoons of oil over high heat until smoking.

Place the burgers in the pan and cook until slightly charred and the spices have formed a crust, about 1½ minutes (be careful not to burn the spices).

Turn the burgers over, reduce the heat to medium, and cook to the desired doneness, about 5 minutes longer for medium-rare. During the last minute of cooking, add 1 slice of cheese to the top of each patty.

Cover the pan or tent it with foil and cook until the cheese is completely melted. While the burgers are cooking, in a large skillet, heat the remaining 1 tablespoon of oil over medium-high heat until it begins to shimmer.

Add the ham and cook until crisp on both sides, about 20 seconds per side. Remove it to a plate lined with paper towels.

Spread some of the rémoulade sauce on the top and bottom of each bun. Transfer the burgers to the bottom buns, and top them with a slice of ham and a drizzle of hot sauce.

Place the bun tops on top and serve immediately.

DANI GARCÍA

COCONUT FRENCH TOAST WITH CHOCOLATE AND MINT

Serves 8

Mint Ice Cream
4¼ cups (1 liter) milk
1⅓ cups (338 grams) heavy cream
2 tablespoons (40 grams) inverted sugar (corn syrup)
7 large egg yolks
1¼ cups (254 grams) granulated sugar
2 ounces (60 grams) stabilizer
Mint leaves

Mousse
6 egg yolks
3 tablespoons (37 grams) granulated sugar
7 tablespoons (95 grams) milk
7 tablespoons (95 grams) heavy cream
7 teaspoons (50 grams) inverted sugar (corn syrup)
8 ounces (225 grams) 72% cacao coating chocolate
About 2 cups (450 grams) semi-whipped cream

Tubes
64% cacao chocolate

Coconut Cream
2 gelatin sheets or 2 teaspoons granules
5 egg yolks
About 12 ounces (½ liter) heavy cream
2 tablespoons (25 grams) sugar
2 ounces (60 grams) coconut gianduja, finely chopped

French Toast
11 ounces (312.5 grams) milk
11 ounces (312.5 grams) heavy cream
6 tablespoons (78 grams) sugar, plus more for the pan
1.5 ounces (47 grams) coconut gianduja
1 vanilla bean
4 slices (about ¾ ounce each) firm-textured bread,
preferably day old

To make the mint ice cream: In a saucepan, combine the milk, cream, and inverted sugar (corn syrup). Bring to a boil.

Add the egg yolks and sugar. Stir in the mint leaves and let cool for 24 hours. Strain and put through an ice-cream maker.

To make the mousse: Blend the egg yolks and granulated sugar together in a medium-size heatproof bowl.

In a small saucepan, combine the milk, cream, and inverted sugar (corn syrup) and bring to a boil.

Whisk the milk-cream mixture into the egg-yolk mixture. Add the chocolate. Let sit until cool. Gently fold in the semi-whipped cream. Chill until serving time.

To make the tubes: Melt the chocolate. Form it into tubes with the help of specialty plastic PVC tubes or cannoli tubes. Chill.

To make the coconut cream: Soak the gelatin in water. Place the egg yolks in a medium-size heatproof bowl. In a saucepan, combine the cream and sugar and bring to a boil.

Pour the cream over the egg yolks, then add the gelatin sheets. Pass through a fine-mesh sieve and let cool at room temperature.

To make the French toast: In a medium saucepan, combine the milk, cream, sugar, gianduja, and vanilla bean. Bring to a boil and cook for 5 minutes. Remove from the heat and let sit until the temperature gets below 150°F.

Cut the bread into cubes and soak them in the coconut milk, covered halfway, for 10 minutes. Turn the bread once and let sit for another 10 minutes, then take the pieces out, put them on a rack, and store at room temperature for at least 24 hours so they keep their shape and don't disintegrate.

Heat a little bit of sugar in a skillet and when it begins to brown, add the French toast and caramelize on both sides.

To assemble: Place a strip of coconut cream on the plate, a piece of caramelized French toast alongside it, with a mousse-filled chocolate tube and a small scoop of mint ice cream.

PETER GILMORE
SASHIMI OF HIRAMASA KINGFISH

Serves 8

Smoked Eel Brandade Pearls
2½ ounces smoked eel meat
About 1 cup milk
2½ ounces white-fleshed fish (cod or snapper)
4 tablespoons softened unsalted butter
About 3 tablespoons extra-virgin olive oil
Juice of ½ lemon
About 2 ounces mashed potato
Fine sea salt
¼ cup (30 grams) crème fraîche
About 2¼ cups (500 milliliters) grapeseed oil
About ½ cup (100 milliliters) strained egg whites

Tapioca Bundles
About 2 ounces (50 grams) smoked eel, sliced
About 2 cups (500 milliliters) chicken stock
3½ ounces (100 grams) tapioca pearls
Fine sea salt
1 tablespoon grapeseed oil, infused with ginger
and spring onion

Horseradish Cream
¾ ounce (20 grams) freshly grated horseradish
About 1 cup (200 milliliters) crème fraîche

Smoked Eel Flowers
7-ounce (200-gram) piece daikon radish
6 cups raw rice
Smoked Eel Brandade Pearls

Garnishes
8 stalks white celery, finely julienned
3 tablespoons (50 grams) castor sugar
13½ tablespoons (200 milliliters) apple cider vinegar
2 kohlrabi
32 Chinese artichokes
32 small nasturtium leaves

Octopus
About 1 pound (500 grams) octopus
Coarse sea salt
1 cup plus 3 tablespoons grapeseed oil,
infused with ginger and spring onion

Sashimi
About 2½ pounds (1 kilogram) Hiramasa kingfish fillet
14 tablespoons (200 milliliters) white soy
1 tablespoon grapeseed oil, infused with ginger
and spring onion

To make the brandade pearls: Make sure the smoked eel flesh is boneless and skinless. Bring the milk to the boil, remove from the heat and add the smoked eel. Allow the eel to soak in the warm milk for 10 minutes. Drain the eel and discard the milk.

In a steamer, steam the white fish until it flakes.

Mix the eel and flaked white fish in a small pot. Using a fork, mash the fish and eel together with 2 tablespoons of the butter. Drizzle 1½ tablespoons of the extra-virgin olive oil and the lemon juice onto the mixture. Mix well with the fork as you go. Add the mashed potato and mix well. Add the remaining 2 tablespoons of butter and 1½ tablespoons of olive oil and mix well. Season to taste with sea salt.

Allow the mixture to cool and then fold in the crème fraîche. Place the mixture in the refrigerator for at least 1 hour.

Take some of the mixture in the palm of your hand and roll until you have a ball about the size of a small marble. You will need 8 balls altogether. You may have some additional mixture left over, which you can use elsewhere.

Place the grapeseed oil in a small saucepan and heat to about 158°F (70°C).

Using an eye dropper, drop the strained egg whites into the oil, drop by drop in rapid succession. After you have about 30 egg white droplets, stop and gently stir them around. They need about 1 minute in the oil to set fully.

Carefully sieve out the egg white pearls using a fine strainer and place the pearls on a flat metal tray. Repeat this process several times, making sure you maintain the oil temperature at about 158°F until you have a sufficient amount of egg white pearls to coat 8 marble-size balls of brandade mixture.

To coat the brandade mixture, line 8 demitasse cups with 5 × 5-inch squares of plastic wrap. Place a teaspoonful of egg white pearls in the middle and spread them out.

Place a ball of brandade in the middle and carefully lift the four corners of the plastic together. The aim is to coat the brandade balls in the egg white pearls with the aid of the plastic wrap.

When you have 8 perfectly covered balls, leave them in the refrigerator until needed.

To make the tapioca bundles: Combine the smoked eel and chicken stock in a saucepan and bring to a boil. Reduce to a gentle simmer and cook for 10 minutes.

Strain the stock into a clean saucepan. Bring the stock back to a boil and stir in the tapioca. Cook the tapioca until its opaque starch has reduced to a very small dot, 7 to 8 min-

utes. Test the tapioca by tasting it; it should be soft but not mushy.

Strain the tapioca and discard the stock. Place the tapioca on a baking sheet, season with sea salt and the grapeseed infused oil.

Allow the tapioca to cool. When it's cool, form the tapioca into approximately 40 small bundles.

To make the horseradish cream: Stir the horseradish into the crème fraiche and season to taste.

To make the smoked eel flowers: Using a mandoline, slice the daikon radish into paper-thin slices. Using a 7/8-inch round cutter, cut rounds out of the slices.

In a small pot of boiling water, blanch the radish rounds for 2 seconds and refresh them in ice water. Pat dry. Spread the rice on a rimmed baking sheet to a depth of 1 inch.

Lay a 3-inch square of plastic wrap on the rice. Use your finger to create an impression in the center of the square to a depth of 3/4 inch. Place 5 daikon rounds in an overlapping circle on the plastic wrap. Press the rounds down in the center.

Using a piping bag, add a small dot of the horseradish cream in the center (save the remaining horseradish cream for assembling the dish later).

Unwrap the smoked eel brandade pearls and carefully place a pearl in the center. Repeat for the remaining brandade pearls. Place the tray in the refrigerator for the smoked eel flowers to set.

To make the garnishes: Lightly salt the celery and marinate it for 1 hour. Rinse the celery in cold water. Divide the celery into 16 small bunches. Twist each bunch into a spiral and set aside.

Dissolve the sugar in the vinegar. Peel the kohlrabi and slice on the mandoline to paper-thin slices. Cut the slices into 3/4-inch-wide strips. Place the strips in the vinegar mixture and marinate for 1 hour.

To make the octopus: Remove the tentacles from the body; you will only need the tentacles for this recipe. With some coarse sea salt, scrub the tentacles under running water. This will help to remove any slimy coating.

Once fully rinsed, remove the suckers with a sharp knife horizontally and then cut into small lengths.

Heat the infused oil in a small saucepan to 158°F (70°C). Poach the sliced octopus for about 1 minute. Remove the octopus and drain.

To make the sashimi: Remove the skin and most of the blood-line from the kingfish fillet.

(continued)

Cut the kingfish into 1-inch-wide slices across the fillet. You will need 6 slices per portion. Your slices should be approximately 2³/₄ inches (7 centimeters) long.

Briefly marinate the kingfish slices in the white soy, 10 seconds. Drain the slices and brush on the infused oil.

To assemble the plates: Squeeze out all the vinegar from the pickled kohlrabi. In the bottom of each serving bowl, place 2 teaspoons of horseradish cream.

Place a small bundle of pickled kohlrabi on top, and then 3 slices of the marinated sashimi kingfish.

Next, place another 2 teaspoons of horseradish cream on the kingfish, another small bundle of pickled kohlrabi, and then the other 3 slices of marinated kingfish.

Garnish each plate with 4 Chinese artichokes, 2 celery twists, 5 tapioca bundles, and 4 pieces of octopus.

Place a smoked eel flower in the center of the dish. Finally, garnish each with 4 nasturtium leaves and serve.

LAURENT GRAS
BOUILLABAISSE

Serves 6 to 8

Bouillabaisse
½ cup olive oil
1 pound white onions, sliced
½ pound leeks, white parts only, sliced
½ pound fennel, sliced
2 ounces garlic, chopped (about 1 head)
Sea salt
2 pounds tomatoes, diced
4 ounces tomato paste
½ cup pastis
2 dried fennel stalks
2 small chili peppers
4 strips of orange zest, blanched
Saffron, to taste
1 sar (1½ pounds)
1 pageot (1½ pounds)
2 rascasses (1½ pounds)
1 grondin (1½ pounds)
1 John Dory (2 pounds)
4 large Yukon Gold potatoes, peeled
and cut into ½-inch slices
2 spiny lobsters (1½ pounds each)
1 pound mussels, scrubbed and debearded

Rouille
2 cloves garlic, peeled
1 egg yolk
Saffron
Sea salt
½ cup olive oil

Croutons
Baguette
Olive oil

To make the bouillabaisse: In a big pot, heat the olive oil. Add the onions, leeks, fennel, and garlic and season with salt. Cook over medium heat until tender.

Add the tomatoes and let simmer slowly to get to a marmalade consistency.

Add the tomato paste, pastis, fennel stalks, chili peppers, orange zest, and saffron and cook for another 20 minutes over low heat. Let cool completely.

When they're cold, place the vegetables in the pot that will be used to cook the bouillabaisse. Add the sar, pageot, rascasse, grondin, John Dory, and the potatoes and coat with the cooked vegetables. Cover with plastic wrap and let sit overnight.

Cover the bouillabaisse with water, and season with salt. Bring to a boil over high heat, skim often, and lower the heat.

Split the spiny lobster, remove the vein, and add the lobster to the pot along with the mussels. When cooked, place all the seafood on a platter and keep warm. Discard the dried fennel stalks and orange zest. Blend the cooking liquid, season properly, and pass it though a fine chinois. Keep hot until needed.

To make the rouille: With a mortar and pestle, pound the garlic to a paste. Add the egg yolk, saffron, and salt. Add the olive oil and mix until it gets to a mayonnaise consistency.

To make the croutons: Slice the baguette and rub it with olive oil. Toast on both sides.

Fish and shellfish are tableside service. Cover with the bouillon. Serve the croutons and rouille on the side.

DANIEL HUMM

HERB-ROASTED LAMB WITH ZUCCHINI AND MINT

Serves 4

Pickled Mustard Seeds
½ cup mustard seeds
1 cup white balsamic vinegar
2 teaspoons salt
1 teaspoon sugar

Brown Butter
1½ pounds butter
5 sprigs thyme
2 cloves garlic, crushed but kept whole

Lamb Jus
10 pounds lamb bones, cut into 2-inch pieces
¼ cup canola oil
4 cups sliced Spanish onions
2 cups diced carrots
2 cups diced celery
2 cups diced leeks
2 heads garlic, peeled and separated into cloves
½ cup tomato paste
4 cups red wine
2 bay leaves
10 sprigs thyme
25 black peppercorns
4 gallons chicken stock

Lamb Sauce
2 cups lamb jus
2 sprigs mint
2 tablespoons rendered lamb fat (see note)
3 tablespoons pickled mustard seeds
½ teaspoon salt

Lamb
2 lamb loins (2½ pounds)
2 teaspoons salt
1 tablespoon canola oil

Ratatouille-Stuffed Squash Blossoms
4 medium zucchini
3 tablespoons olive oil
3 cloves garlic, crushed but kept whole
6 yellow bell peppers, peeled and diced
3 sprigs thyme
6 red bell peppers, peeled and diced
1½ teaspoons salt
1 teaspoon fresh lemon juice
8 squash blossoms

For Assembly
Fleur de sel
2 tablespoons butter

To make the pickled mustard seeds: Bring a medium saucepan of water to a boil. Add the mustard seeds and boil for 30 seconds. Drain the seeds in a sieve and rinse well under cold water. Transfer to a medium bowl.

Bring the vinegar, salt, and sugar to a boil in a small saucepan over medium heat. Pour the liquid over the mustard seeds and let cool at room temperature. Cover and leave at room temperature overnight.

To make the brown butter: Place the butter in a medium saucepan over medium heat. Simmer for about 40 minutes. At this point, the butter should be clear and a light caramel color. Continue to simmer the butter and whisk vigorously until the color is walnut brown.

Place the thyme and garlic in a chinois lined with cheesecloth. Strain the browned butter over the thyme and garlic. Store in the refrigerator until ready to use.

To make the lamb jus: Preheat the oven to 375°F. Spread the lamb bones in a single layer on 2 large rimmed baking sheets and roast until golden brown, 1 hour to 1 hour, 15 minutes; turn the bones after 30 minutes.

In a 6-quart pot, heat the oil over high heat. Add the onions, carrots, celery, leeks, and garlic and cook until they caramelize, 10 to 15 minutes.

Add the tomato paste and stir until caramelized, 5 to 7 minutes longer. Add the red wine and cook until reduced to a syrup consistency.

Tie the bay leaves, thyme, and peppercorns in cheesecloth. Add the sachet and bones to the pot and cover with the chicken stock. Bring to a simmer over medium heat and skim the stock of all impurities and fats that rise to the top. Simmer over low heat, uncovered, for 4 hours, skimming every 30 minutes.

Strain through a fine-mesh chinois and return to the pot. Cook over medium heat, simmering, not allowing to boil. Skim every 30 minutes. Reduce to 4 cups. Strain again and chill over ice. Reserve in the refrigerator.

To make the lamb sauce: Heat the lamb jus in a small saucepan. Remove from the heat, add the mint, and steep for 5 minutes. Strain, and stir in the rendered lamb fat and pickled mustard seeds. Season with salt.

Note: To render the lamb fat, grind the lamb fat in a meat grinder or have this done by your butcher. Place the lamb fat and 1/4 cup of water in a medium pot over low heat. Render the fat, making sure not to achieve any color. Once all the water has been cooked out and the fat is completely rendered, strain through a fine-mesh chinois.

To make the lamb: Trim all but 1/4 inch of the external fat from the lamb. Season all sides of the loins with the salt.

In a large sauté pan or skillet, heat the oil over medium-high heat. Sear the lamb, fat-side down, and continue to render the fat for 6 to 8 minutes, depending on the amount of fat. Quickly flip the lamb and sear the other side. Remove from the skillet and place on a roasting rack, fat-side up. Roast in the oven for 15 minutes or until meat thermometer registers 135°F. Remove from the oven and allow it to rest for 15 minutes.

To make the ratatouille-stuffed squash blossoms: Cut the peel off the zucchini, leaving 1/16 inch of flesh attached. Discard the center and seeds. Dice the strips of zucchini (1/8 inch).

In a small skillet, heat 1 tablespoon of the oil with 1 clove of garlic. Once the garlic begins to sizzle, add the diced yellow bell pepper and 1 thyme sprig and sauté for 1 minute. Remove from the pan and cool over ice. Discard the garlic. Repeat this process for the red bell pepper and zucchini, using the remaining oil, garlic, and thyme.

Once all the vegetables have been sautéed and cooled, mix them together and season with the salt and lemon juice.

Remove the stamens from the insides of the squash blossoms. Carefully pull back the tips of the blossoms and fill with 1 1/2 tablespoons of the zucchini-pepper filling.

To assemble the dish: Trim the ends off the roasted lamb. Slice them down the center lengthwise and crosswise, yielding 4 strips from each loin that are approximately 3 inches by 3/4 inch. Brush them with the brown butter and sprinkle them with fleur de sel.

In a large sauté pan, warm the 2 tablespoons of butter over medium heat until it begins to foam. Add the ratatouille-stuffed squash blossoms and baste with the butter until warm in the center.

Place a strip of lamb on the plate and place one squash blossom next to it. Finish each plate with the lamb sauce.

DAN HUNTER

VINE-SMOKED FLOUNDER WITH GARLIC AND CIDER

Serves 4

2 cups good olive oil
½ cup cider vinegar
1 garlic clove
Red gum or other dense wood that will create dense, hot embers
Dried grape vines
2 whole flounder (1¾ to 2 pounds each)
Sea salt

In a food processor, combine the oil, vinegar, and garlic. Process until the garlic is smooth and the oil and vinegar have emulsified.

Prepare the grill. Make a fairly large wood fire about 45 minutes before you want to cook the fish, so that it has enough time to burn down to a bed of hot red embers. (It is important that when you cook over wood, you do so with red embers. The smoke from unburnt wood has a bitterness that can taint the flavor of the food, so it is necessary that you have enough heat in the embers. And adding fresh wood to the grill during the cooking process can create a bitter smoke.)

Once the flames have died down and the grill is hot, cover the embers with grape vines, which will create a sweeter smoke.

Using scissors, cut all the fins from the fish (these have the potential to burn if they are left on). Using a pastry brush, "paint" the entire fish with the dressing. Place the fish on the grill, top-side down.

Allow the fish to slowly cook through about 80 percent without turning it. This will allow the skin to caramelize. While the fish is cooking, baste it with the dressing every couple of minutes. After about 10 minutes, carefully turn the fish, baste it again, season it with sea salt, and serve.

DAVID KINCH
ABALONE MEUNIÈRE STYLE WITH SEAWEED PERSILLADE

Serves 4

Persillade
6 tablespoons extra-virgin olive oil
1 small onion, finely diced
1 small clove garlic, finely chopped
1 cup "laitue de mer" dried seaweed, soaked in cold water and well rinsed
1 tablespoon capers, finely chopped
Salt
1 tablespoon champagne vinegar
Lemon zest

Abalone
1 large live California abalone (about 1 pound)
Sake
Light soy sauce
Sea salt

To make the persillade (this can be done a day in advance): In a skillet, heat 2 tablespoons of the oil over low heat. Add the onion and sauté, stirring occasionally; make sure it doesn't color. Add the garlic and continue to cook and stir until the onion is completely soft.

Remove the mixture from the pan and let cool in a bowl.

Chop the seaweed fairly fine and stir into the cooled onion mix along with the capers. Taste to see if it needs a pinch of salt (it might not need it because of the capers and the natural salinity of the seaweed).

Add the vinegar, lemon zest, and remaining 4 tablespoons of oil. It should have the consistency of a loose paste.

To make the abalone: Grab the abalone by the shell and scrub the abalone itself with a new steel-wool scrub pad while holding the abalone under running water. You want to try to remove as much of the slime as possible. Be a bit gentle around the skirt of the abalone. Rinse well.

Place the abalone in a pot and cover with cold water by several inches. Put the pot over medium heat and bring the water to a simmer. Skim any impurities that gather on the surface.

Remove the abalone from the pot (reserve the cooking water) and remove the meat from the shell. It should almost slide out of the shell, but if there is a bit of resistance, gently scoop the muscle out with a spoon. Remove the liver and the membrane surrounding the foot on the bottom of the abalone with a pair of scissors. Reserve the liver.

Put the abalone back in the cooking water and return to a simmer. Season the water at this point with sake—about 1 cup per liter of water—a little bit of soy, and a pinch of salt. Do not make it too salty, as the liquid will reduce over time.

Gently simmer the abalone until tender, about 4 hours. Let cool to a warm temperature in the liquid. If the liquid has been seasoned properly, it will be superb in its own right. You may completely chill the abalone in the liquid and gently reheat it if you want to cook the abalone in advance, but it is at its best when it has just finished simmering.

Peel the membrane off the liver and puree it on a flat surface using the side of a chef knife. Add the puree the persillade and stir.

Cut the abalone into thin slices. Add a couple of spoonfuls of the persillade and toss to coat evenly.

EMERIL LAGASSE
BARBECUED SHRIMP AND ROSEMARY BISCUITS

Serves 4 to 6

Shrimp
2 pounds medium (21 to 24 count) shrimp in their shells
1 tablespoon Emeril's Original Essence
or Creole Seasoning
½ teaspoon ground black pepper
1 tablespoon vegetable oil
1 cup heavy cream
¼ cup Barbecue Sauce Base
2 tablespoons unsalted butter, cut into pieces
Rosemary Biscuits

Creole Seasoning
Makes ⅓ cup
2 tablespoons plus 1½ teaspoons paprika
2 tablespoons salt
2 tablespoons garlic powder
1 tablespoon ground black pepper
1 tablespoon onion powder
1 tablespoon cayenne pepper
1 tablespoon dried oregano
1 tablespoon dried thyme

Shrimp Stock
Makes 3 quarts
1 pound shrimp shells and heads
1 cup coarsely chopped yellow onions
½ cup coarsely chopped celery
½ cup coarsely chopped carrots
3 garlic cloves, peeled and smashed
3 bay leaves
1 teaspoon black peppercorns
1 teaspoon dried thyme
2 teaspoons salt

Barbecue Sauce Base
Makes about ½ cup
1 tablespoon olive oil
½ cup finely chopped yellow onion
1 teaspoon salt
1 teaspoon coarsely ground black pepper
3 bay leaves
1 tablespoon minced garlic
3 lemons, peeled, white pith removed, and quartered
½ cup dry white wine
2 cups Shrimp Stock
1 cup Worcestershire sauce

Rosemary Biscuits
Makes 12 mini biscuits
1 cup all-purpose flour
1 teaspoon baking powder
½ teaspoon salt
⅛ teaspoon baking soda
3 tablespoons unsalted butter
½ to ¾ cup buttermilk
1 tablespoon minced fresh rosemary

To make the shrimp: Peel and devein the shrimp, leaving only their tails attached. (Reserve the shells, if desired, to make the shrimp stock.)

Season the shrimp with the Essence and black pepper, tossing to coat evenly. Cover and refrigerate while you make the barbecue sauce base and the rosemary biscuits.

In a large skillet, heat the oil over high heat. Add the seasoned shrimp and cook, stirring, until they begin to turn pink, about 2 minutes.

Add the cream and barbecue sauce base. Reduce the heat to medium high and simmer, stirring, until reduced by half, about 3 minutes.

Transfer the shrimp to a platter with tongs. Gradually whisk the butter into the sauce. Remove from the heat.

Place 2 or 3 biscuits on each plate. Divide the shrimp among the biscuits and top each serving with $1/3$ to $1/2$ cup of the sauce. Serve hot.

To make the creole seasoning: Combine all the ingredients thoroughly and store in an airtight container for up to 3 months.

To make the shrimp stock: Place the shrimp shells and heads in a large colander and rinse under cold running water.

Place all the ingredients in a heavy 6-quart stockpot. Add 1 gallon of water to cover, and bring the mixture to a boil over high heat, skimming with a slotted spoon to remove any foam that rises to the surface.

Reduce the heat to medium-low and simmer for 45 minutes.

Remove the stock from the heat and strain through a fine-mesh sieve. Store the stock in an airtight container for up to 3 days, refrigerated, or freeze for up to 2 months.

To make the barbecue sauce base: In a medium, heavy saucepan, heat the oil over medium-high heat. Add the onion,

salt, pepper, and bay leaves, and cook, stirring, until the onions are soft, about 2 minutes.

Add the garlic, lemons, and wine, and cook for 2 minutes. Add the shrimp stock and Worcestershire sauce and bring to a boil over high heat.

Reduce the heat to medium-low and simmer until the sauce is reduced to $1/2$ cup, about 1 hour 15 minutes.

Strain the sauce through a fine-mesh sieve, pressing on the solids with the back of a spoon. Set aside until needed. The sauce base can be refrigerated in an airtight container for up to 3 days, or frozen for up to 2 months.

To make the rosemary biscuits: Preheat the oven to 400°F. Sift the flour, baking powder, salt, and baking soda into a large bowl.

Work the butter into the flour with your fingers or a fork until the mixture resembles coarse crumbs.

Add $1/2$ cup of buttermilk, a little at a time, using your hands to work it in just until thoroughly incorporated and a smooth ball of dough forms.

Add up to $1/4$ cup more buttermilk if the mixture is too dry. Be very careful not to overwork or overhandle the dough, or the biscuits will be tough.

On a lightly floured surface, pat the dough into a circle about 7 inches in diameter and $1/2$ inch thick. Using a 1-inch round cookie cutter, cut out 12 biscuits.

Place the biscuits on a large baking sheet. Bake until golden on top and lightly browned on the bottom, 10 to 12 minutes. Serve warm.

SUSUR LEE

HONG KONG–STYLE WONTON NOODLE SOUP

Serves 8

Wontons

1 pound ground pork (not lean)
1 pound shrimp, peeled, deveined, and finely chopped
(or 1 pound frozen peeled shrimp, thawed and finely chopped)
5 to 6 strands yellow chives, chopped
1 piece fresh ginger, peeled and minced
1 tablespoon soy sauce
1 tablespoon black rice vinegar
1 teaspoon toasted sesame oil
Pinch of salt
Pinch of ground black pepper
Flour, for dusting
1 package wonton skins (about 50), thawed if frozen
1 egg, lightly beaten

Soup

1 pound pork bones
1 piece fresh ginger, peeled and sliced
1 large chicken thigh (or 2 quarts chicken broth)
2 ounces dried shrimp
8 ounces egg noodles
50 wontons
5 to 6 strands yellow chives, chopped

To make the wontons: Thoroughly mix the pork, shrimp, yellow chives, and ginger in a large bowl. Add the soy sauce, vinegar, sesame oil, salt, and pepper. The filling will be sticky and slightly wet.

Lightly dust a work surface with flour and keep some extra flour within hand's reach.

Angle a wonton skin so that it faces you like a diamond. With your fingertips or a spoon, spread a thin layer of beaten egg along the top two edges of the wrapper.

Place a quarter-size spoonful of filling in the center of the skin. Fold it over.

Place the finished wonton on a plate. Keep the wontons covered with a damp towel to prevent them from drying out.

Repeat folding until the filling or wrappers are used up. If you're making wontons ahead of time (or if you don't need all of these), they can be frozen.

To prepare the soup: Combine the pork bones and ginger in a large pot. Add the chicken thigh and 2 quarts water (or the chicken broth, omitting the water).

Simmer for 2 hours, adding the dried shrimp in the last 20 minutes. Strain out the solids.

Bring the broth to a boil. Add the noodles and cook until al dente, 3 to 5 minutes, depending on the thickness of the noodles.

Meanwhile, in a separate pot, bring 2 quarts water to a boil. Add the wontons and simmer uncovered, stirring gently, until done, 4 to 7 minutes. (Trick of the trade: When the dumplings float to the top, that usually means they're done. Unless there is too much air inside the wontons because of bad folding.) Cut one open to check for doneness.

Divide the soup and noodles into serving bowls. Add 5 or 6 wontons per bowl. Garnish with the chives and serve hot.

PAUL LIEBRANDT
COD CROQUETTES

Makes 40 croquettes

½ pound (200 grams) salt cod
½ pound (200 grams) Yukon Gold potatoes, cooked and riced
2 tablespoons (20 grams) lime zest
About 1 teaspoon (4 grams) Activa RM
1 teaspoon (5 grams) finely minced tarragon
1½ ounces (40 grams) cooked foie gras
3 cloves (10 grams) garlic, pureed
Salt and pepper to taste
1 egg, beaten
About 1 cup dried potato flakes
Oil, for deep-frying
Malt vinegar

Mix the salt cod, potatoes, lime zest, Activa RM, tarragon, foie gras, garlic,
salt and pepper together to form a paste. Keep very cold.

Roll into small round balls. Dip the balls in the egg and roll in the dried potato flakes.
Let set in refrigerator for at least 1 hour or up to 8 hours.

In a large stockpot, heat 1 inch of oil to 350°F over medium heat.
Fry 15 to 20 croquettes at a time until golden, 1 minute. Season with malt vinegar.

Note: You may wish to soak the salt cod in water before using.

BARBARA LYNCH
SWEETBREADS WITH CHESTNUT CREAM

Serves 4 to 6

Sweetbreads

2¼ pounds veal sweetbreads
3 carrots, cut crosswise into ½-inch slices
2 stalks celery, quartered
1 large white onion, cut into eighths
2 sprigs flat-leaf parsley
2 sprigs thyme
1 bay leaf
6 whole black peppercorns
Kosher salt and ground black pepper
⅓ cup all-purpose flour
8 tablespoons (1 stick) unsalted butter

Chestnut Cream

1½ cups fresh chestnuts
1 slice bacon, diced
¼ cup diced carrot
¼ cup peeled, diced celery (reserve any tender
celery leaves for garnish)
¼ cup diced onion
¼ cup peeled, diced parsnip
½ cup port, preferably ruby port
½ cup heavy cream
2 cups chicken broth (or water)
Kosher salt and ground black pepper

1½ teaspoons unsalted butter
2 tablespoons peeled, finely diced Granny Smith apple
Fleur de sel

To prepare the sweetbreads: Put the sweetbreads in a bowl and cover with cold water; refrigerate overnight.

Drain the sweetbreads, pat dry, and transfer to a 6-quart pot with 12 cups of water. Add the carrots, celery, onion, parsley, thyme, bay leaf, and peppercorns. Season with salt and pepper to taste, cover, and bring to a boil. Uncover, reduce to a simmer, and cook until tender, about 10 minutes. Set a fine strainer over a 5-quart pot and drain the sweetbreads. Peel the membrane from the sweetbreads and pat dry; refrigerate.

To make the chestnut cream: Preheat the oven to 350°F. With a paring knife, score the chestnuts with an X on their flatter side and roast them on a baking sheet until the spot where they've been scored opens up, about 15 minutes.

Let the chestnuts cool just until you can handle them and peel away the shell as well as the inner skin, which can be bitter. Reserve 3 of the chestnuts and chop the rest.

In a medium saucepan, cook the bacon over medium heat until crisp. Add about half of the carrot, celery, onion, and parsnip (reserve the rest for serving) and cook, stirring often, until tender and just slightly colored, 6 to 8 minutes.

Add the chopped chestnuts and the port, increase the heat to medium-high, and cook until the wine is reduced by half. Add the cream and the broth and simmer until the vegetables are very tender and the flavors combined, about 40 minutes.

Transfer the mixture to a blender and puree until smooth. Pass it through a fine-mesh strainer into a clean saucepan, pressing on the solids with a ladle. Season to taste with salt and pepper. If it's too thick, thin it with a little water and taste it again for seasoning. Keep warm if serving right away.

To sauté the sweetbreads: Season the sweetbreads with salt and pepper. Put the flour in a shallow dish and add the sweetbreads, tossing to coat. Shake off the excess flour and transfer them to a rack set in a rimmed baking sheet.

Melt 4 tablespoons of butter in a 12-inch skillet over medium heat. Add half of the sweetbreads and cook, turning once, until golden brown, about 5 minutes. Transfer to a paper towel–lined plate to drain. Repeat with another 4 tablespoons of butter and the remaining sweetbreads.

Meanwhile, just before serving, finely slice the reserved chestnuts. Melt 1½ teaspoons of butter in a small skillet over medium heat.

Add the reserved vegetables, apple, and sliced chestnuts and cook, stirring, until just tender, 1 to 2 minutes. Season this "vegetable brunoise" to taste with salt and pepper.

To assemble: Spoon the chestnut cream onto the center of each plate and arrange the sweetbreads on top. Finish with the vegetable brunoise, the reserved celery leaves, and fleur de sel and serve.

GUALTIERO MARCHESI

A BRILLIANT IDEA: RICE WITH CUTTLEFISH INK

Carnaroli rice
Light fish stock
Cuttlefish ink
Extra-virgin olive oil
Grated pecorino cheese
Silver flakes

Cook the Carnaroli rice in a light fish stock and add a little cuttlefish ink.
Fold a drizzle of extra-virgin olive oil and grated pecorino cheese into the rice.

Spread the risotto on a plate and sprinkle with silver flakes.

GEORGE MENDES

DRY-AGED RIBEYE STEAK WITH RED WINE–BLACK TRUFFLE SAUCE

Serves 4

Red Wine–Black Truffle Sauce
1 pound beef trimmings
2 tablespoons canola oil
2 tablespoons unsalted butter
½ cup peeled and sliced onion
½ cup peeled and sliced carrot
½ cup peeled and sliced celery
3 garlic cloves, crushed
1 tablespoon black peppercorns
1 tablespoon tomato paste
¼ cup brandy
1 cup red wine
2 cups veal stock
1 tablespoon fresh black truffles, minced (or canned, if not in season)

Steak
4 dry-aged ribeye steaks, cut into 12-ounce portions
Sea salt
2 tablespoons canola oil
2 tablespoons unsalted butter
4 sprigs fresh thyme
2 shallots, minced

To make the red wine–black truffle sauce: In heavy-bottomed sauce pan, caramelize the beef trimmings in 2 tablespoons of canola oil. Add the butter, then all the vegetables and peppercorns. Add the tomato paste and cook 1 minute more. Deglaze with the brandy and then add the red wine. Reduce by half.

Next, add the veal stock and cook slowly for 1½ to 2 hours on simmer, skimming the impurities that surface.

Then pass the sauce through a fine-mesh sieve or chinois. Adjust the seasoning, then add the truffles. Keep warm.

To cook the steak: Heat a heavy black cast-iron pan over medium-high heat. Season the ribeye on all sides with the sea salt. Add the canola oil to the pan and sear the steak first on the outer edge where thin layer of fat is, to render. Then cook on both sides over high heat to achieve a nice sear or char.

Continue cooking until the desired doneness is reached. Add the butter, thyme, and minced shallot. Baste over low heat for 2 minutes. Remove from the pan and let the steak rest on a wire rack for half the time it took to cook.

Serve along with the sauce and a vegetable of choice, such as a potato gratin or puree or root vegetables.

MORIMOTO
MISO SOUP

Serves 4

1 piece (4 × 6 inches) rishiri kombu
4 cups filtered water
½ cup dried bonito flakes
4 tablespoons miso paste
Half pack silken tofu (6 ounces), cut into small cubes
2 scallions, chopped

Wipe the piece of rishiri kombu softly with a wet towel to remove any grit off the kombu (but leave the white powder that contains the source of umami).

Place the kombu in a medium saucepan and add the filtered water. Let it sit overnight at room temperature.

Next day, remove the kombu and discard. Bring the water to a boil over medium heat. When it boils, remove it from the heat and add the bonito flakes. Leave it until the flakes sink to the bottom, 15 to 20 minutes.

Strain the dashi (stock) through a cheesecloth-lined sieve into a clean saucepan.

Bring the dashi to a simmer over medium heat. Stir the miso paste into the dashi and add the tofu.

Continue to simmer, but as soon as it comes to a boil, remove it from the heat immediately.

Add the scallions and serve in individual bowls.

PATRICK O'CONNELL
HOW TO MAKE A CUP OF TEA

The Japanese say that if you can serve tea, you can do anything. I've always loved this sentiment because so often in life—especially in the kitchen—the simplest tasks are often the most difficult. You might ask, "Why is this?" Because these small details require the most mindfulness and they are often given the least. Ironing a shirt, for example, is a transformative process requiring total mental and physical concentration. The same with sweeping the floor. There should be no room for another thought in the mind while one is engaged in such an activity. Total immersion can be wonderfully therapeutic and provides a kind of working meditative state.

We have a small sign above the tea station in our restaurant with instructions for making tea.

Hot the pot: Add boiling water to the teapot and let rest 1 minute while measuring the tea.

Measure loose tea carefully and place in a tea ball or strainer. Dump the water out of the pot. Add the tea and fill the pot ²/₃ full with boiling water (for black tea). Green tea is best brewed with 180°F water.

Using a timer, allow black tea to brew for 4 to 5 minutes and green tea 1 to 2 minutes.

Remove the leaves and pour the tea mindfully into hot cups—thinking to yourself that everything is going to be all right. And it will be.

ENRIQUE OLVERA
MOLE NEGRO

Makes 5 quarts

20 chilhuacle negro chiles
7 mulato chiles
7 pasilla chiles
15 smoked mora chiles (chipotle mora)
9 ounces (250 grams) lard
2 cups (250 grams) sesame seeds
1¾ cups (250 grams) raw peanuts
2 cups (250 grams) almonds
¾ cup (125 grams) creole nuts
1 cup (125 grams) cashew or other nuts
2 cups (250 grams) raisins
1¼ cups (250 grams) plantain
2 slices bread
1 large (250 grams) roasted white onion
2 garlic cloves, peeled and roasted
1 cinnamon stick
½ teaspoon black pepper
½ teaspoon ground cloves
½ teaspoon ground cumin
½ teaspoon fresh or dried thyme leaves
½ teaspoon fresh or dried marjoram
4 bay leaves
9 ounces (250 grams) oaxaqueño chocolate
1¼ cups (250 grams) brown sugar
Salt, to taste
1 tablespoon ground ginger
1 tablespoon ground nutmeg

Remove and reserve the seeds from the chilhuacle negro, mulato, and pasilla chiles. Put all the chiles in a large bowl and cover with warm water. Let soak for 1 hour. Drain and reserve the liquid.

Meanwhile, in an ungreased skillet, toast the chile seeds until brown. Set aside.

In a saucepan, melt about 6 ounces of the lard. Cook the following ingredients separately: sesame seeds, peanuts, almonds, creole nuts, cashews, raisins, plantain, bread, roasted onion, and garlic. Mix them together.

In another saucepan, heat about 3 ounces of the lard until it smokes. Add chiles and the nut mixture. Add the reserved soaking liquid slowly to avoid burning.

Add the cinnamon stick, black pepper, cloves, cumin, thyme, marjoram, bay leaves, chocolate, brown sugar, salt, ginger, and nutmeg. Cook for 3 hours.

MARTHA ORTIZ
NATIONALISTIC GUACAMOLE

Serves 2

6 tablespoons chopped white onion
11 tablespoons fresh lime juice
10 ounces avocado flesh
About 2 cups chopped cilantro
5 tablespoons deseeded and chopped serrano chiles, or to taste
Salt
1 tablespoon pomegranate seeds
1 tablespoon requesón
2 pieces dried chile de árbol, fried
Homemade *totopos* (fried tortilla chips)

Combine the onion and lime juice in a bowl and let sit for 30 minutes to "mellow" the onion. Drain and set the onion aside.

Carefully mash the avocado in a bowl or *molcajete.*

Blend in the cilantro, the mellowed onion, and the serrano chiles. Season with salt to taste.

Serve the guacamole in an eye-catching dish and garnish with the pomegranate seeds, requesón, and chile de árbol.

Serve with homemade *totopos* for dipping.

DANIEL PATTERSON
ALBALONE

Serves 4

2 cups escarole hearts, cleaned and cut in 1-inch pieces
5 tablespoons butter
Salt
Rice wine vinegar
Freshly ground black pepper
4 abalone (order small ones from Monterey Bay Abalone; they ship), cleaned and pounded
Flour, for dusting
½ teaspoon minced shallots
2 to 3 tablespoons fresh lemon juice
½ teaspoon chopped caperberries
Chopped herbs, such as parsley and tarragon (optional)

In a skillet, cook the escarole in 1 tablespoon of butter, with just enough water to allow it to steam, and salt to taste.

Season with rice wine vinegar and black pepper to taste. Keep warm.

Season the abalone lightly with salt and dust with flour. In a large skillet, heat the remaining 4 tablespoons of butter over medium heat.

When the butter has just finished bubbling, add the abalone, foot-side up. Increase the heat to medium-high and cook for 30 to 45 seconds on the first side. Then flip and cook for an additional 45 seconds, until just cooked. Transfer the abalone to a plate.

Add the shallots to the skillet and cook for 20 seconds, shaking the pan.

Add the lemon juice and caperberries and stir. Taste and add more salt or lemon juice.

Return the abalone to the pan and baste with the sauce until the abalone are hot. Remove the pan from the heat.

To serve, divide the escarole among 4 plates or shallow bowls. Put an abalone on top of each.

Spoon the brown butter sauce over the abalone, and if you like, sprinkle with some fresh herbs.

WOLFGANG PUCK
SWEET CORN AGNOLOTTI WITH WHITE TRUFFLES

Serves 10

Filling

Makes about 2 cups of filling, for about 100 agnolotti
1 cup organic heavy cream
4 ears organic white corn, grated through the medium holes of a box grater (about 2 cups)
1 teaspoon sugar
1 teaspoon kosher salt
¼ teaspoon freshly ground black pepper
3 ounces organic mascarpone cheese
1 ounce organic goat cheese
2 tablespoons grated Parmesan cheese
1 teaspoon fresh thyme leaves, minced

Agnolotti Dough

3 cups flour
8 cage-free egg yolks
1 teaspoon kosher salt
1 teaspoon extra-virgin olive oil
Seminola or flour, for dusting

Assembly

Egg wash
½ cup organic free-range chicken stock
6 ounces unsalted butter
2 sprigs sage
Salt and freshly ground black pepper
White truffle

To make the filling: In a medium skillet, bring the cream to a boil. Reduce until only ⅓ cup remains.

Stir in the grated corn, sugar, salt, and pepper. Bring the mixture to a slow boil, stirring constantly.

Continue to cook until the mixture reduces and is thick enough to heavily coat the spoon.

Transfer the mixture to a medium bowl. Stir in the cheeses and thyme and mix until well blended. Taste and adjust the seasoning with salt and pepper.

Place the bowl in a larger bowl filled with ice and water to allow the filling to set.

To make the agnolotti dough: In a food processor, combine the flour, egg yolks, salt, oil, and 2 tablespoons of water.

Process until the dough begins to hold together, then stop the machine and pinch the dough to test it. If it's too dry, add up to 1 more tablespoon of water and process until it forms a moist ball.

Turn out the dough onto a lightly floured work surface and knead by hand until a smooth ball is formed.

Loosely wrap the dough in plastic and let it rest at room temperature for 30 minutes to 1 hour.

Cut the dough into 4 equal pieces. Keep the other pieces covered in plastic while you roll out one piece at a time, by hand with a rolling pin or through the rollers of a pasta machine, stretching the dough to the desired thickness.

If using a pasta machine, set the rollers at the widest opening. Flatten the first piece of dough into a thick strip no wider than the machine, to enable it to pass through the rollers. If necessary, dust the pasta very lightly with flour. Run the pasta through the machine.

Fold it in thirds crosswise and run it through the machine again. Repeat this procedure two more times, until the dough is smooth and somewhat elastic.
Set the machine to the next smaller opening and run the dough through the rollers.

Continue rolling and stretching the dough, using the next smaller opening each time, until the next-to-last or last opening is reached, dusting lightly with flour only as necessary. (The strip of dough will be long. If you don't have enough space on your worktable, halfway through the rolling process, cut the strip of dough in half and continue to work with each piece separately, keeping the unused dough covered.)

To assemble the agnolotti: Brush the dough with egg wash. Mound little heaps of filling about 1 inch apart. Fold over and squeeze the dough together in between filling mounds.

With a serrated pasta cutter, cut the agnolotti. Cut away the excess dough lengthwise; there should be no more than ¼ inch around the edges.

Bring a large pot of salted water to a boil.

Meanwhile, in a heavy skillet, combine the stock, butter, and sage. Boil until the mixture emulsifies. Season with salt and pepper to taste.

Cook the agnolotti until al dente, 2 to 3 minutes. Remove with a slotted spoon and toss gently in the sage butter. Serve in soup plates and shave white truffle on top.

To take advantage of the wonderful truffle aroma, cover each individual bowl of agnolotti with another plate. When the bowls are brought to the table, remove the top plate so the truffle aroma escapes just before the guest takes the first bite.

RACHAEL RAY

SPAGHETTI AGLIO E OLIO

Serves 4

Salt
1 pound spaghetti, chitarra, or any long-strand pasta
¼ cup EVOO (extra-virgin olive oil)
8 to 10 good-quality Italian flat anchovy fillets
6 to 8 garlic cloves, grated or finely chopped
1 red chile pepper, such as Italian cherry or Fresno, seeded and finely chopped
Black pepper
½ cup chopped fresh flat-leaf parsley
½ cup fresh breadcrumbs, toasted (optional)

Bring a large pot of water to a boil for the pasta. Salt the water, add the pasta, and cook to just shy of al dente.

Reserve a ladle or small cup of the starchy cooking water and drain. Meanwhile, in a large skillet, heat the oil over medium-low heat.

When the oil starts to ripple, add the anchovies and stir until they melt into the oil (little bits of bones are OK; they will melt in).

When the anchovies are fully melted, stir in the garlic and chile pepper along with some coarsely ground black pepper. Cook, stirring constantly, for 2 to 3 minutes.

Add the parsley along with the starchy cooking water. Add the drained spaghetti to the anchovy-oil mixture (ideally straight from the water to the pan) and toss vigorously for 1 to 2 minutes so the pasta absorbs the flavors.

Serve as is or top with a sprinkling of toasted breadcrumbs.

JOËL ROBUCHON

PAIN CLASSIQUE (CLASSIC FRENCH BAGUETTE)

Makes about 15 baguettes

About 7 cups (2.2 pounds/1 kilogram) bread flour
2¾ cups water at 57°F (14°C)
¼ teaspoon (1 gram) malt powder
¼ teaspoon (1 gram) dry yeast powder
4 teaspoons salt
7 ounces (200 grams) leftover fermented dough, traditional

The dough needs to be made the day before you bake the baguettes.

In the bowl of an electric mixer, combine the flour, water, and malt. Mix the dough on low speed for 1 minute, then add the yeast. Continue mixing on low speed for 3 minutes. Cover the bowl with plastic wrap and set aside for 20 minutes.

Add the salt and the fermented dough to the mixer bowl and mix for 4 minutes on low speed, then for 30 seconds on medium speed.

Divide the dough into 2 pieces and set aside for 30 minutes in the proofer at 77°F (25°C).

Fold the dough and let rest again in the proofer at 77°F (25°C) for 30 minutes.

Fold the dough one more time, wrap well, and keep in the refrigerator at 39°F (4°C) until the next day.

Divide the dough into pieces weighing about 2 ounces (50 grams) each. Shape them loosely into balls. Put them in the proofer at 77°F (25°C) for 1 hour 30 minutes.

Line baking sheets with parchment paper. Shape each ball of dough into a baguette and place them on the baking sheets. Sprinkle the loaves with some flour and return to the proofer for 1 hour 15 minutes.

Preheat the oven to 500°F (260°C) on the top and 425°F (215°C) on the bottom, with steam.

Make 3 diagonal cuts in the top of each baguette with a razor-sharp blade.

Bake for 14 minutes.

After baking, let cool at least 15 minutes on a wire rack to make sure the bottom of the baguette will not be soft later.

RUTH ROGERS

SLOW-COOKED TAGLIATELLE WITH TOMATO SAUCE

Serves 4

3 tablespoons olive oil
2 garlic cloves, slivered
Pinch of red pepper flakes
Salt and ground black pepper
1 jar (28 ounces) San Marzano plum tomatoes, drained
12 ounces tagliatelle pasta

In a large skillet, heat the oil. Add the garlic, red pepper flakes, salt, and black pepper.

Before the garlic browns, reduce the heat and add the tomatoes, stirring to break them up.

Cook slowly, stirring occasionally, for at least 1½ hours.

The oil should come to the surface and the sauce will be dark red and extremely thick with no juice at all.

Bring a large pot of salted water to a boil. Add the tagliatelle and cook until al dente.

Drain, add to the sauce, and toss to combine.

ALBERT ROUX

SKIRT STEAK WITH ENGLISH CHIPS

Serves 1

½ pound skirt steak
3 tablespoons olive oil
2 shallots, finely chopped
2 garlic cloves, smashed
1 sprig thyme
1 teaspoon good red wine vinegar
Salt and pepper
3 Rooster potatoes
1 tablespoon sunflower oil
½ tablespoon butter
Chopped parsley, for garnish
Minced garlic, for garnish
Béarnaise sauce, for serving (optional)

Trim off all sinew, if any, flatten, and marinate the steak overnight with the olive oil, shallots, garlic, thyme, and vinegar.

Heat the grill well, quickly grill the meat on both sides, and season to taste with salt and pepper.

Peel and cut the Rooster potatoes into small pieces or slices. Sauté the potatoes in sunflower oil with butter until golden to brown.

Sprinkle with parsley and minced garlic before serving. Serve with béarnaise sauce, if you like.

THE SANTINI FAMILY

FOIE GRAS WITH SUMMER FRUIT

Serves 4

4 tablespoons butter
¼ cup passito wine
¼ cup meat broth
2 sprigs rosemary
Balsamic vinegar
½ cup cherries
½ cup raspberries
Four ½-inch-thick slices foie gras (goose or duck)
Coarse sea salt
1 teaspoon rubbed sage

Melt 2 tablespoons of the butter in an aluminum skillet. Add the wine and simmer to evaporate the liquid; the sugars in the wine will coat the sides of the pan and caramelize. Add the broth and use it to "deglaze" the pan, stirring up the caramelized sugars. Flavor it with 1 sprig of rosemary.

Continue cooking until you have a soft and silky sauce, 4 to 5 minutes. Remove from the heat and add a couple of drops of balsamic vinegar, the cherries, and the raspberries.

In a large nonstick skillet, melt the remaining 2 tablespoons butter, and let it brown, being careful not to let it burn. When it starts to smoke, put in the foie gras. Reduce the heat to medium. Turn the foie gras over, sprinkle with salt, sage, and the second sprig of rosemary, minced. Cook until crisp and golden on both sides and heated through on the inside, 3 to 4 minutes.

Serve with the prepared sauce and your choice of summer fruits.

BEN SHEWRY

THE HANGI

Feeds 40

80 potatoes
40 kumaras (sweet potatoes)
40 large carrots
40 yellow onions
Salt
Oil
1 wild goose, plucked and gutted
2 wild boar shoulders, brined
2 heads cabbage

Find a quiet place without a building or house in sight; ideally this would be in an isolated area like something out of *The Lord of the Rings,* for dramatic effect. Choose a spot sheltered from strong winds and maybe with some natural seating. Your friends will need somewhere to sit as they drink beer and watch you dig the pit. On that note, there should be a cool stream close by so you can tie a string around the neck of your beer bottle, then tie the other end onto something on the riverbank to secure it before throwing the bottle into the stream. This is an old trick of my father's and quite an ingenious way of cooling beer. He would have these bottles set up around the farm, and whenever he felt like a cool beer, there was never a bottle too far away.

The pit should be wide and long enough to fit all your wire baskets comfortably and about 2 feet deep. The last time I put down a hangi, it was for 100 people, and we used a front-end loader to dig it—although that was probably cheating. Once you have your pit ready, lay the branches and tree trunks over it, followed by a layer of rocks. Repeat this, crossing the branches at opposite angles, until you have no more rocks or wood. The bonfire should be rather large. Light it, and when it is well and truly ablaze, it is time to start your food preparations. The fire will take several hours to die down, so there is no rush. Now's probably a good time to have another beer—if your useless mates have left any.

Peel the potatoes, kumaras, carrots, and onions and toss them in some salt and oil. Lay them out in the wire racks.

Lay the meats and cabbage on the racks and season well. The fire should be burning down by now, and all the rocks should have fallen into the pit. When the fire has completely burnt out and the rocks are white hot, it is time to lay the hangi.

Soak your hessian sacks in plenty of cold water and lay them over the rocks. The first layer of food should be the racks of meat and cabbage—they will take the longest to cook and protect the vegetables from getting burnt (hopefully). Lay the other racks down and cover the whole thing with more damp sacks to seal the food away from the earth.

Cover the whole lot with plenty of earth. Sit back and enjoy the smell of earth and flesh cooking as the steam rises from the pit. The hangi needs to be left now for 4 to 6 hours. It's been said that it's difficult to overcook a hangi, although I will admit that with my last attempt I nearly succeeded.

Dig it up and tear at the food with your hands in a frenzied fashion. You will be hallucinating and fatigued from staying up all night laying this damn hangi. You won't even know if it's dirt or meat you are eating. At this point, the scene should look like one of those bear attacks you see on the Discovery Channel. But seriously, it can be an amazing way to spend some time out of the city with friends and family, and it's the way I'd most like to go out. Something real, with history and emotion. And without air and graces.

MICHAEL SYMON
LITTLE PORK MEATBALLS

Serves 10

1 cup finely diced day-old bread
½ cup milk
3 tablespoons olive oil
2 garlic cloves, minced
3 shallots, minced
Salt
1 teaspoon ground coriander
¼ teaspoon ground cumin
¼ teaspoon red pepper flakes
3 pounds coarsely ground pork (75-25)
2 tablespoons chopped fresh mint
Grated zest of 1 lemon
About 4 cups lard
Greek yogurt, for serving
Lemon wedges, for serving

In a small bowl, combine the bread and milk. Let soak for 10 minutes, then squeeze out the excess milk.

Meanwhile, in a large skillet, heat the olive oil over medium heat. Add the garlic and shallot and a large pinch of salt. Cook until just softened. Add the coriander, cumin, and pepper flakes and heat over low heat for 1 minute. Set aside to cool.

In a large bowl, mix the pork with the shallot-spice mixture, soaked (and squeezed) bread, mint, and lemon zest. Form into small balls (1-inch diameter). In a large skillet, melt enough lard to come to 1 inch. Add the meatballs and shallow-fry until the internal temperature reaches 160°F, about 3 minutes a side.

Serve with Greek yogurt and lemon wedges.

BILL TELEPAN
BLUEBERRY AND PEACH CRUMBLE

Serves 8

Filling
2 pounds ripe peaches, sliced
3 cups packed blueberries
¼ cup sugar
1½ teaspoons cornstarch
¼ teaspoon ground cinnamon
Juice of ½ large lemon (about 1 tablespoon)

Crumb Topping
4 tablespoons (½ stick) chilled unsalted butter, cut up
½ cup plus 2 tablespoons all-purpose flour
½ cup sugar
½ teaspoon pure vanilla extract
Grated zest of 1 lemon (about 1 teaspoon)

Preheat the oven to 350°F.

To make the filling: In a large bowl, toss together the peaches, blueberries, sugar, cornstarch, cinnamon, and lemon juice. Place in a 9 × 9-inch baking pan.

To make the topping: Combine the butter, flour, sugar, vanilla, and lemon zest in a mixer bowl. Using the paddle at low speed, mix until the crumbs are pea-size. Spread evenly over the blueberries and peaches.

Bake until the streusel is lightly brown, 45 minutes to 1 hour. Let cool to room temperature and serve with ice cream.

Mmmmmmm . . .

MARC VETRI
MINT CHOCOLATE SUNDAES

Serves 4 to 6

Semifreddo
12 egg yolks
2½ cups sugar
2 teaspoons mint extract
12 egg whites
24 ounces heavy cream
3½ ounces chocolate, chopped

Chocolate Cookies
8 ounces butter
1½ cups sugar
1 teaspoon mint extract
1 egg
1½ cups flour
½ cup cocoa powder
1 teaspoon baking powder
½ teaspoon salt

To make the semifreddo: Using an electric mixer, whip the egg yolks, sugar, and mint extract until light and fluffy.

In a separate bowl, whip the egg whites until soft peaks form. In a medium bowl, whip the cream to soft peaks. Fold the yolk mixture and whites into the cream until completely incorporated. Put in the freezer for an hour to set up.

Remove the semifreddo from the freezer and fold in the chocolate. Put back in the freezer until you're ready to serve.

To make the cookies: Preheat the oven to 350°F. Cream the butter, sugar, and mint extract together. Add the egg and mix until incorporated. In a separate bowl, mix the flour, cocoa powder, baking powder, and salt together and add to the butter mixture. Mix until completely incorporated.

Divide the batter into 5 even portions, and roll each into a ball. Press down slightly. Bake for 12 minutes.

Serve 2 scoops of semifreddo with 2 cookies. Drizzle with chocolate sauce if desired. It also makes a great semifreddo sandwich!

MARCO PIERRE WHITE
GULLS' EGGS WITH MAYONNAISE AND CELERY SALT

Serves 4 to 6

12 gulls' eggs
Celery salt
Hellmann's mayonnaise, for serving

Cook the eggs in a pan of simmering water for 5 minutes and 10 seconds.
Remove the pan from the heat and run the eggs under cold water while half peeling them.
Spread enough celery salt over a large serving plate to cover, then arrange the eggs on top.
Serve with the mayonnaise for dipping.

MICHAEL WHITE
GLASS EELS WITH SAGE

Serves 4 as a starter

2 tablespoons extra-virgin olive oil
1 garlic clove, unpeeled
10 sage leaves
12 ounces glass eels
Sea salt
Ground black pepper
Lemon wedges, for serving

Heat a skillet over medium heat. Add the oil and the unpeeled garlic clove and heat gently for 2 to 3 minutes, being careful not to let the oil bubble.

Add the sage leaves and sauté them in the oil until the leaves begin to crisp, about 1 minute.

Add the glass eels. Return the heat to warm. Season with sea salt and pepper to taste. Lightly toss until the eels are just cooked. They will turn from translucent to opaque very quickly.

Remove from the heat and serve the eels and the now-crispy sage leaves with a few drops of freshly squeezed lemon juice.

RESTAURANTS

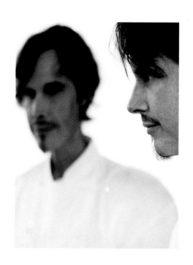

GRANT ACHATZ

The Aviary *(Chicago, Illinois)*
Next Restaurant *(Chicago)*
Alinea *(Chicago)*

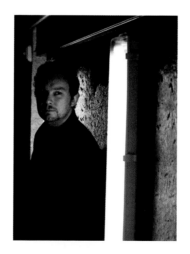

ALBERT ADRIÀ

Tickets *(Barcelona, Spain)*
41° *(Barcelona)*
Inopia Classic Bar *(Barcelona)*

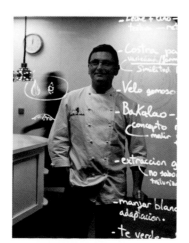

ANDONI LUIS ADURIZ

Mugaritz *(Errenteria, Spain)*

MASSIMILIANO ALAJMO

Le Calandre *(Sarmeola di Ruban, Italy)*

ALEX ATALA

Dalva e Dito *(São Paulo, Brazil)*
D.O.M. *(São Paulo)*

PAUL BARTOLOTTA

Lake Park Bistro *(Milwaukee, Wisconsin)*
Mr. B's—A Bartolotta Steakhouse *(Brookfield, Wisconsin)*
Ristorante Bartolotta *(Wauwatosa, Wisconsin)*
Bacchus—A Bartolotta Restaurant *(Milwaukee)*
Pizzeria Piccola *(Wauwatosa)*

JOE BEEF
(David McMillan and Frédéric Morin)

Joe Beef *(Montreal, Canada)*
Liverpool House *(Montreal)*

SHANNON BENNETT

Vue de Monde *(Melbourne, Australia)*

JOHN BESH

Luke Riverwalk *(San Antonio, Texas)*
American Sector *(New Orleans, Louisiana)*
Domenica *(New Orleans)*
Luke *(New Orleans)*
La Provence *(Lacombe, Louisiana)*
Restaurant August *(New Orleans)*
Besh Steak *(New Orleans)*

HESTON BLUMENTHAL

Dinner by Heston Blumenthal *(London, England)*
The Hinds Head *(Bray, England)*
The Fat Duck *(Bray)*

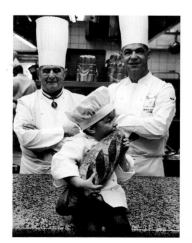

PAUL AND JÉRÔME BOCUSE

Le Sud *(Geneva, Switzerland)*
Ouest Express *(Lyon, France)*
Brasserie de l'Ouest *(Lyon)*
Les Chefs de France *(Orlando, Florida)*
Restaurant Bocuse—Auberge du Pont de Collonges *(Lyon)*

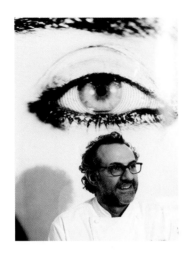

MASSIMO BOTTURA

Osteria Francescana *(Modena, Italy)*

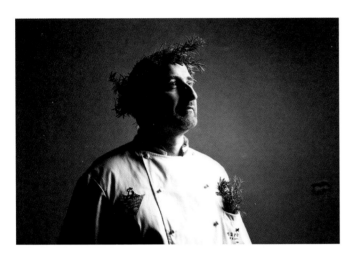

CESARE CASELLA

Salumeria Rosi Parmacotto *(New York, New York - Parma, Italy)*

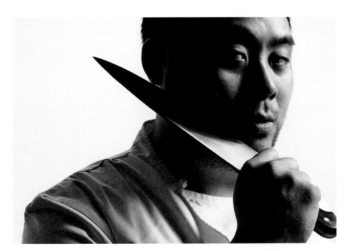

DAVID CHANG

Momofuku *(Sydney, Australia)*
Má Pêche *(New York, New York)*
Momofuku Ko *(New York)*
Momofuku Ssäm Bar *(New York)*
Momofuku Noodle Bar *(New York)*

ROY CHOI

Kogi *(Los Angeles, California)*

TOM COLICCHIO

Craft *(New York, New York - Los Angeles, California - Dallas, Texas - Atlanta, Georgia)*
Craftbar *(New York - Los Angeles - Atlanta)*
Colicchio & Sons *(New York)*
'wichcraft *(New York - Las Vegas, Nevada - San Francisco, California)*
Craftsteak *(Ledyard, Connecticut - Las Vegas)*
Riverpark *(New York)*
The Tides *(Kiawah Island, North Carolina)*
Hearth Restaurant *(New York)*

TRACI DES JARDINS

Manzanita *(Truckee, California)*
Public House *(San Francisco, California)*
Mijita *(One Ferry Building, San Francisco)*
Mijita *(Willie Mays Plaza, San Francisco)*
Jardiniere *(San Francisco)*

TODD ENGLISH

Olives *(Las Vegas, Nevada - New York, New York - Boston, Massachusetts)*
Figs *(Charlestown, Massachusetts - Boston - Palm Beach Gardens, Florida)* Figs at 29 Fair *(Nantucket, Massachusetts)*
Bluezoo *(Lake Buena Vista, Florida)* Bonfire *(Boston - New York)* da Campo Osteria *(Ft. Lauderdale, Florida)* Kingfish *(Boston)* Todd English *(Aboard the* Queen Mary 2 *- Aboard the* Queen Victoria*)* Tuscany *(Uncasville, Connecticut)*
Isabelle's Curly Cakes *(Boston)* Wild Olives *(Boca Raton, Florida)* Todd English P.U.B *(Las Vegas)* Ça Va *(New York)*
The Plaza Food Hall *(New York)*

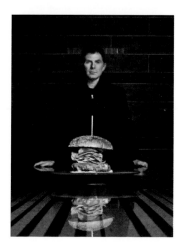

BOBBY FLAY

Mesa Grill *(New York, New York - Las Vegas, Nevada)*
Bar Americain *(New York - Uncasville, Connecticut)*
Bobby Flay Steak *(Atlantic City, New Jersey)*
Mesa Grill *(Paradise Island, Bahamas)*
Bobby's Burger Palace *(Lake Grove, New York - Eatontown, New Jersey - Paramus, New Jersey)*
Bobby's Burger Palace *(Uncasville - Philadelphia, Pennsylvania)*

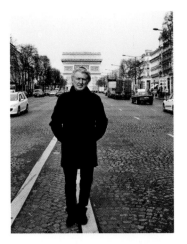

PIERRE GAGNAIRE

Pierre Gagnaire Tokyo *(Tokyo, Japan)*
Twist *(Las Vegas, Nevada)*
Pierre *(Hong Kong, China)*
Sketch *(London, England)*
Pierre Gagnaire *(Paris, France - Courchevel, France - Seoul, South Korea)*
Restaurant Gaya *(Paris)*
Reflets *(Dubai, United Arab Emirates)*
Colette *(Saint-Tropez, France)*
Les Menus *(Moscow, Russia)*

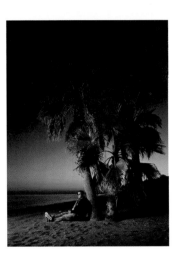

DANI GARCÍA

El Calima *(Marbella, Spain)*

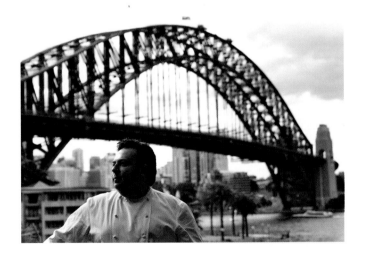

PETER GILMORE

Quay *(Sydney, Australia)*

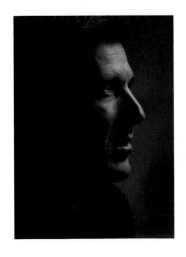

LAURENT GRAS

Currently no restaurants

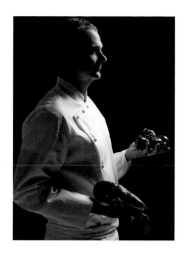

DANIEL HUMM

Eleven Madison Park *(New York, New York)*

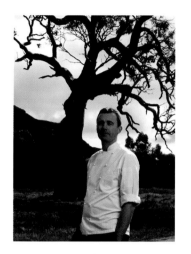

DAN HUNTER

Royal Mail *(Dunkeld, Australia)*

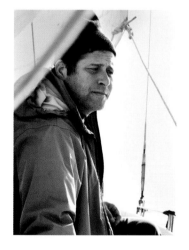

DAVID KINCH

Manresa Restaurant *(Los Gatos, California)*

EMERIL LAGASSE

Emeril's *(New Orleans, Louisiana)*
Nola Restaurant *(New Orleans)*
Emeril's Delmonico *(New Orleans)*
Emeril's New Orleans Fish House *(New Orleans)*
Delmonico Steakhouse *(Las Vegas, Nevada)*
Table 10 *(Las Vegas)*
Lagasse's Stadium *(Las Vegas)*
Emeril's Orlando *(Orlando, Florida)*
Emeril's Tchoup Chop *(Orlando)*
Emeril's Miami Beach *(Miami Beach, Florida)*
Emeril's Chop House *(Bethlehem, Pennsylvania)*
Burgers and More by Emeril *(Bethlehem)*

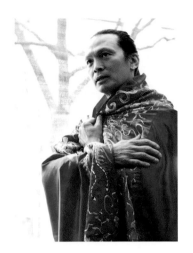

SUSUR LEE

Chinois *(Singapore)*
Lee Restaurant *(Toronto, Canada)*
Zentan *(Washington, DC)*
Shang *(New York, New York)*

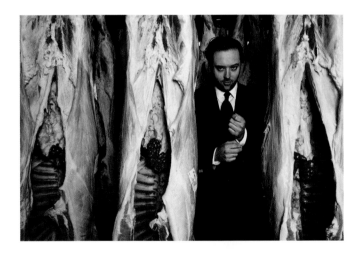

PAUL LIEBRANDT

Corton *(New York, New York)*

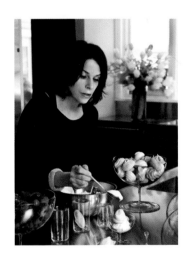

BARBARA LYNCH

No. 9 Park *(Boston, Massachusetts)*
The Butcher Shop *(Boston)*
B&G Oysters *(Boston)*
Niche Catour *(Boston)*
Plum Produce *(Boston)*
Stir *(Boston)*
Drink *(Boston)*
Sportello *(Boston)*
Menton *(Boston)*

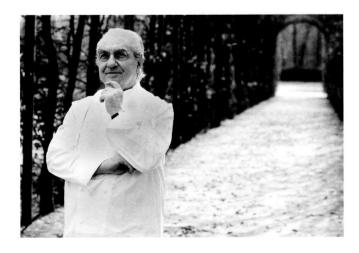

GUALTIERO MARCHESI

Ristorante Gualtiero Marchesi *(Erbusco, Italy)*

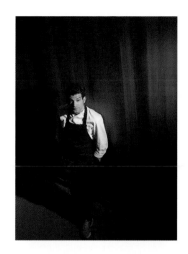

GEORGE MENDES

Aldea *(New York, New York)*

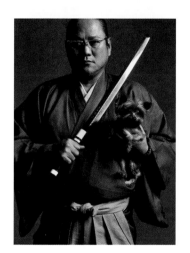

MORIMOTO

Morimoto *(Philadelphia, Pennsylvania - New York, New York - Boca Raton, Florida)*
Wasabi *(Mumbai, India)*
Morimoto XEX *(Tokyo, Japan)*

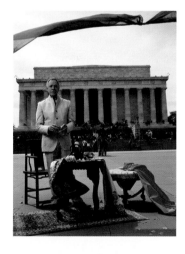

PATRICK O'CONNELL

The Inn at Little Washington *(Washington, Virginia)*

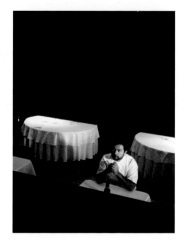

ENRIQUE OLVERA

Pujol *(Mexico City, Mexico)*
La Purificadora Restaurant *(Mexico City)*

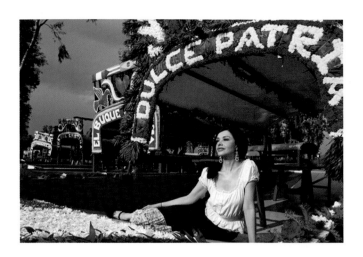

MARTHA ORTIZ

Dulce Patria *(Mexico City, Mexico)*
Barroco *(Mexico City)*

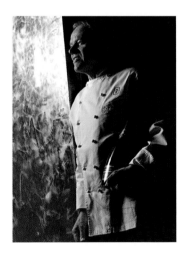

DANIEL PATTERSON

Plum *(Oakland, California)*
Il Cane Rosso *(San Francisco, California)*
Bracina *(Oakland)*
Coi *(San Francisco)*

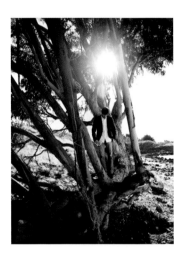

WOLFGANG PUCK

Spago *(Beverly Hills, California - Las Vegas, Nevada - Maui, Hawaii - Beaver Creek, Colorado)*
Cut *(Beverly Hills - Las Vegas - Singapore - London, England)*
Chinois *(Santa Monica, California)*
Wolfgang Puck Pizzeria & Cucina *(Las Vegas)*

RACHAEL RAY

Chef, author, and television host

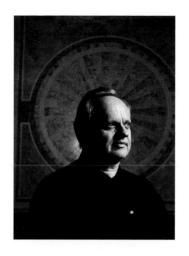

JOËL ROBUCHON

The Pastry Shop & Lounge *(Singapore)*
L'Atelier de Joël Robuchon *(Singapore - Taipei, Taiwan - Hong Kong, China - London, England - New York, New York - Las Vegas, New York - Tokyo, Japan - Paris, France)*
La Table de Joël Robuchon *(Singapore - Nagoya, Japan)*
Yoshi *(Monte Carlo, Monaco)*
Joël Robuchon at The Mansion *(Las Vegas, Nevada)*
Restaurant Joël Robuchon *(Monte Carlo)*
Robuchon a Galera *(Macao, China)*

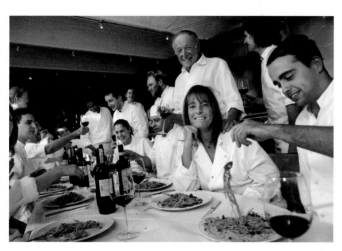

RUTH ROGERS

The River Café *(London, England)*

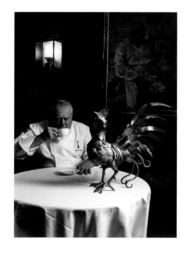

ALBERT ROUX

Le Gavroche *(London, England)* Chez Roux *(La Torretta Resort and Spa, Montgomery, Texas)* Château de Montreuil Relais & Chateaux *(Montreuil-sur-Mer, France)* Brasserie Roux *(London - Heathrow Airport)* The Walbrook *(London)*
Chez Roux at Rocpool Reserve *(Inverness, Scotland)*
Chez Roux at Inver Lodge Hotel *(Sutherland, Scotland)*
Chez Roux at Greywalls Hotel *(East Lothian, Scotland)*
Roux at Parliament Square *(London)* Inverlochy Castle *(Fort William, Scotland)*
Roux at the Landau *(London)*

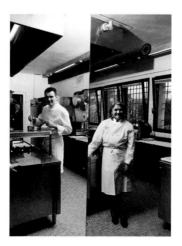

THE SANTINI FAMILY

Dal Pescatore *(Canneto sull'Oglio, Italy)*

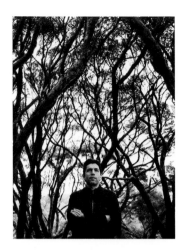

BEN SHEWRY

Attica *(Melbourne, Australia)*

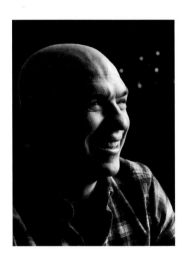

MICHAEL SYMON

Michael Symon's Roast *(Detroit, Michigan)*
Lola Bistro *(Cleveland, Ohio)*
The B Spot *(Eton, Ohio)*
Lolita *(Cleveland)*

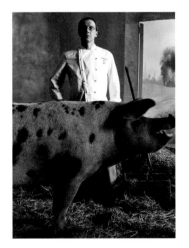

BILL TELEPAN

Telepan *(New York, New York)*

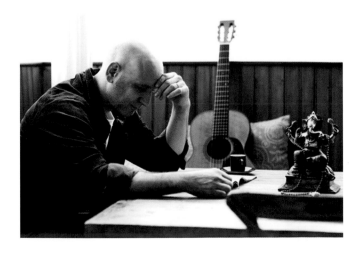

MARC VETRI

Amis *(Philadelphia, Pennsylvania)*
Osteria *(Philadelphia)*
Vetri *(Philadelphia)*

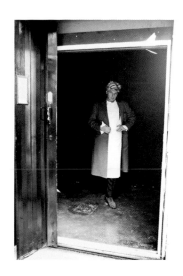

MARCO PIERRE WHITE

Wheeler's of St. James *(London, England)*
Marco *(London)*
Kings Road Steakhouse *(London)*
Steak & Alehouse *(London)*
The Box Tree *(Ilkley, England)*
The Chequers Hotel *(Maresfield, England)*
Marco Pierre White's The Swan Inn *(Aughton, England)*
Marco Pierre White Steakhouse, Bar & Grill *(Birmingham, Bristol, Chester, England - Dublin, Ireland)*
Frankie's *(Dublin, Dubai)*
Frankie's Criterion *(Knightsbridge, London)*
Frankie's Braganza *(Chiswick, London)*
Frankie's Stamford Bridge *(London)*

MICHAEL WHITE

Ai Fiori *(New York, New York)*
Marea *(New York)*
Due Mari *(New Brunswick, New Jersey)*
Due Terre *(Bernardsville, New Jersey)*
Morini *(New York)*

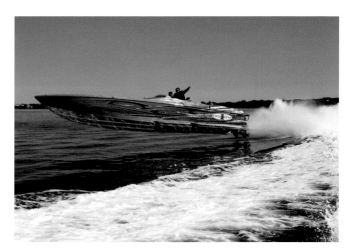

WHO, WHEN, & WHERE

CHEFS	NATIVE COUNTRY	CITY	SHOOT LOCATION	SHOOT DATE
Grant Achatz	USA	Chicago	Alinea Restaurant, Chicago, Illinois	12/1/2010
Albert Adria	SPAIN	Barcelona	Tickets Restaurant, Barcelona, Spain	1/31/2011
Andoni Luis Aduriz	SPAIN	San Sebastien	Mugaritz Restaurant, San Sebastien, Spain	2/1/2010
Massimiliano Alajmo	ITALY	Padua	Italian Culinary Academy, New York	1/13/2011
Alex Atala	BRAZIL	Sao Paulo	D.O.M restaurant, Sao Paulo, Brazil	3/28/2011
Paul Bartolotta	USA	Las Vegas	Industria Studios, New York	3/2/2011
Shannon Bennett	AUSTRALIA	Melbourne	Melbourne, Australia	9/21/2007
John Besh	USA	New Orleans	A swamp in Sliddel, Louisiana	1/20/2010
Heston Blumenthal	UK	London	Dinner by Heston Blumenthal, Mandarin Oriental Hotel, London	3/8/2011
Jérôme & Paul Bocuse	FRANCE	Lyon	Restaurant Bocuse, Lyon, France	1/23/2011
Massimo Bottura	ITALY	Modena	Massimo's home	3/18/2011
Cesare Casella	USA	New York	Industria Studios, New York	5/2/2007
David Chang	USA	New York	Industria Studios, New York	11/15/2010
Roy Choi	USA	Los Angeles	Corner of Western & Fountain, Los Angeles (at 4 am!)	2/12/2011
Tom Colicchio	USA	New York	Mattituck, Long Island, New York	11/26/2010
Traci Des Jardins	USA	San Francisco	A loft in the Dogpatch area, San Francisco	12/15/2010
Todd English	USA	New York	W Hotel, Union Square, New York	3/23/2011
Bobby Flay	USA	New York	Bobby's Burger Palace, Paramus, New Jersey	1/8/2010
Pierre Gagnaire	FRANCE	Paris	Restaurante Gagnaire, Paris	2/14/2011
Dani Garcia	SPAIN	Marbella	The beach, Marbella, Spain	2/2/2011
Peter Gilmore	AUSTRALIA	Sydney	Quay Restaurant, Sydney, Australia	9/6/2010
Laurent Gras	USA	New York	Industria Studios, New York	12/13/2010
Daniel Humm	USA	New York	Industria Studios, New York	7/27/2010
Dan Hunter	AUSTRALIA	Dunkeld	Royal Mail Hotel, Dunkeld, Australia	9/2/2010
David Kinch	USA	San Francisco	Monterey Bay, Santa Cruz, California	1/9/2010
Emeril Lagasse	USA	New Orleans	Emeril's New Orleans, Louisiana	3/20/2011
Susur Lee	CANADA	Toronto	Lee Lounge, Toronto, Canada	3/11/2011
Paul Liebrandt	USA	New York	Slaughterhouse in New Jersey	11/23/2010
Barbara Lynch	USA	Boston	The Lynch home, Boston, Massachusetts	1/28/2011
Gualtiero Marchesi	ITALY	Franciacorta	Alma Cooking school, Parma, Italy	3/17/2011
David McMillan & Frédéric Morin	CANADA	Montreal	Point St. Charles, Montreal	2/8/2011
George Mendes	USA	New York	Aldea Restaurant, New York	4/22/2011
Morimoto	USA	New York	Industria Studios, New York	2/21/2011
Patrick O'Connell	USA	Virginia	The Washington Mall, Washington DC	4/20/2011
Enrique Olvera	MEXICO	Mexico City	Restaurant Pujol, Mexico City	4/2/2011
Martha Ortiz	MEXICO	Mexico City	Xochimilco, Mexico City	4/2/2011
Daniel Patterson	USA	San Francisco	Coast Park, Oakland, California	1/10/2010
Wolfgang Puck	USA	Los Angeles	WP24, downtown Los Angeles	3/21/2011
Rachael Ray	USA	New York	Rachel Ray TV show studio, New York	4/12/2011
Joël Robuchon	FRANCE	Paris	L'Atelier de Joël Robuchon, New York	11/13/2010
Ruth Rogers	UK	London	The River Café, London	3/7/2011
The Santini Family	ITALY	Renate	Dal Pescatore restaurant, Renate, Italy	3/18/2011
Ben Shewry	AUSTRALIA	Melbourne	Ocean Grove, outside Melbourne	9/1/2010
Michael Symon	USA	Cleveland	The Symons' home, Cleveland, Ohio	11/22/2010
Bill Telepan	USA	New York	Industria Studios, New York	7/27/2010
Marc Vetri	USA	Philadelphia	The Vetri home, Philadelphia, Pennsylvania	12/7/2010
Marco Pierre White	UK	London	The Worx Studio, London,	3/8/2011
Michael White	USA	New York	Hudson River, near Pelham, New York	9/21/2010

THANKS

Adam Sachs
Alessandro, Louis, and Eva Russo
Alex Acuna
Alexei Oreskovic
Alice Shin
Allie Smith
Allison Reynolds
Allison Williams
ALMA La Scuola Internazionale di
Cucina Italiana
Amy Rossetti
Andrea and the crew at Milk
Andrea Campos
Andrea Zanlari
Andrew Hall at Andrew Martin
Anne Madden
Anthony Susi
Beanie and Charlie Wetenhall
Begona Coronel
Ben Schott
Benjamin Mulligan
Bernardaud
Bertha Gonzales
Beth and Curtis Groves
Bob Mundell
Brittany Siegman
Brooke Tabberer
Cameron Levkoff
Carmen Marc Valvo
Carol and Kip Gering
Caroline Bubris
Cassandra Barry
Chiaki Takada
Chris Snow
Christine Hahn
Christine Mulkhe
Conor and Kate Horgan
Courtney Michaelson
Damion Sanchez
Dan Bates
Danny Blanco
Dino Rotolo
Doug Draper
Eliana Mennillo
Enrico Vignol
Esme Emmanuel Berg
Forest Roberts
Francis Carol
Gail Simmons
Gema Urquijo
Gina Gargano

Guy Job
Guy Marlowe
Gwyneth Paltrow
Industria Superstudios
Italian Culinary Academy
Jason Johnson
Jennifer Crawford
Jeremy Abrams
Jess Shadbolt
Jessica Branson
Jilly Lagasse
Joanna Horgan
Joel Stein
Joey Popovich
John and Leslie Unwin
John Barr
John Lyons
José Andrés
José Ramón Calvo
Julianne Bagnato
Julie and Phil D'Accord
Kate Krader
Kevin Chojnowski
Khaled Anwar
Kristen Powers
Laurence Kretchmer
Lee Schrager
Leslie Lefkowitz
Lindsey Valdez
Liz Einbinder
Liz Gunnison
Llorenc Sagarra
Luciano White
Maggie Boone
Maggie McCabe
Maisie Wilhelm
Mandy Oser
Manny Ciminello
Marc Low
Marc-Olivier Frappier
Maria Rodale
Marisa Huff
Mark Pastore
Mark Stone
Martine and Yves Sicard
Mary Barr
Mary Louise Parker
Mathieu Gaudet
Megan Baldwin
Melanie Klausner
Merika Brown

Michael Harvey
Michelle Boxer
Michelle Terrebonne
Miles Kerr
Monica Brown
Mr. Ishii
Nancy and David Coles
Natalie Decleve
Natasha Phan
Nathalie Franques
Nilou Motamed
Olivia Young
Pam Lewy
Pat LaFrieda
Pavia Rosati
Peter Lindberg
Peter Wetenhall
Phillipe Braun
Pim Techamuanvivit
Rachel Felder
Rachel Harrison
Rachel Hayden
Rafael Costa
Rebecca Yody
Riccardo Carelli
Rob Lorraine
Sally Metzler
Sara Foldenauer
Sarah and Will King
Sarah Hearn
Sarah Rosenberg
Scott Waxman
Skip and Kit Gering
Stephanie Banyas
Stephanie Fray
Stephanie March
Sue Allat
Sue Chan
Surma and Bruno Mauro
Susana Nieto
Tarick Richards
Teresa Russo
Thomas Ciminello
Tim Bizzaro
Tracy Anderson
Trish Jones
Uncle David, Lisa, Fiona,
Phil, Rob, Rachel,
Benjamin, Simon, Camilla,
Melanie, Marc, Annabel,
and Steven

Even though I joke that I am a "one-man band," it is not true. Without all these special people, I would be nothing. Thank you.

(The following list is not in any particular order, so don't get crazy, people!)

Nigel, the best husband and friend in the world.

Emma and Jack, sweet children, I love you.

My parents, George and Mary, who taught me anything is possible.

Florence Sicard, Olivia Windisch, and Marie Cortadellas for carrying on the tradition of a beautiful No11-designed book. Giovanni, I miss you.

Karen Rinaldi for your belief and indulging my passions.

Shannon Welch, Nancy Bailey, Chris Gaugler, Emily Weber, and Yelena Gitlin for cracking the whip and getting this damn book together.

Donna and Altour International for navigating my 80,000 miles of flying around the globe in six months and getting me home in one piece.

Becca Parrish, Helen Medvedovsky, and the beautiful girls at Becca PR for spreading the word about me, me, me!

Geoff Katz, Pam Katz (I am not going to forget you this time!), Jennifer Stanek, Hugo Reyes, Allison Krupke, Danny Greer, Lisa Toman, and Jeff Dymowski: Better agents could not be found.

Drew Patrick, my lawyer: Thanks for keeping me out of trouble.

Farley Chase, the best literary agent a girl could have, and the lovely Kristin Powers.

Jenny Askew, Taylor Steel, and Matt Roady, who came along on the journey and followed my mantra: Nod your head and smile.

A BIG thank you all the chefs who have been part of
My Last Supper and to the few who went out of their way to consult on my list and give me secret email addresses galore . . . Don't worry; I'll take those secrets to my grave!

Thank you, my lovely Eric R., Daniel B., Mario B., Cesare C., José A., Dave C., and Tony B.

Marco Pierre White, my newfound friend, thank you for allowing me to hide your best feature and for writing the introduction to my book. Life would be too short without "Marco-isms."

Rodale books may be purchased for business
or promotional use or for special sales.
For information, please write to:
Special Markets Department, Rodale, Inc.,
733 Third Avenue, New York, NY 10017.

Printed in China

Rodale Inc. makes every effort to use acid-free ♾, recycled paper ♻.

All recipes in *My Last Supper: The Next Course* appear courtesy of,
and with copyright assigned to, each respective chef, except in the cases
where the recipes have previously appeared and are reprinted
with gracious permission.

Fried Chicken and Octo Vinaigrette from *Momofuku*, by David Chang and Peter Meehan,
photographs by Gabriele Stabile, copyright © 2009 by David Chang and Peter Meehan,
photographs copyright © 2009 by Gabriele Stabile. Used by permission of
Clarkson Potter/Publishers, an imprint of the Crown Publishing Group,
a division of Random House, Inc.

Whole Wheat Bread originally published in *Ingredienti*,
by Massimiliano and Raffaele Alajmo (Turnaround).
Reprinted courtesy of Massimiliano Alajmo.

Pot-Au-Feu originally published in *Bocuse in Your Kitchen*,
by Paul Bocuse (Flammarion). Reprinted courtesy of Jérôme Bocuse.

Gulls Eggs with Mayonnaise and Celery Salt originally published in
Marco Made Easy: A Three-Star Chef Makes It Simple, by Marco Pierre White
(Weidenfeld & Nicolson, a division of Orion Publishing Group).
Reprinted courtesy of Marco Pierre White.

Mom's Chocolate Birthday Cake originally published in *Better Homes & Gardens*.
Reprinted courtesy of Grant Achatz.

Book design by Florence Sicard Russo & Olivia Windisch, No11 Inc.

Typeset by Olivia Windisch, No11 Inc.

Library Of Congress Cataloging-In-Publication Data is on file with the publisher.

ISBN-13: 978–1–60529–076–8 hardcover

Distributed to the trade by Macmillan

2 4 6 8 10 9 7 5 3 1 hardcover

We inspire and enable people to improve their lives and the world around them.
www.rodalebooks.com